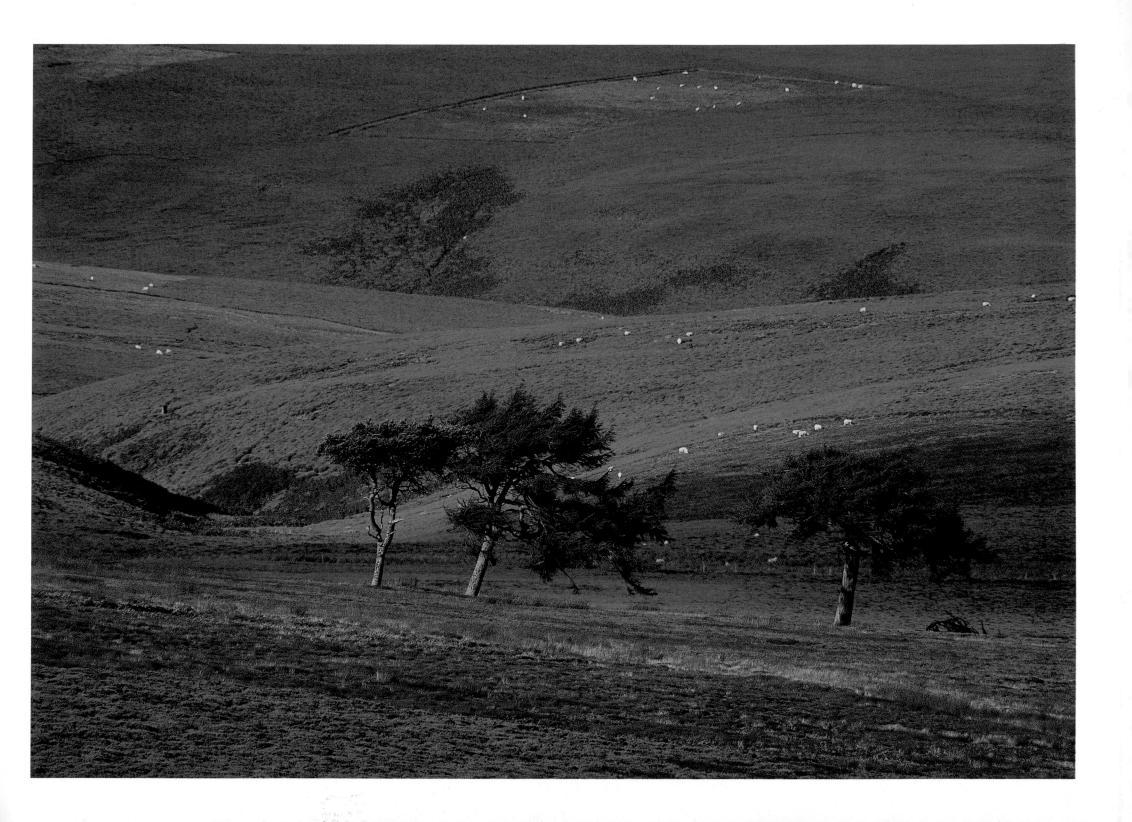

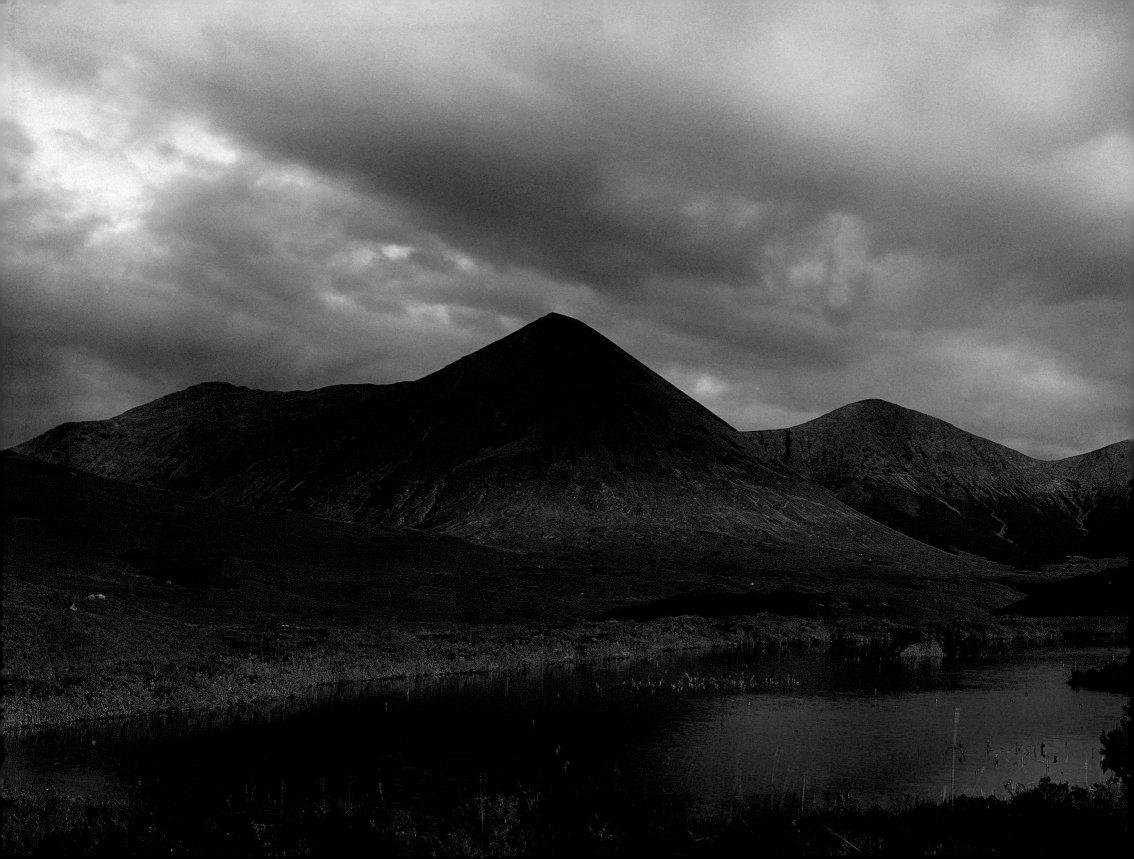

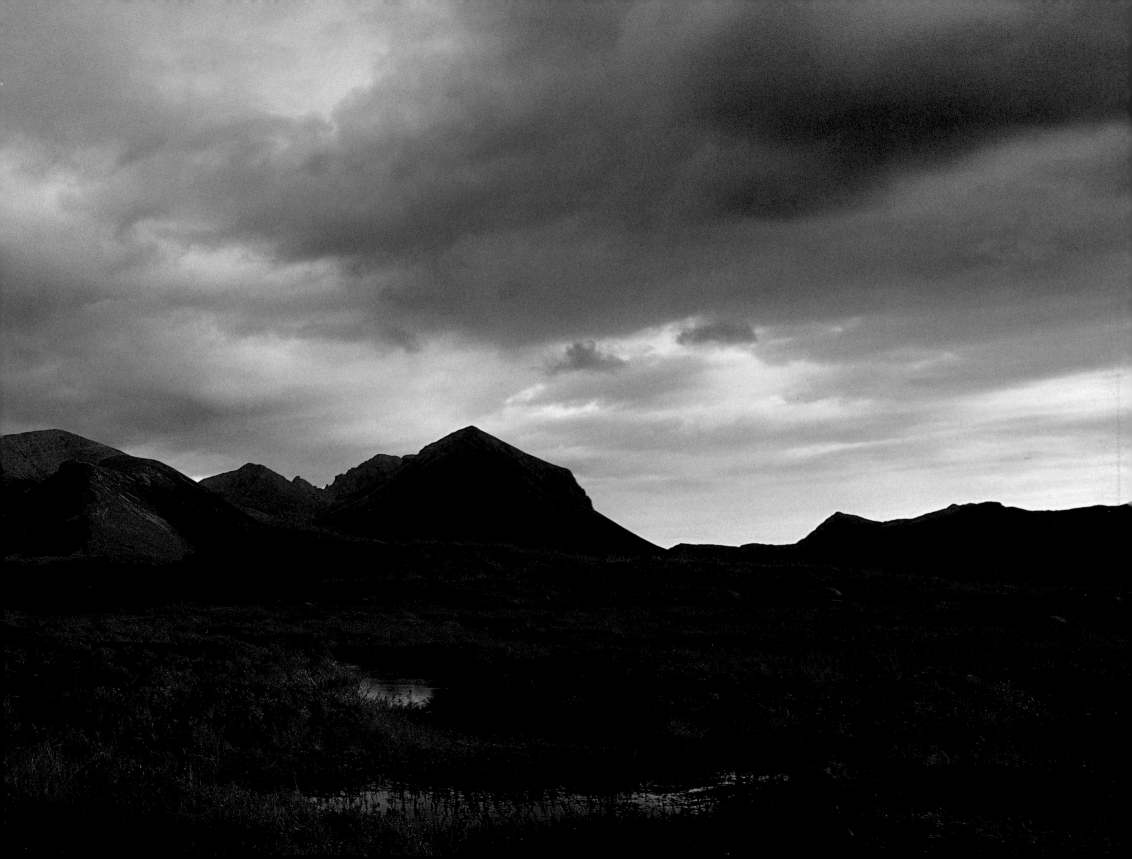

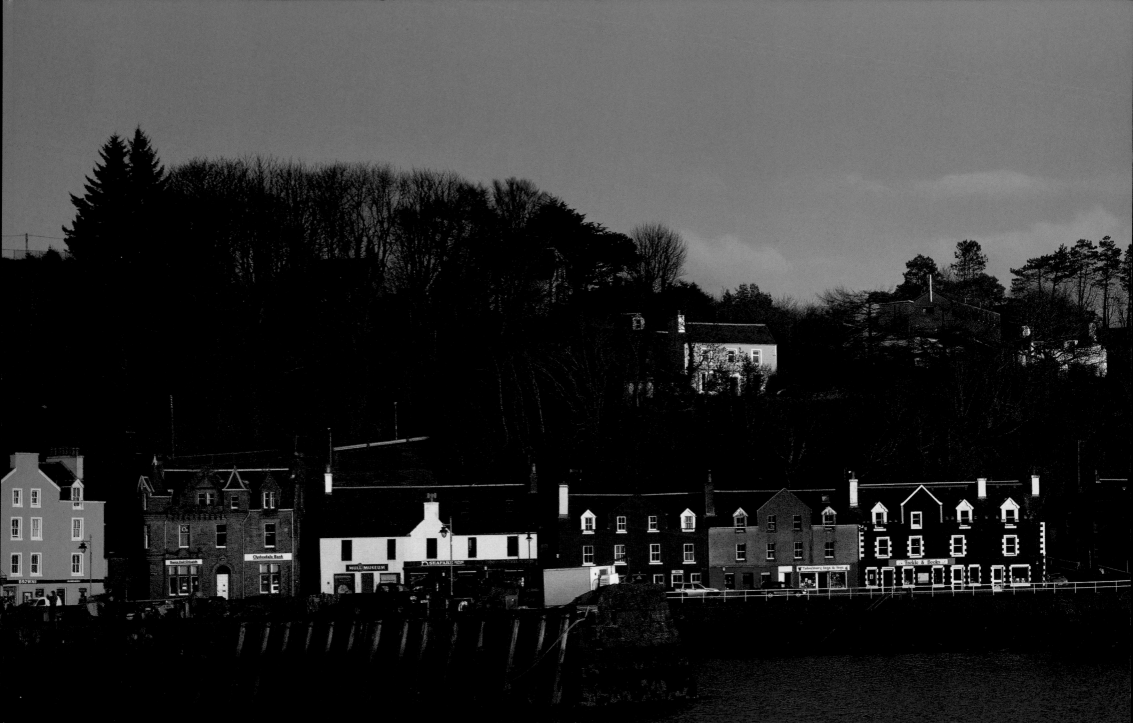

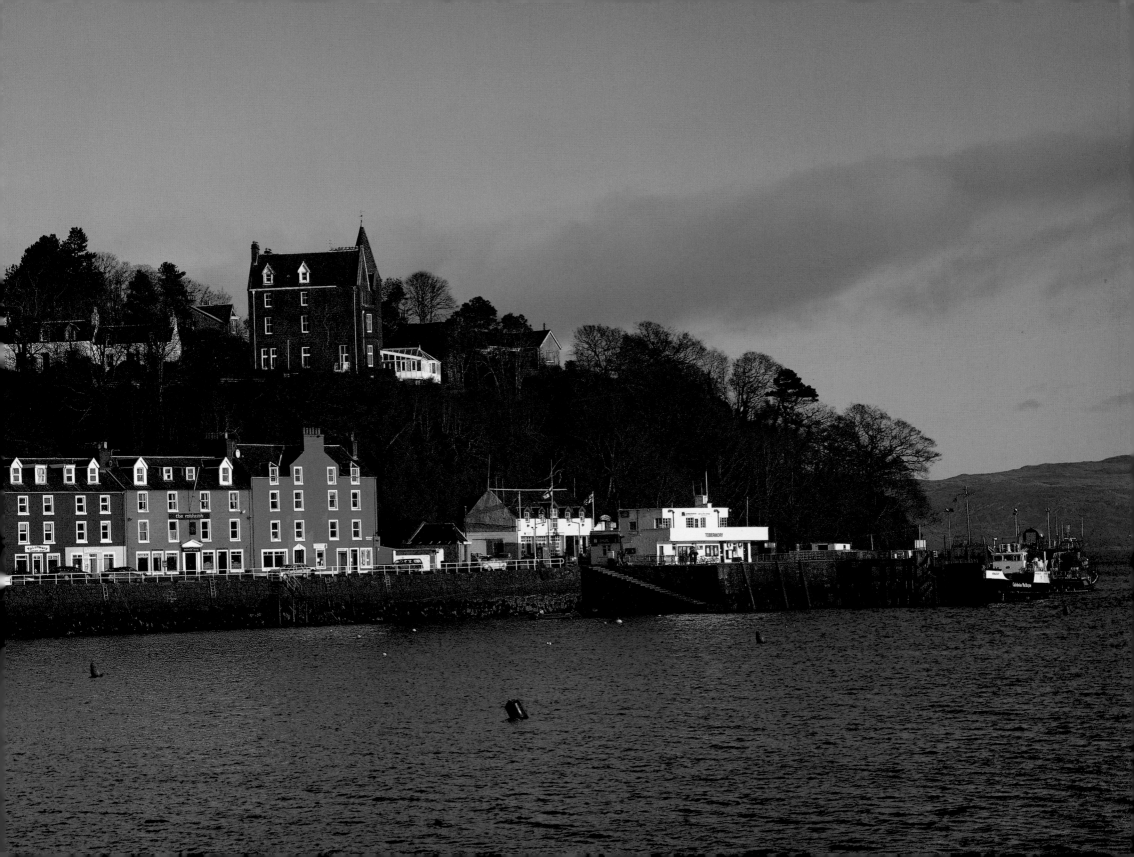

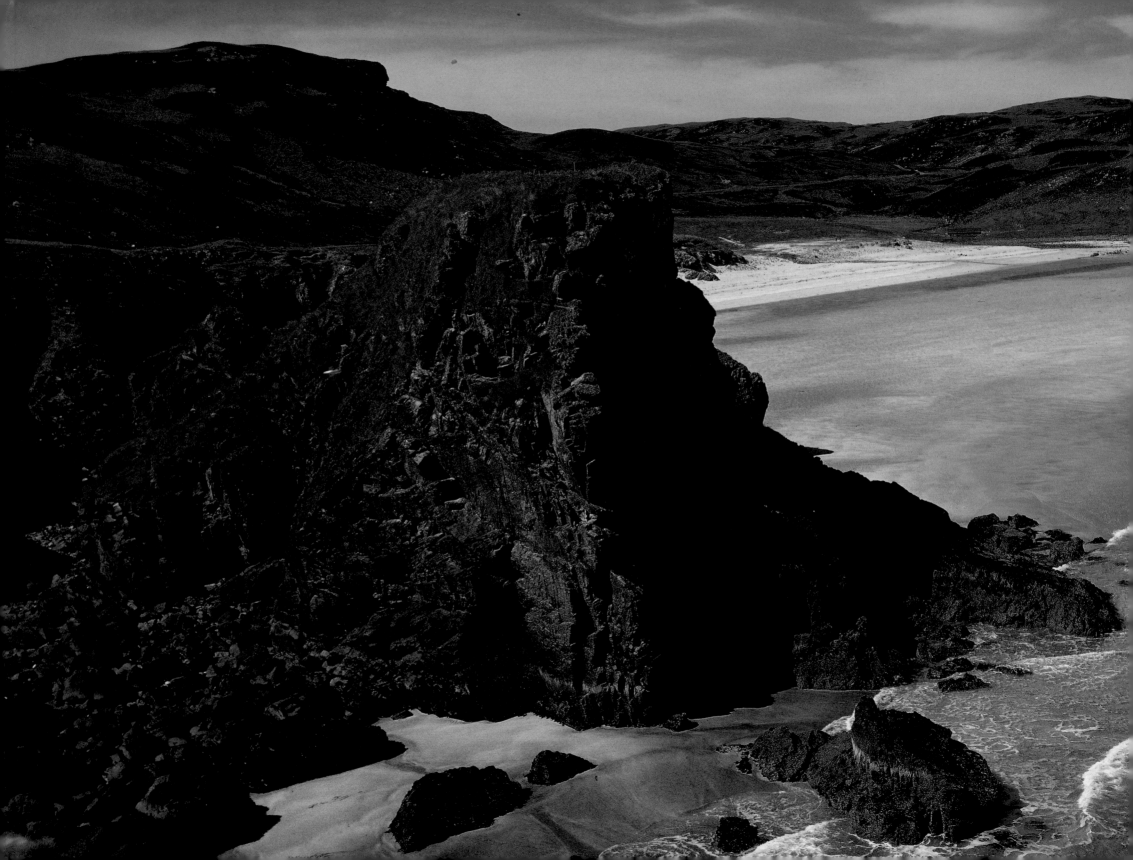

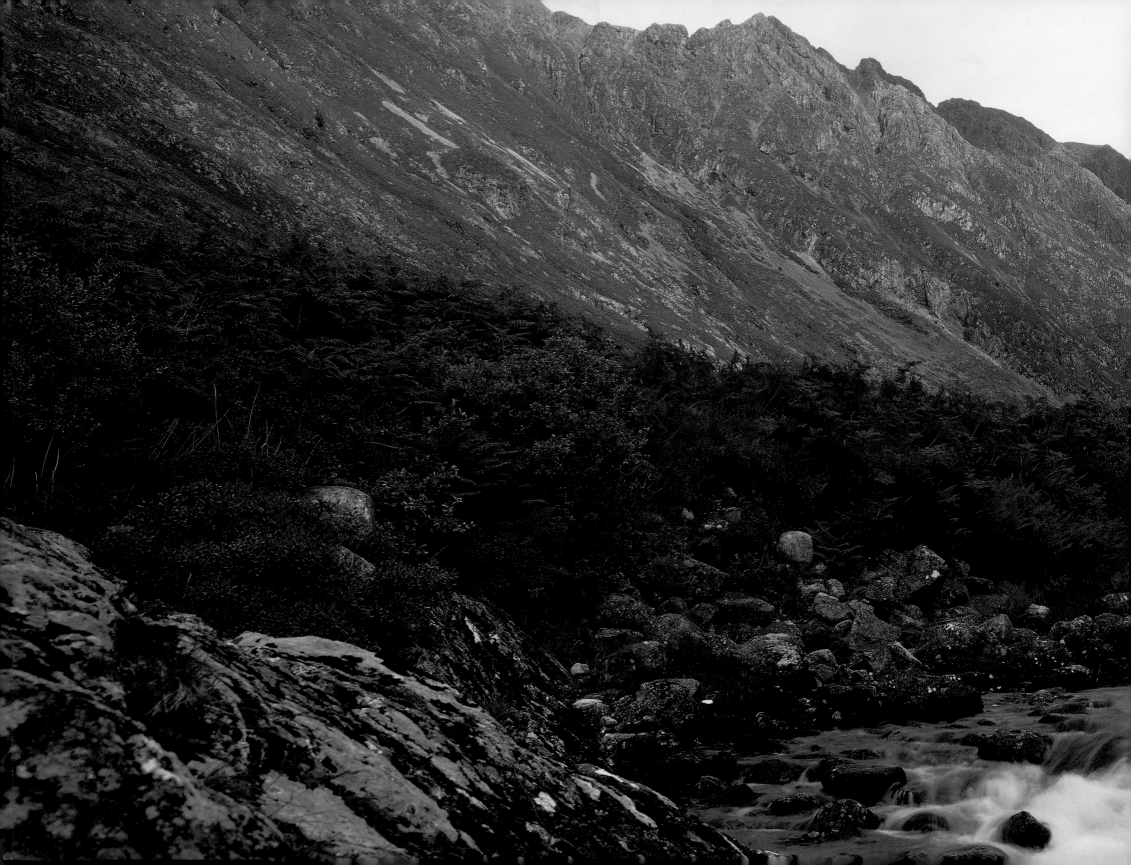

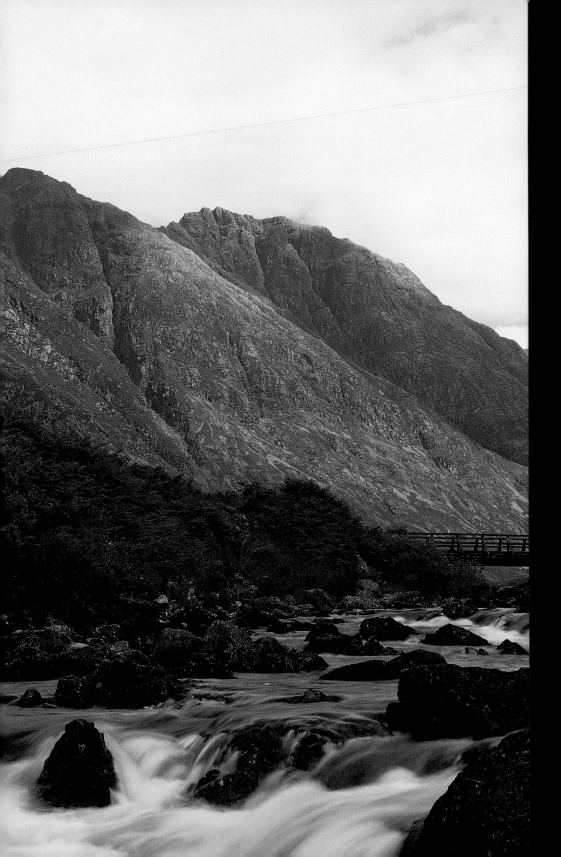

S P E C T A C U L A R

Text by

James Gracie

Photography by

Sue Anderson

and

Mike Caldwell

Laurie Campbell

Ed Collacott

Kathy Collins

Douglas Corrance

Harry Cory-Wright

Ian Cumming

Brian Fair

David Lyons

David Robertson

Fritz von der Schulenberg

Mick Sharp

Phil Sheldon

Alisdair Smith

Christopher Simon Sykes

Paul Tompkins

John Warburton-Lee

UNIVERSE

Published by Universe Publishing
A Division of Rizzoli International Publications, Inc.
300 Park Avenue South
New York, NY 10010
www.rizzoliusa.com

© 2013 Universe Publishing
Text © James Gracie

Picture Editor: Julia Brown
Picture Assistant: Louise Glasson
Editor: Rebecca Miles
Designer: Clare Thorpe

2019 2020 2021 2022 / 10 9 8 7 6

Printed in China

ISBN-13: 978-0-7893-2479-5

Library of Congress Catalog Control Number: 2012950208

All photographs are copyright of the photographers as credited here. All photographs supplied by Sue Anderson except the following:
(a above; b below; l left; r right)
NHPA (Laurie Campbell): 1, 24 l; Ed Collacott: 2-3, 4-5, 48-9, 60-1, 68-9; Getty Images: 16 (Marcus Brooke), 20 l, 115 (Yann Layma); Photolibrary.com (Chad Ehlers): 17 l; Photos.com: 17 ar, 17 br; The Art Archive: 18 (Culver Pictures), 32 l (Private Collection); The Bridgeman Art Library: 18, 26, 27, 28 (Scottish National Portrait Gallery, Edinburgh), 19 l, 29 (Private Collection), 30-1 (Yale Center for British Art, Paul Mellon Collection); Alamy: 19 r, 21 (John Peters), 32 r; Corbis (Macduff Everton): 24 r; Mick Sharp: 25; The National Trust for Scotland: 30 (Fyvie Castle), 80, 83 (Alisdair Smith), 80-1 (Kathy Collins) 74, 82 (David Robertson); The Scotsman Publications: 33, 98, 99 b; David Lyons: 44 r, 50 l, 62 b, 67 al, 87, 134 bl, 134 br; Mike Caldwell: 50 r, 118-9, 124, 139 r; Axiom Photographic Agency: 57, 104 (Ian Cumming), 122 r (Paul Quayle); Brian Fair: 66 l, 66 r, 114 al, 114 ar; Interior Archive: 75 l (Fritz von der Schulenburg), 75 r, 94, 44 r (Christopher Simon Sykes); Douglas Corrance: 101; John Warburton-Lee: 120 bl, 120 ar; Scottish Viewpoint (Paul Tompkins): 123 l, 135; Harry Cory-Wright: 125 br; Phil Sheldon: 138.
Endpapers: Baird Clan tartan.

PAGE 1

Heather-covered Hills

Scottish heather flowers mainly in late summer and in autumn, covering the hillsides with a deep carpet of white or vivid pink, as shown in this picture, taken in the Lammermuir Hills in southeast Scotland.

PREVIOUS PAGES

Red Cuillins, Skye

Possibly the most majestic and awe-inspiring mountains in Britain, the Cuillins lie on the island of Skye in the Inner Hebrides.

Glen Affric

Scotland's largest remaining remnant of the ancient Caledonian pine and birch forest is to be found in remote Glen Affric, 27 miles (43 km) west of Inverness. It is now a National Nature Reserve.

Tobermory

In 1788 the British Fisheries Society established a station at Tobermory, on the island of Mull, which up until then had been a huddle of cottages round a small bay. At the same time the Society built cottages along the seafront, which have now been painted in bright colours.

Garry Beach, Tolsta, Lewis

Located at Tolsta on the island of Lewis, beautiful Garry Beach features five sea stacks at its southern end. These are great pillars of rock made when sea and wind eroded the softer rock surrounding them.

Aonach Eagach, Glencoe

Glencoe was the site of a notorious massacre in 1672. Dozens of members of the Clan MacDonald were butchered by a party of Campbells who had accepted their hospitality, because the MacDonald chief had been late in pledging allegiance to the king.

THIS PAGE

A Piper at the Glenfinnan Highland Games

Glenfinnan, where Bonnie Prince Charlie raised his standard in 1745, hosts one of the most popular Highland Games in Scotland. Here a piper competes against a majestic background of mountain and loch.

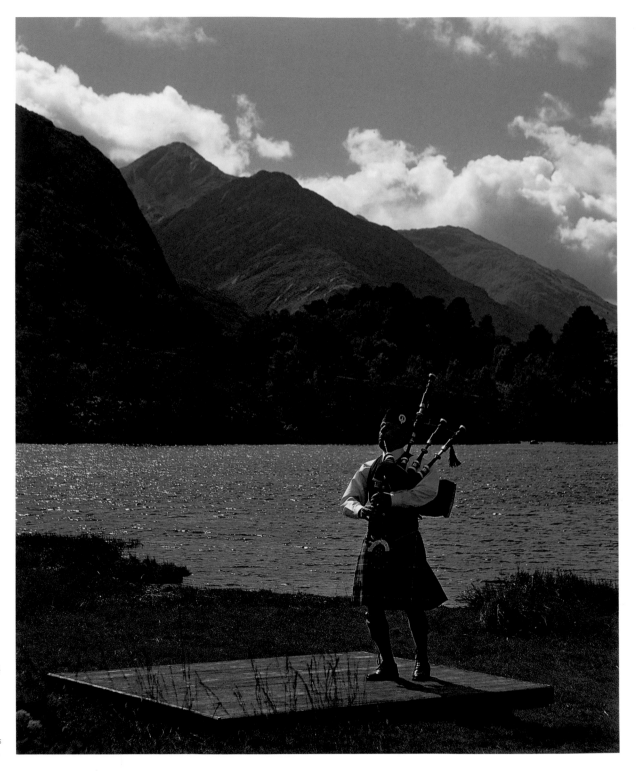

CONTENTS

Introduction 16

Scotland's History 26

Ancient Landscapes
and the Birth of Christianity 34

Highlands and Islands 48

Castles and Gardens 74

Towns and Cities 98

Scottish Life 118

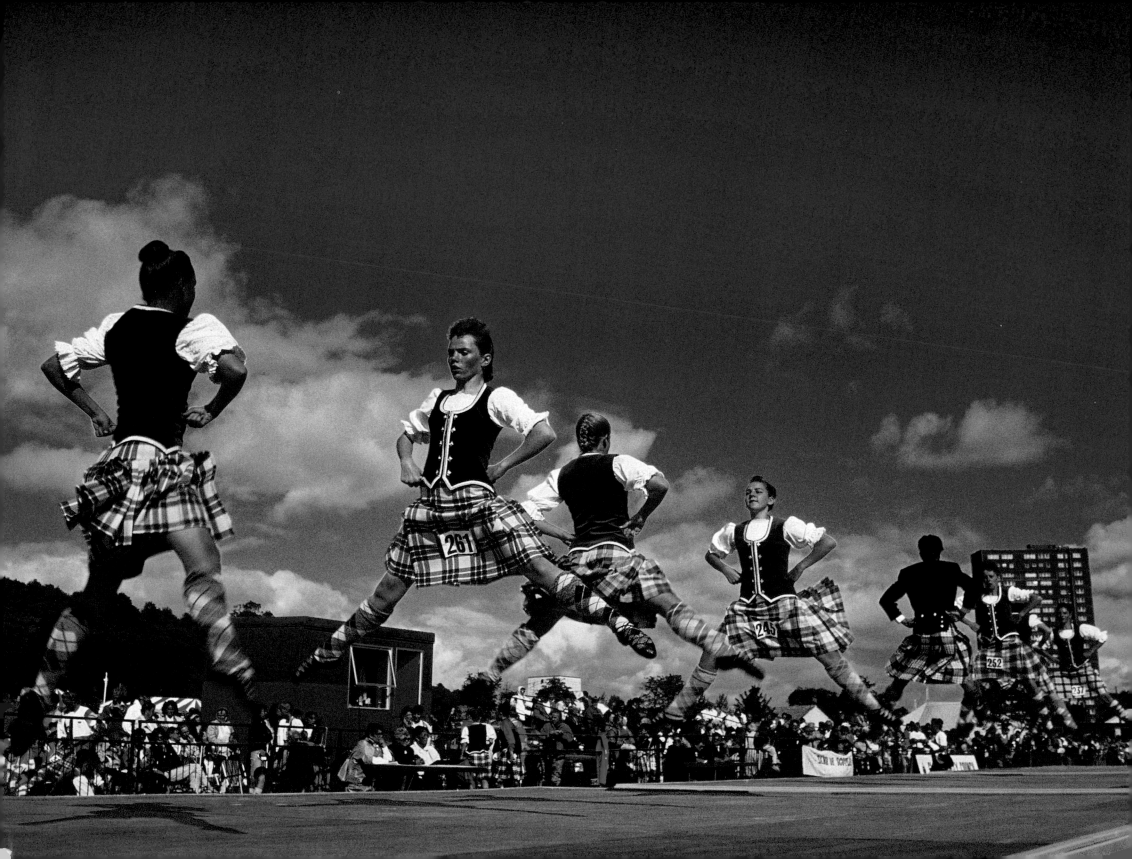

INTRODUCTION

We Scots have always punched above our weight. We're a small country with a population of just over five million and an area of 30,000 square miles (77,700 sq km), yet have contributed so much to the sum total of human knowledge and endeavour. In the field of medicine our discoveries have included penicillin, anesthetics and antiseptics. We also pioneered surgery, anatomy and midwifery. In the fields of science and engineering we gave the world television, telephones, Macadamed roads, facsimile machines, bicycles, radar, the pneumatic tyre, the thermos flask, the modern steam engine, waterproof coats, kaleidoscopes, logarithms, the first cloned mammal, the science of economics, steam hammers and adhesive postage stamps.

And we're not finished yet. The Bank of England was founded by a Scot, as was the worldwide savings bank movement. A Scot founded the American and Chilean navies, as well as the national parks movement in the United States.

But Scotland is a country steeped in a universal image far removed from its achievements. Kilts – bagpipes – tartan – mountains – glens – heather; these are the icons that have gone around the world. We have four people to thank for this – Bonnie Prince Charlie, Sir Walter Scott, Queen Victoria and Sir Harry Lauder.

Bonnie Prince Charlie started it all. His fight to regain the throne of Britain for the Stuarts was romantic enough to capture imaginations throughout Europe. But his Jacobite Uprising wasn't a "Scotland against England" struggle – it was more of a civil war, with Scots and English on both sides. And the fact that he was ultimately defeated didn't tarnish his image one bit.

In 1822 George IV came to Scotland, and Sir Walter Scott was given the task of organizing his arrival at Leith. He was the ideal man for the job, as his novels popularized Scotland all over Europe, making it a place of misty glens and kilted heroes. Unfortunately he went overboard, and the King stepped ashore in a "chief of chiefs" costume – pink tights, a short kilt in the Stuart tartan, an enormous feathered bonnet and all the other supposed trappings of a Highland gentleman. From that day on Highland dress of this kind (minus the pink tights, thank goodness) was adopted as the national dress of Scotland, and there's no doubting the fact that it gave the country an identity that was soon recognized across the world.

When Queen Victoria discovered the country, its popularity soared even more, and people didn't just read about the place – they began making pilgrimages into the Highlands to admire the scenery. Scotland had become fashionable, and no Victorian drawing room was complete without a painting of Highland cattle up to their knees in the waters of a loch. Scotland's image was then refined even further by Sir Harry Lauder. Born in 1870, Lauder had become the world's most famous music-hall entertainer by the early years of the 20th century. His kilt, tweed jacket, bonnet and knobbly walking stick became known the world over. He portrayed the average Scot as not too bright, sentimental, fond of whisky, and mean with money, even though he himself was none of these.

But Scotland has survived it all, and a visit shows that there is so much more to the country than its popular image. Certainly it has achingly beautiful mountains, lochs and misty glens. But some parts are as soft and appealing as English counties, while others

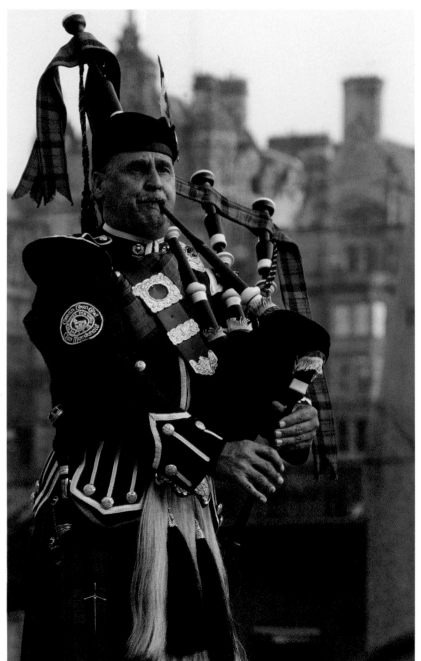

OPPOSITE
Highland Dancers
Highland dancing is a popular event at Highland Games, especially among young girls and teenagers, who compete in the games "circuit".

LEFT
Piper in Princes Street, Edinburgh
The bagpipes are Scotland's national instrument, and are shown here played by a piper in Edinburgh.

BELOW TOP
The Saltire – Scotland's National Flag
The oldest national flag in Europe, the Saltire dates from 832CE and shows St. Andrew's Cross on an azure background.

BELOW BOTTOM
The Sporran
An essential part of Highland dress, the sporran is a pouch hanging from the waist. It is used for holding what would otherwise be held in trouser pockets.

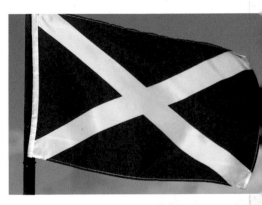

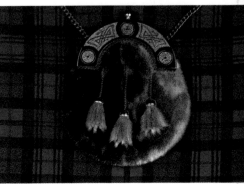

Sir Walter Scott

The novelist Sir Walter Scott (1771–1832), more than anyone, was responsible for creating Scotland's modern image. He studied law, and spent his working life in the Borders, where he was sheriff-depute (judge) in Selkirk. In this portrait by Sir William Allan, we see him in his beloved Borders, with one of the Eildon Hills in the background.

Alexander Graham Bell

Bell was born in Edinburgh in 1847, and emigrated to Canada in 1870. From an early age he was interested in helping the deaf, and this led to his invention of the "electric speech machine", which led directly to the invention of the telephone.

John Boyd Dunlop

Cycling, up until the 1880s, was a bone-shaking experience. In 1887, John Boyd Dunlop invented the pneumatic tyre, fitting his son's bike with air-filled tyres instead of solid ones, to make the ride more comfortable. The Dunlop Rubber Company Ltd. later supplied tyres for the new motor-car industry.

Sir Alexander Fleming

Scotland's contribution to medicine can never be over-estimated. Born in 1881, Alexander Fleming qualified as a doctor in 1904. In 1928, while at London University, he observed that a mould he had accidentally developed kept germs at bay. He called the substance penicillin.

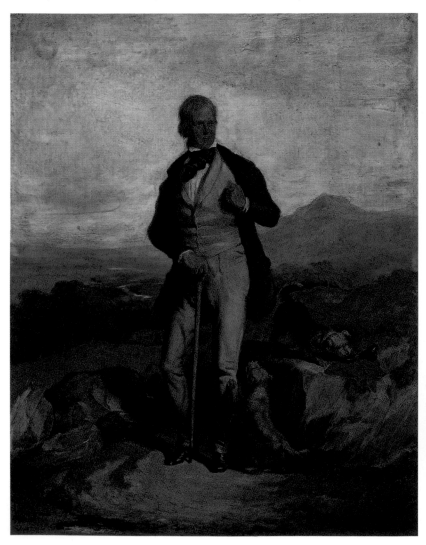

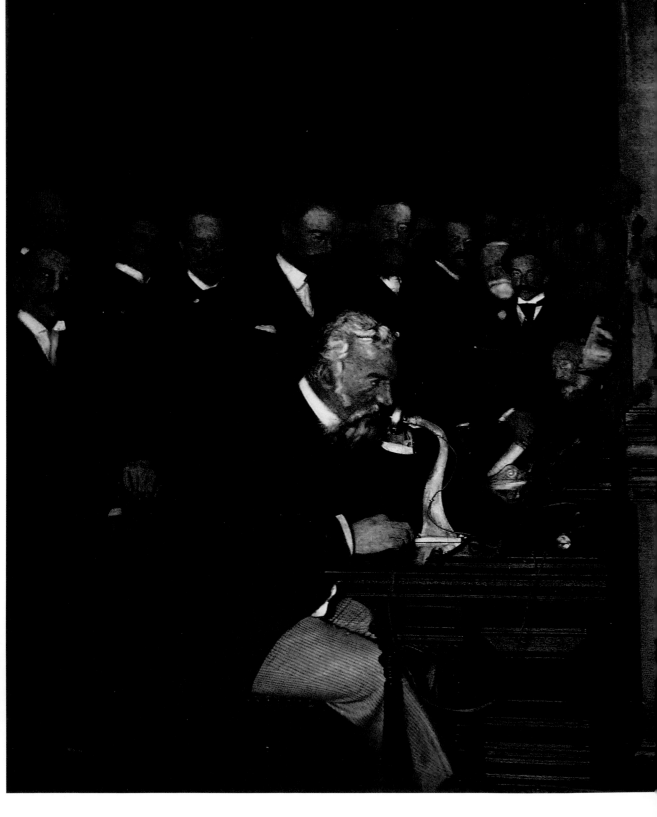

are industrialized. Our cities are vibrant and sophisticated, with Glasgow rapidly becoming a fashionable European holiday destination. And Edinburgh has regained much of its former glory now that the country's Parliament meets there.

The country's west coast is a surprise to many. Here, thanks to the Gulf Stream, palm trees and other exotic plants flourish happily. The gardens are famous, from Inverewe in the north to Port Logan in the south. Another surprising area is the Scottish Borders. Many tourists drive straight through it heading for what they imagine to be the real Scotland – the Highlands – not realizing that the area has more raw history than any other part of the country. In the 15th and 16th centuries, the Borders were the first line of defence against the English, and suffered because of it. Its ruined abbeys still retain a haunting beauty that speaks not only of spirituality, but also of bloodshed and great bravery.

If you go west from the Borders, you'll come to another beautiful area that is largely undiscovered – Dumfries and Galloway. It is a mix of pastoral scenery, moorland, quiet villages, spectacular coastlines and intimate market towns. And to its north is Ayrshire, the home of Scotland's national poet, Robert Burns. This is dairying country, lush and green, and as far removed from the grandeur of the Highlands as it is possible to be.

Over the years, one word has truly defined Scotland, and that word is "freedom". This proud nation still reveres William Wallace and Robert the Bruce, who fought the expansionist plans of Edward I of England 700 years ago. Later, when the Reformation arrived in Scotland, it was welcomed not only because of the need for religious reform, but also because it helped to limit the influence of the Catholic French on Scotland's government in the turbulent 16th century.

The Union of the Crowns of Scotland and England in 1603 saw the end of independent Scottish and English monarchies. The Scots had always viewed their rulers differently from the English. They were there to do the people's bidding, not the other way around. And there is one further, vital difference between Scottish and English monarchs. English kings and queens ruled a country. Scottish kings and queens ruled a people, which is why Mary Stuart is always referred to as "Mary Queen of Scots".

Us Scots are a pragmatic people, touched with a strong sense of Celtic romance. We aren't mean – in fact we are very generous – but we are careful with our money. We aren't drunkards, even though we gave whisky to the world and enjoy a dram or two. We value education, and point gleefully to the fact that while England was getting along with two universities, Scotland already had four.

And we don't take our country for granted. We are still overawed by its scenery, and want to show it off. And if we are a wee bit suspicious on occasions, it's because we are a small country on the edge of a larger one, so guard our customs jealously. But this doesn't interfere with our friendliness. We genuinely want to share what we see as our good fortune with everyone.

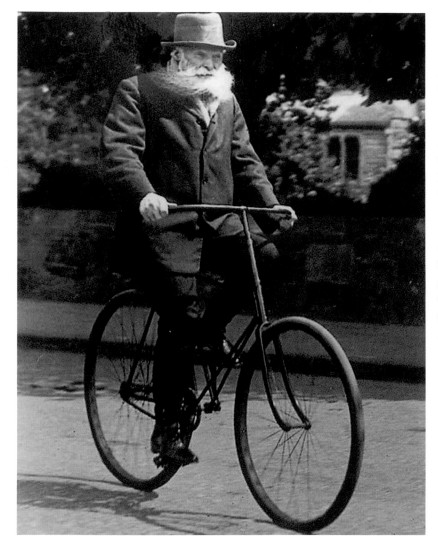

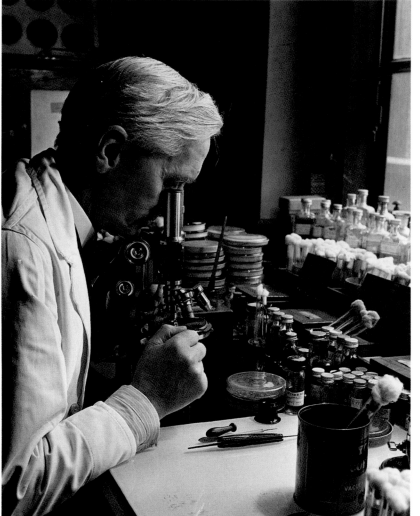

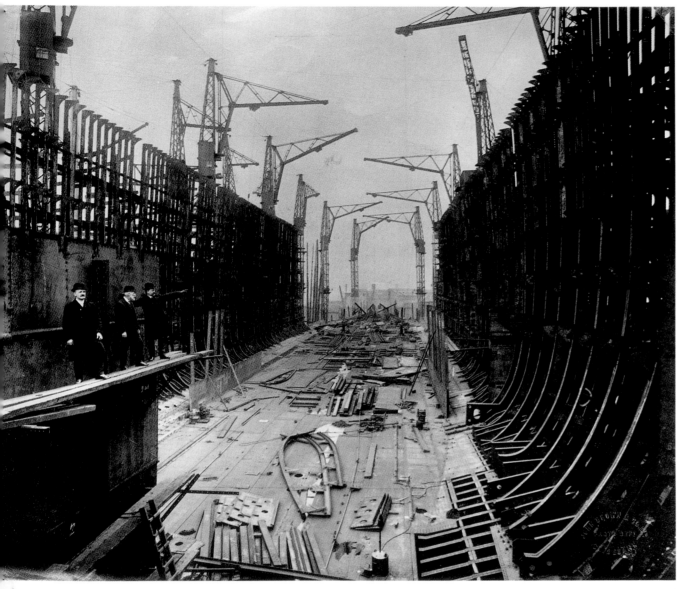

Shipbuilding on the Clyde

In the 1860s, over 80 per cent of all ships built in Britain were made on the River Clyde. This continued for many years, employing thousands of men. This photograph, dated c.1900, shows the construction of a ship in Clydebank, where the mighty John Brown shipyard was located. It built the Queen Mary (now at Long Beach California), the Queen Elizabeth, and the Queen Elizabeth II, known as the QEII. Now most of the yards have closed, leaving only a handful to continue the proud tradition.

Scotland's Oil Industry

The first licences for North Sea oil and gas exploration were granted in 1964, although it wasn't until 1969 that oil in commercial quantities was discovered. By the year 2000, more than six per cent of the country's workforce were employed in the oil industry, with Aberdeen being Europe's "oil capital". In the Cromarty Firth oil rigs can be seen in for repair, storage or salvage, and while they seem incongruous in such a setting, they still have a certain grandeur.

Glenfinnan Viaduct

The Highlands of Scotland were finally opened up to the rest of Britain in the mid-19th century by the introduction of the railways. It required great feats of civil engineering – not to mention imagination – to build rail tracks on boggy, shifting moorland, around the contours of forbidding mountains, and to throw great viaducts across lonely glens, such as this one at Glenfinnan, west of Fort William.

Forth Rail Bridge

Opened in 1890, the Forth Rail Bridge is yet another civil engineering triumph for the engineers who built Scotland's railways. It is an internationally recognized structure, and at one time was known as the "eighth wonder of the world". It took seven years to build, used 55,000 tons of steel, and is over a mile and a half long (2.4 km) and 361 ft (110 m) high. Each year it carries 60,000 trains across the Firth of Forth.

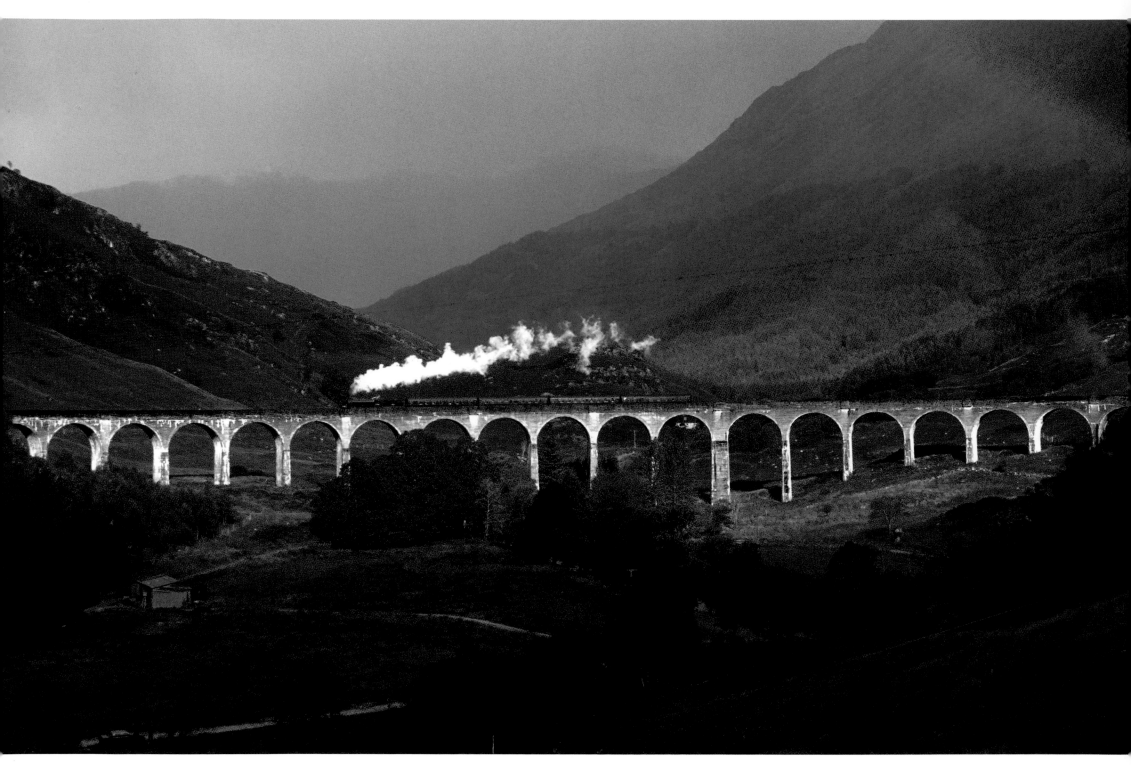

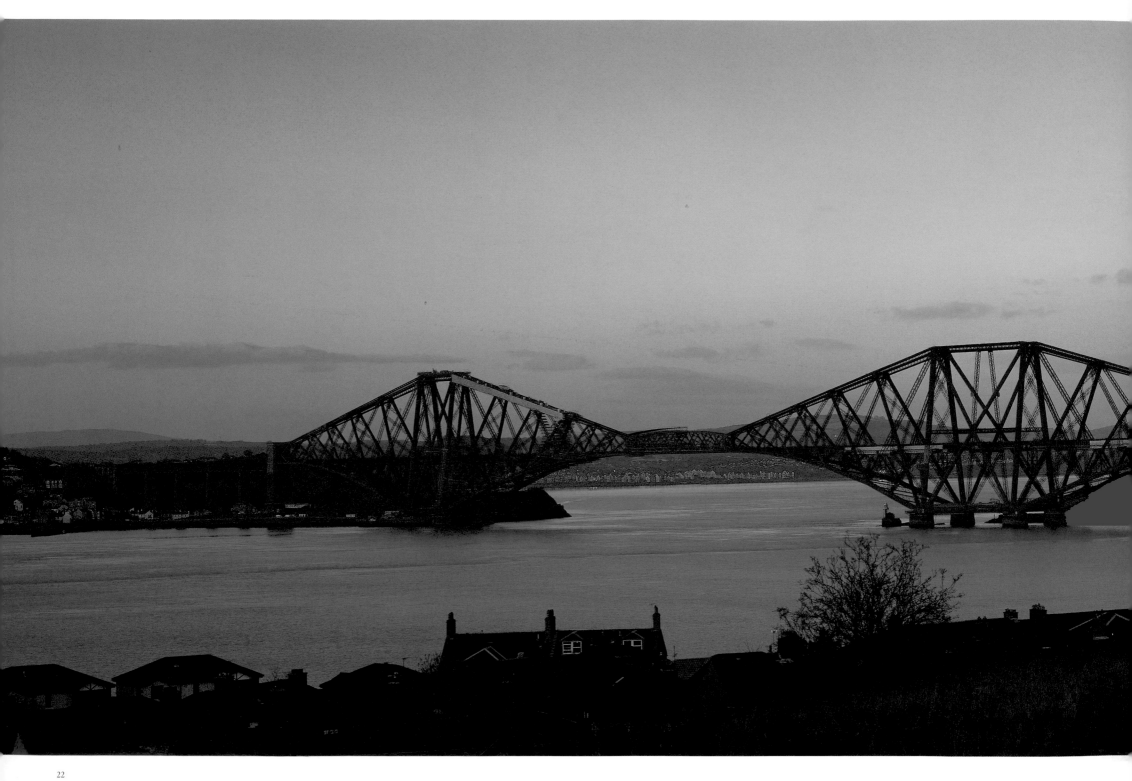

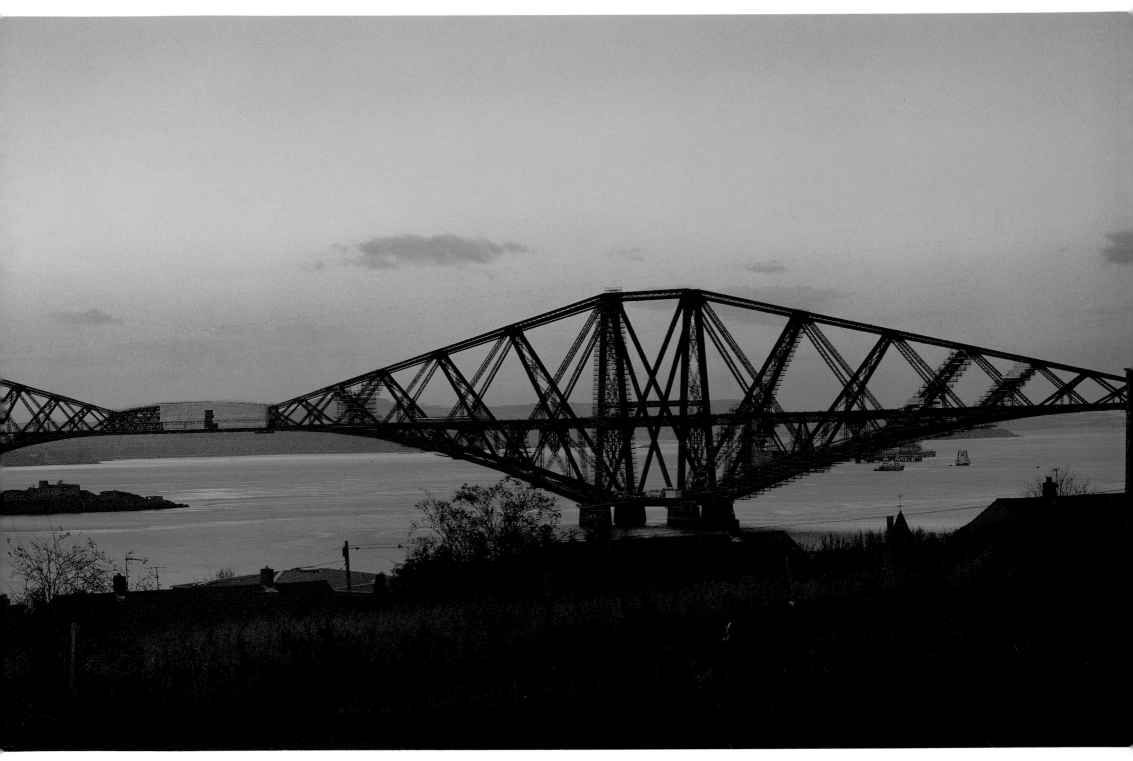

Scott's View

Sir Walter Scott loved the Scottish Borders, and spent all of his adult life here. His favourite view is now called "Scott's View", and takes in the three peaks of the Eildon Hills, where King Arthur and his court are supposed to lie buried. When Scott died his funeral cortège stopped here for a few moments on its way to Dryburgh Abbey, where he is buried.

BELOW
Stag

The red deer is Scotland's largest wild land mammal, originally living in the Caledonian Forest that once covered the whole of Scotland. Now it is a moorland creature, seeking the shelter of woodland in the winter months. Ever since Sir Edward Landseer painted "Monarch of the Glen" in 1851, the stag has been a symbol of the independence and grandeur of the Highlands.

RIGHT
Whisky

Scotland's national drink has been distilled for centuries. The distilleries themselves are often located in picturesque spots, such as this one in beautiful Speyside, one of the main distilling areas of Scotland, where The Glenlivet is distilled.

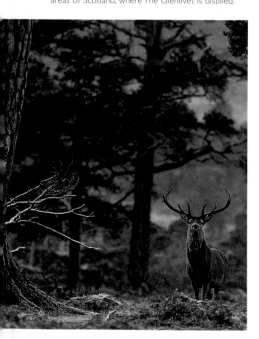

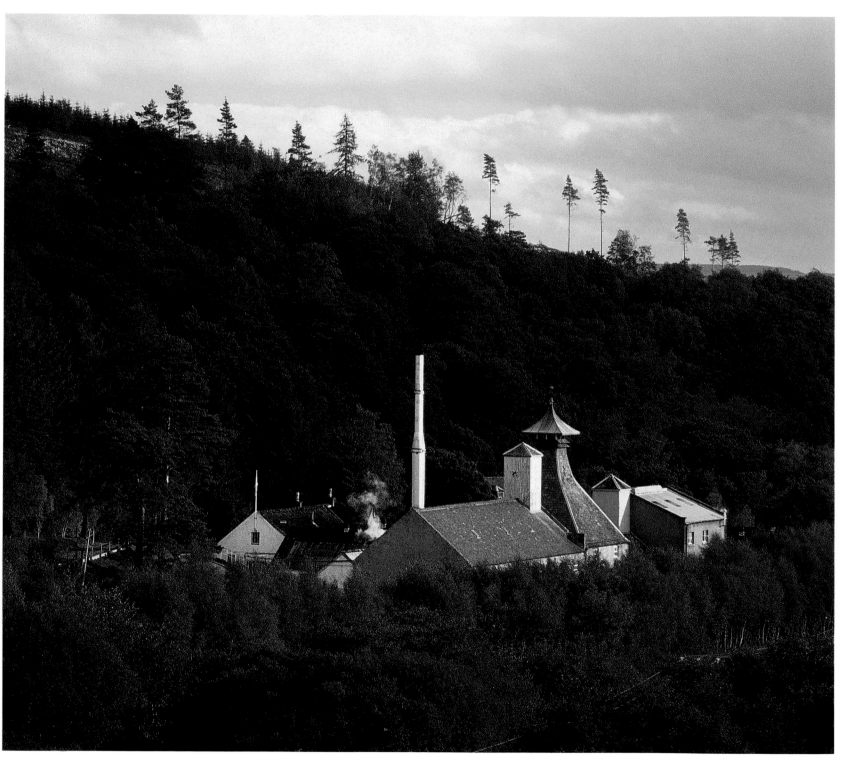

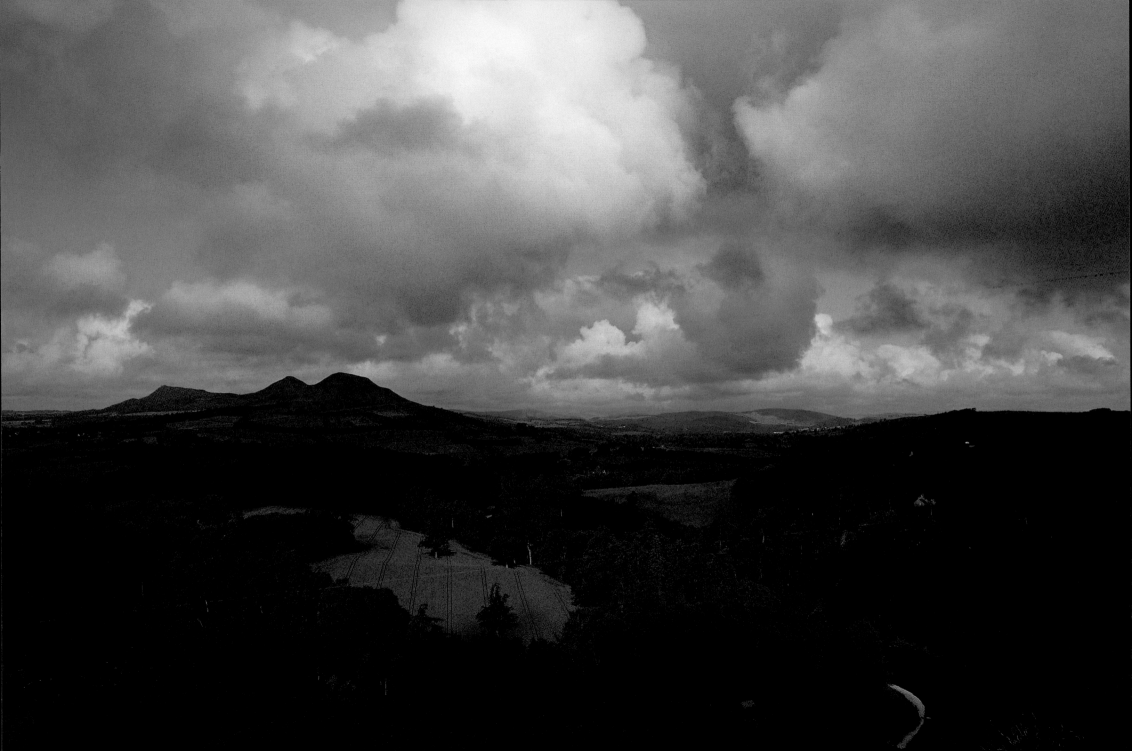

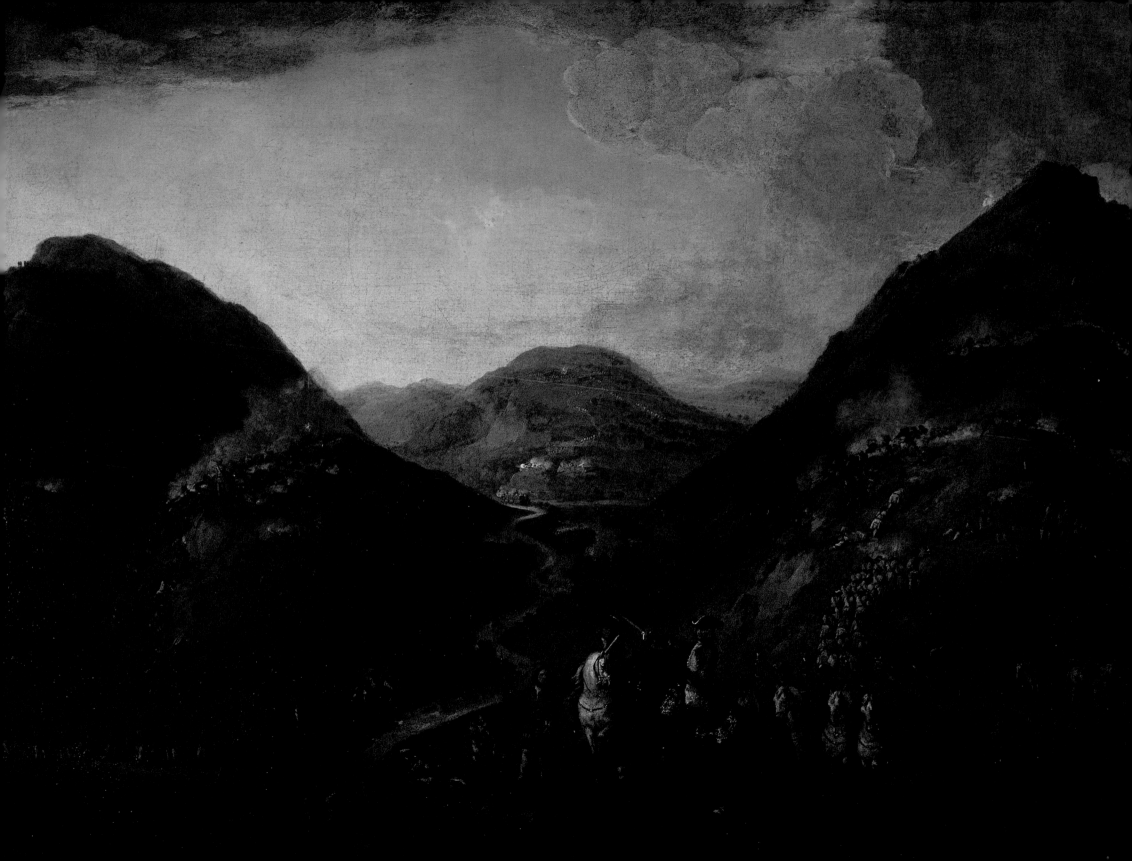

SCOTLAND'S HISTORY

About 7000BCE, after the ice from the last Ice Age melted, Mesolithic people first came to Scotland as hunters and gatherers during the summer, taking advantage of the plentiful game, berries and plants. As temperatures rose they gradually moved ever northward into what is now the Highlands. By about 4000BCE the Neolithic ("New Stone Age") peoples arrived. They came from Mediterranean areas, and brought with them the skills of agriculture and pottery, meaning that people could now live in settled communities. Soon after, another Neolithic people – the "Beaker People" (so-called because of the distinctive beakers found in their graves) – crossed from present-day Spain. Then, a few centuries before the birth of Christ, the people that are most associated with Scotland – the dark-haired Celts – arrived from Europe. When the Romans arrived in Scotland, they named them the "Picts", meaning the "painted ones" after their habit of tattooing their bodies.

In the 5th century, the area of Scotland now called Argyll was colonized by a tribe of Celtic people from Ulster called the "Scotti", and this colony soon developed into the kingdom of Dalriada, with its capital at Dunadd. At about the same time, three other kingdoms emerged: the kingdom of the aforementioned Picts, with its capital at Inverness, the Britons of Strathclyde with their capital at Dumbarton and the Angles of the Lothians, centred on Edinburgh.

In 843CE, Kenneth McAlpin, King of Dalriada, inherited the throne of the Picts, creating the first kingdom of Scotland. It covered that part of the country roughly north of the rivers Forth and Clyde. In 1018 Malcolm II brought the area of the Lothians into Scotland after winning the Battle of Caham. Strathclyde became part of Scotland in 1034, when its ruler, Duncan (Malcolm II's grandson) also ascended the throne of Scotland. Finally, in 1472, Orkney and Shetland passed to Scotland through the marriage of James III to Margaret, daughter of the King of Norway and Denmark, and the country was complete.

Throughout the earlier amalgamations, Norsemen from Scandinavia were constantly harrying the country, but gradually the bloodthirsty raids abated, to be replaced by peaceful settlement. The Norse language and customs mingled with those of the already established Celts, and indeed some areas of the country, such as the Western Isles, still show Norse influences, especially in place names. And there are still many fair-haired people living in the country.

In 1290, Alexander III, last of the Celtic kings, was killed when he and his horse plunged over a cliff in Fife, leaving as his heir his three-year-old granddaughter, Margaret of Norway. When she was seven, Margaret left for Scotland to ascend the throne. However, she died during the voyage, and the country was left without a monarch. Edward I of England was asked to arbitrate on the many claimants that came forward. He saw his chance, as he had always coveted Scotland, and chose as a puppet-king John Baliol, who, however, eventually renounced his homage to him. Thus began the "Wars of Independence", which threw up two of Scotland's great heroes – Sir William Wallace, a commoner, and Robert the Bruce, who had a good claim to the Scottish throne. At the Battle of Bannockburn in 1314, Bruce finally secured independence, although even after that some English monarchs continued to lay claim to Scotland as a vassal state.

The Protestant Reformation came to Scotland in 1560. At the same time, Scotland had a Catholic monarch, Mary Queen of Scots, who had previously been married to the Catholic king of France. Under pressure, Mary eventually abdicated in favour of her Protestant son, James VI, but she still remained a rallying point for disaffected Catholics in England and Scotland. She fled to England to seek the protection of Queen Elizabeth. Instead of protection, however, ultimately she found the executioner's axe, as she was considered too much of a threat. She still looms large in Scottish and English history, and has been a favourite topic in literature ever since.

James VI went on to ascend the throne of England as James I, and thus established the Stuart dynasty in Britain. But though the Stuarts have their roots north of the border, they were a disaster for Scotland. Charles I

The Battle of Glenshiel
The Jacobite Uprising of 1745 was the culmination of a series of attempts to place the Stuarts back on the British throne. In 1719 the "Little Rising" took place, when 300 Spanish troops landed at Eileen Donan Castle (see pp.84–86) to aid a rising of the clans. A battle was fought at Glenshiel, which ended in stalemate. However, it disheartened the Jacobites, who disbanded. Antwerp artist Peter Tilleman's highly stylized painting of the battle was produced in the same year the battle took place.

Mary Queen of Scots
Born at Linlithgow Palace in 1542, Mary has a tragic story that has fascinated people ever since, and there have been more books written about her than any other British monarch. Brought up in France, then married to the man who became Francis II, she was widowed at 18, and returned to Scotland in 1561, the Catholic queen of a Protestant nation. She abdicated in favour of her son in 1567, and died beneath the executioner's axe in England in 1587.

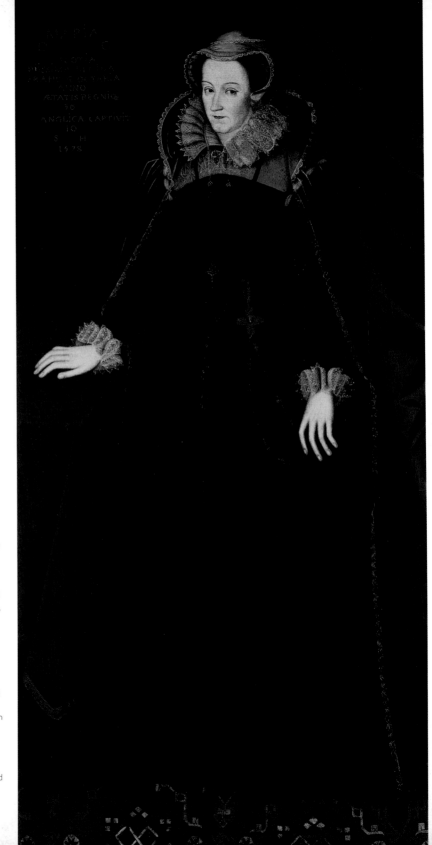

tried to introduce episcopacy into the Presbyterian Church of Scotland, with himself at its head. This led to the "Killing Times", when groups of worshippers, known as Covenanters, refused to worship within the established church, preferring instead to hold their church services, known as conventicles, in remote areas of the country. Charles saw this refusal to recognize him as the head of the church as a form of treason, and many people were harried and killed because they wished to worship according to their conscience. Charles II continued where his father had left off, and it wasn't until William and Mary came to the throne in 1689 that the Scottish church finally threw off the Episcopal form of church government.

The 17th century also threw up one of those romantic heroes whom Scotland does so well – Rob Roy McGregor, who was born in 1671. In truth, he was a minor figure in Scotland's history, although he did fight for the Jacobites at the battle of Sheriffmuir in 1715. And he might have stayed in the shadows had not authors Daniel Defoe and then Sir Walter Scott written about him as a sort of Scottish Robin Hood. Even today, serious historians find it difficult to agree on whether he was a bloodthirsty scoundrel or a man of honour.

The rise of Jacobitism in Britain was strongest in Scotland. This was the movement to restore a member of the House of Stuart (which was Catholic) to the British throne. Although Scotland had embraced a form of Calvinism at the Reformation, large areas remained faithful to the old religion, and even today – notably in some of the Western Isles – Roman Catholicism has always dominated. So adherence to James VII of Scotland (James II of England) – who was Catholic – was

particularly strong. When Charles Edward Stuart (Bonnie Prince Charlie) wanted to raise an army in 1745, he headed for Scotland where he knew support would be strongest. However, the uprising failed, and Charles, for all his romantic image, died a sad, lonely alcoholic in Rome in 1788.

The Union of Parliaments in 1707 consigned the parliaments of Scotland and England to history, replacing them with a British parliament, which met in London. It was a deeply unpopular move in Scotland, and one, which, after all this time, is still resented by some. Two conditions of the Union, however, were that Scotland was to retain its own legal and educational systems, which it still does, guarding them jealously. This, and Scotland's historical links with Europe, may explain why the country is not as anti-European as much of the rest of Britain. It's economic, defence and social policies are already decided outside its borders, and moving this from London to Brussels is seen by some as no big deal.

After the Union of Parliaments, Edinburgh was a capital city without a role. It soon found one, thanks to the Scottish Enlightenment, when the city – and indeed the whole country – threw up such eminent philosophers as David Hume, Adam Smith and Francis Hutcheson, as well as writers such as Ferguson, Burns and Scott. The Enlightenment also led indirectly to the establishment of Edinburgh's elegant New Town, and to the later medical discoveries of the 19th century. It was an exciting time to be in Edinburgh, and the city's fame spread throughout Europe.

The history of Scotland since 1707 is inextricably linked with that of Britain and its empire. By the 1960s, however, Scottish

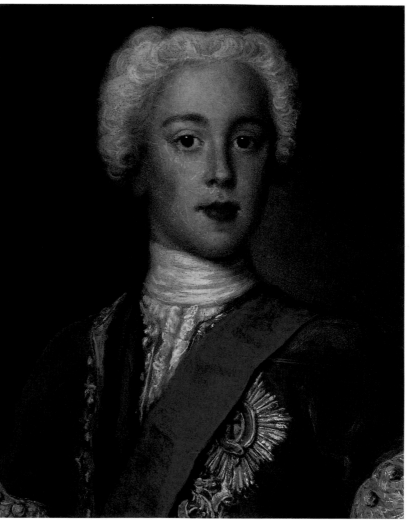

Bonnie Prince Charlie
This portrait of Charles Edward Stuart, better known as Bonnie Prince Charlie, was painted by Antonio David in Rome in 1732, and shows a young, handsome boy of twelve. In 1745 Charles landed in Scotland, determined to retake the British throne for his father, the self-styled James III. He raised the Stuart standard at Glenfinnan, and attracted many Scottish clans to his cause. However, the Jacobite Uprising ended on a bleak and snowy day at Culloden in April 1746, when the Jacobite army was finally defeated.

Edinburgh
Medieval Edinburgh was a warren of narrow alleyways leading off what is now the Royal Mile, which stretched between the castle on its rock and Holyrood Abbey. To the north, where Princes Street Gardens now stand, was the Nor' Loch, and to the south were the city walls, erected soon after Scotland's defeat at Flodden in 1513. Joris Hoefnagel's map of Edinburgh, dating from the late 16th century, clearly shows the loch and the walls, and the spine of the Royal Mile running east to west.

Nationalism was becoming a major force in Scottish politics. This led to a referendum in 1979, which rejected the idea of a Scottish parliament. The referendum of 1997, however, produced a majority in favour of devolution, and now Scotland has its own parliament – a building that cost, much to the dismay of most Scots, a whopping £431m ($796m). No one knows if Scotland will ever gain full independence in the future. The Scottish National Party has never made the breakthrough its adherents crave, and the devolved parliament may have spiked its guns somewhat. But the Scots are a pragmatic people. They see the United Kingdom as a business arrangement, nothing more. If it begins to affect their pockets, they may well dump it and vote for independence.

EDENBVRG.

Castrum puellarum

EDENBVRGVM SCOTIAE METROPOLIS.

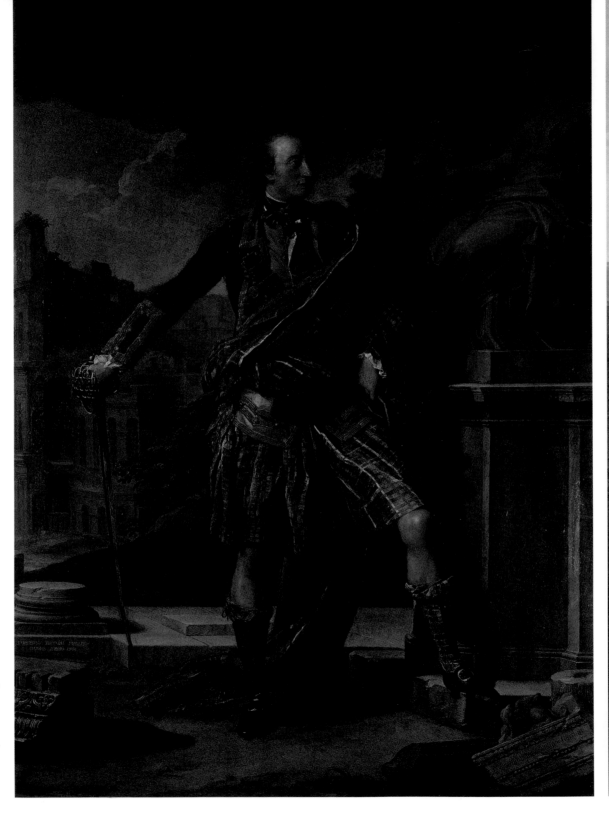

Colonel William Gordon of Fyvie

By the late 18th century the dangers of Jacobitism had passed, and in 1782 the Act of Parliament prohibiting the wearing of tartan, known as the "Dress Act", was repealed. However, even before that, Scottish gentlemen liked to have their portraits painted in full tartan regalia – this portrait of the Hon. Colonel William Gordon of Fyvie being a good example. It was painted in Rome by the Italian artist Pompeo Girolamo Batona between 1765 and 1766, and shows Gordon striking a suitably noble and militaristic pose.

Edinburgh from the Castle

By the mid-19th century, Edinburgh had expanded north to form the New Town, spilling out beyond its former boundary of the Nor' Loch. This painting by David Roberts, dated 1847, shows the recently built Scott Monument and the Royal Scottish Academy on Princes Street. In the middle distance is Calton Hill, and beyond that the Firth of Forth. Immediately below the castle, in the left foreground, is the railway line laid on the bed of the Nor' Loch, which leads into the railway station that later became Waverley Station, Edinburgh's main terminal.

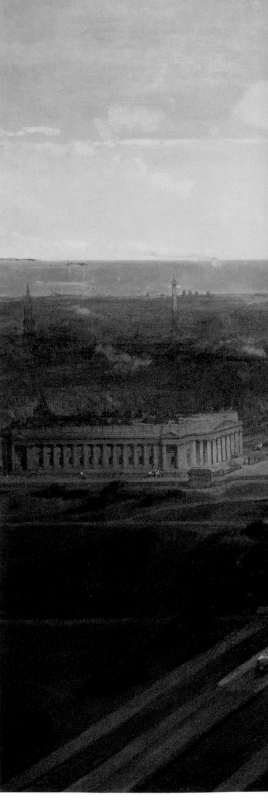

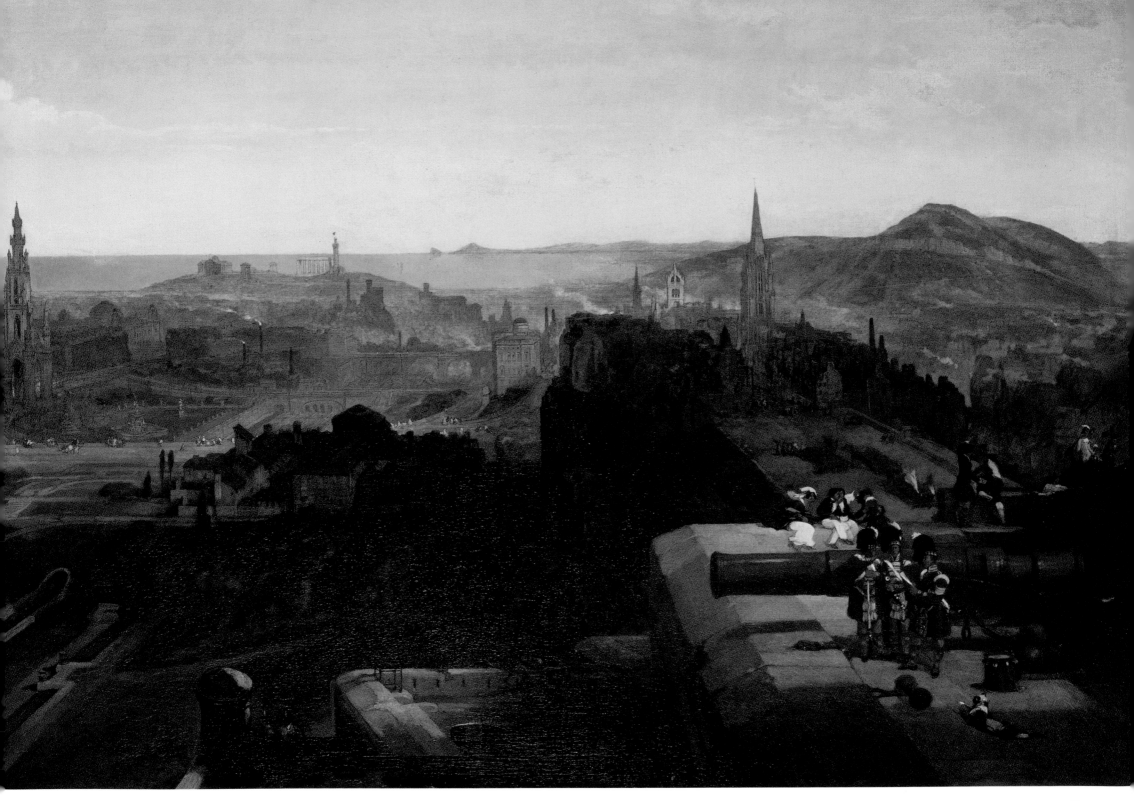

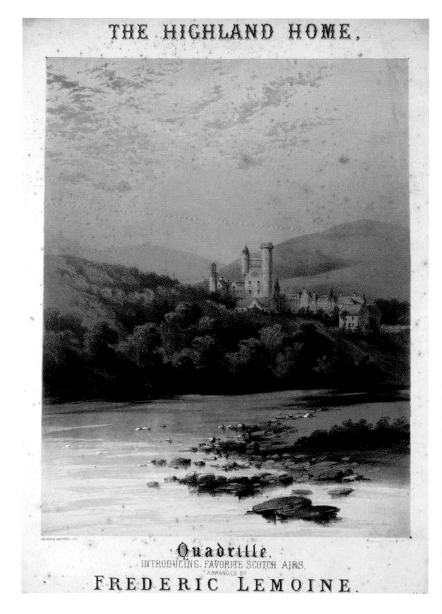

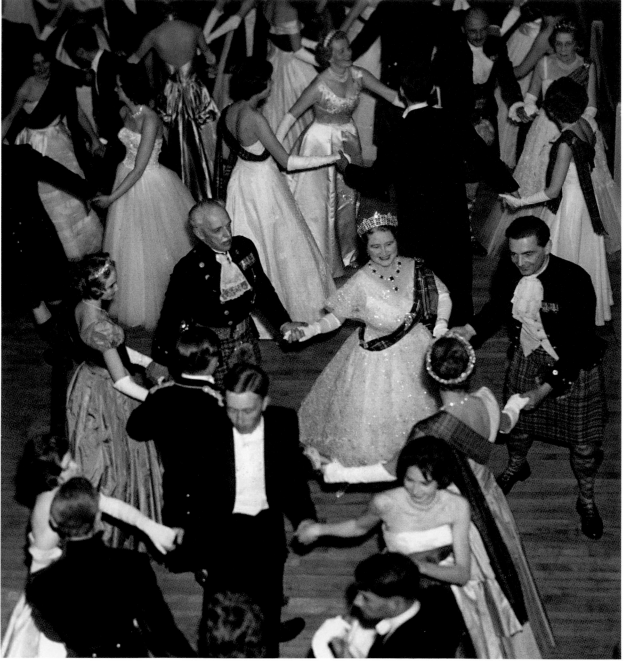

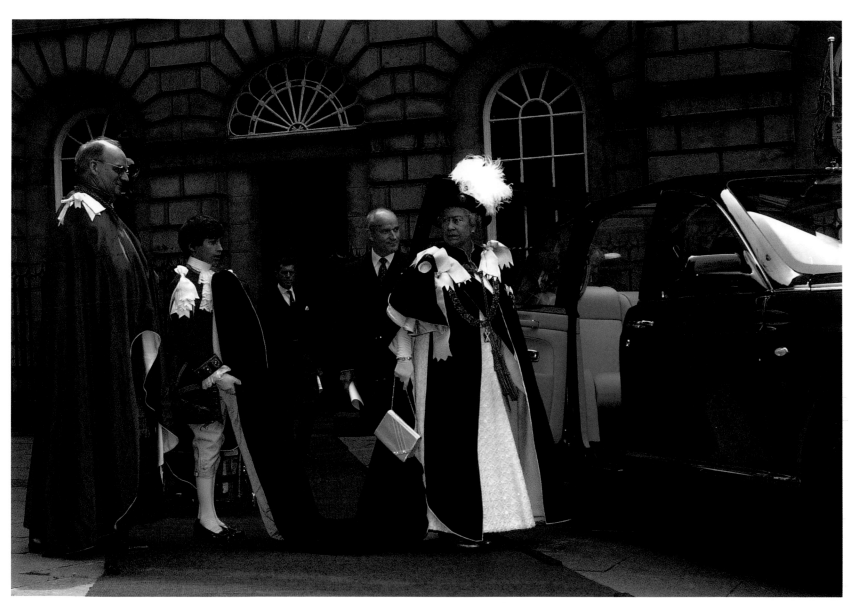

OPPOSITE LEFT

The Highland Home

Scotland (or rather, the Highlands of Scotland) became fashionable among polite society after Queen Victoria fell in love with the place and bought the Balmoral estate in 1852. This was the start of Scottish tourism, and soon paintings of the Highlands were on every drawing room wall, and novels and music proliferated. This Victorian sheet music for piano is a quadrille called *The Highland Home*, written by Frederic Lemoine in 1868. The illustration of Balmoral Castle is by John Brandard.

OPPOSITE RIGHT

The Caledonian Ball

For its relatively small population, Scotland still has a huge influence on the United Kingdom. A highlight of the London season is the Royal Caledonian Ball, founded in 1848, which many members of the Royal family, such as the late Queen Mother (herself Scottish) have attended in the past.

LEFT

The Order of the Thistle

The present Order of the Thistle is Scotland's only order of chivalry, and dates from 1687. It has 16 members appointed by the monarch. This photograph shows the Queen in 2000, dressed in the robes and insignia of the Order, on her way to the Thistle Chapel to install two new knights.

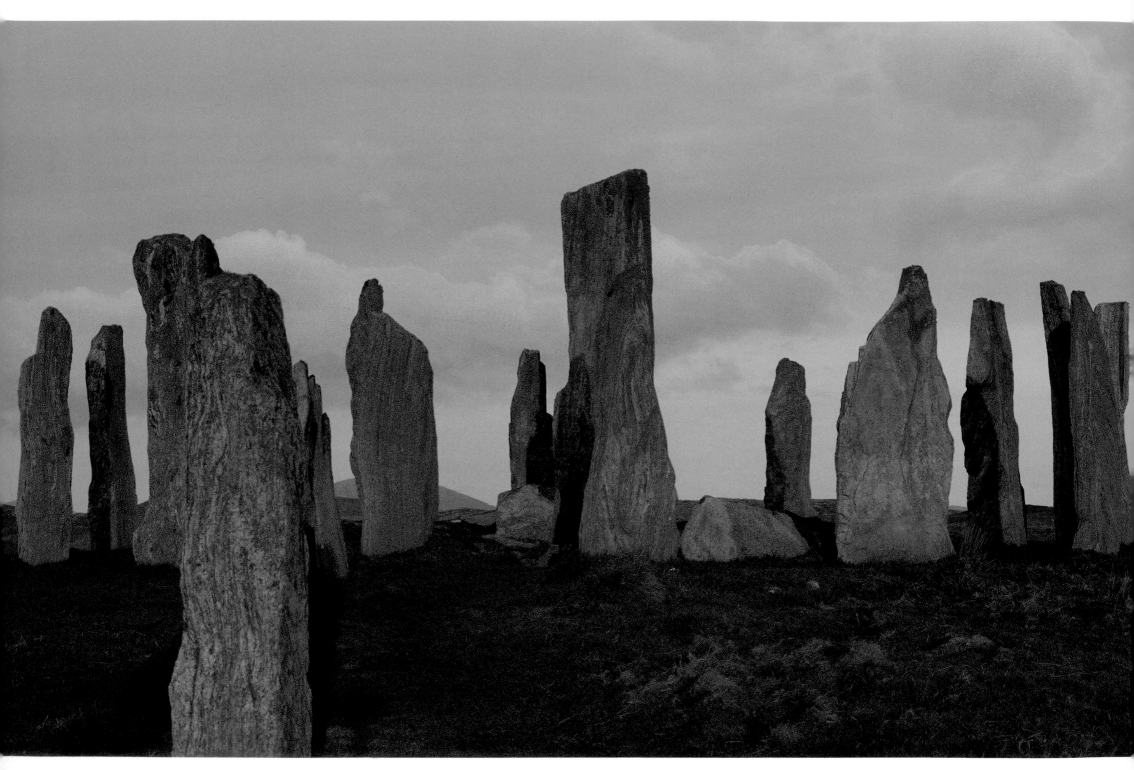

ANCIENT LANDSCAPES AND THE BIRTH OF CHRISTIANITY

The Highlands of Scotland are sometimes referred to as "Europe's last great wilderness". This is a myth, of course, as today man's hand is as evident here as it is anywhere else in Britain. However, once most of the Highlands were covered in forest, before man cleared the trees so that he could grow crops, raise animals and dig peat. Now only small pockets of the original, great "Caledonian Forest" remain.

But large areas have never been intensively farmed. No drainage schemes were ever undertaken, and no regular ploughing was carried out. For this reason many ancient monuments remained largely undisturbed, their only threat being wind and water. Stone circles – burial cairns – standing stones – old forts – ancient Celtic monasteries – castles and churches - you'll find them all in Scotland.

These features seem to echo a more mysterious time, when man danced to a simpler tune. People fully believed in God and gods, and trusted nature's cycles. And these ancient sites are still mysterious. What arcane rituals were carried out inside a stone circle? Why were the dead buried within great mounds? Why were these ancient churches, whose only vestiges now are crumbling walls and tottering tombstones, built in such out-of-the-way places? Why was a castle built at this particular spot? Are these places trying to communicate with us, the people of the 21st century? Can they tell us anything about the human condition?

Perhaps the finest and best-known of Scotland's ancient monuments is Callanish, on the peat lands of Lewis in the Western Isles. This huge stone circle was old when the Egyptians built the Pyramids. It consists of an enormous central circle of thirteen stones – although it is more elliptical than circular –

that measures 38–41 ft (11.5–12.5 m) in diameter. In the middle is a single stone weighing a colossal five tons and rising to 15½ ft (5m). Radiating from the circle toward the four cardinal points are arms of stones, with the northern arm (that is slightly east of north) being a double row of upright stones enclosing a formal avenue. The whole thing measures 400 ft (122 m) from north to south and 150 ft (45 m) from east to west.

What was it? Why was it built? If its builders were farmers, it probably had something to do with computing the times of the year for planting and harvesting. It would have been looked after by a priestly caste that jealously guarded their secret ways of interpreting the heavens. These priests probably encouraged this aura of mystery, making it the central core of their religion. Other peoples settled in the area, and although they knew little of its purpose, they still treated the site with reverence, using it to bury their chiefs. Still later, the Celts arrived. They had scant regard for its religious significance, ploughing the whole site and desecrating the graves.

Other stone circles in Scotland had a similar history. They started off life as practical measuring instruments that gradually accumulated religious significance, and were then abandoned. There were also single standing stones – called "menhirs" – and huge burial cairns where the dead were laid to rest with pomp and ceremony. Nowadays, we desecrate these sites in different ways. Many have been flattened or ploughed up as part of agricultural improvements – especially in the Lowlands – and alternative history enthusiasts theorize that they were once used as landing sites for flying saucers.

The richest area as far as ancient monuments are concerned is Kilmartin in Argyll. More than 150 such monuments have been recorded, as well as 200 later monuments, from circles, stones and cairns to cup and ring markings, forts and castles. The most intriguing of them is the "linear cemetery" – a line of five burial cairns (although there were formerly more) stretching for five miles (eight km) along a glen floor. There's also Temple Wood, where two small stone circles stand side by side. These are easily reached by

The Callanish Standing Stones
Scotland has its mysterious places, and nowhere more so than Callanish in Lewis, where you will find the Callanish Standing Stones, overlooking East Loch Roag. Built more than 4,000 years ago, this immense ring of stones has four stone-girt avenues radiating from it to the four cardinal points, with the ring's northern arm having a double wall on each side, as if it were a processional avenue. Legend says the stones are petrified giants, although a more prosaic explanation is that they were used as an observatory to predict the seasons for agricultural activities.

Dun Carloway Broch
Brochs are unique to Scotland. These Iron Age defensive towers were built between 500BCE and 100CE, and consisted of tall, round towers with two concentric walls. Between the walls were galleries and stairways, and within the central area were wooden-floored rooms used as living quarters and storage areas. Even though they were built without mortar, they have survived remarkably well over the last 2,000 years or so, like this example at Dun Carloway on Lewis.

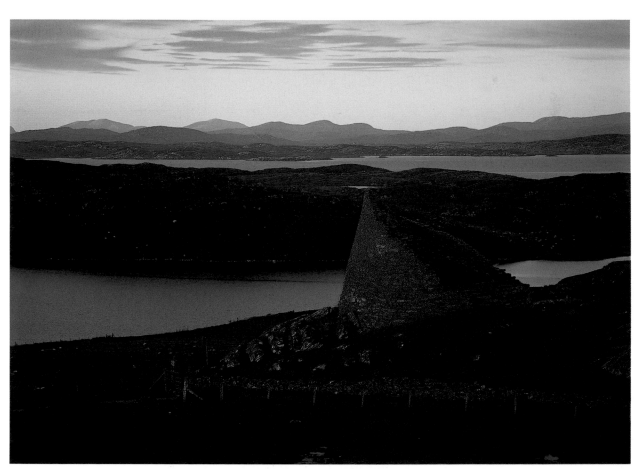

car, and time has indeed given them a seductive air of mystery. The southernmost one may date back at least 3,000 years. And you can still see tourists dreamily touching the stones, as if by doing so they were communicating with ancient times.

On Orkney and Shetland there are similar sites. Here the names – all from Old Norse – add a further layer of mystery. Maeshowe is a chambered burial cairn 36 ft (11 m) high and 300 ft (91 m) in circumference. It dates from about 2,700BCE, as does the Ring of Brodgar and the Stenness Standing Stones. Skara Brae is 5,000 years old – the oldest known prehistoric village in Europe. The settlement of Jarlshof was occupied from the Bronze Age up until the 17th century, and is a complex of earth houses, wheelhouses, brochs, Nordic longhouses and medieval cottages. There are so many such places on the islands that some of them have never been investigated.

The Celts brought Christianity to Scotland. The first known missionary was St. Ninian, who established a Celtic monastery in the 4th century at Whithorn. Then the most famous holy man of them all, St. Columba, came from Ireland in 563CE and established a monastery on the remote island of Iona. There's no doubting that Iona today, with its medieval abbey and ruins, is one of the most haunting places in the country. But there is little to see of the original monastery, as it was built of turf, wood and mud. However, at Kingarth on the island of Bute you can still make out the remains of a Celtic monastery founded by St. Blane in the 7th century. It gives a good idea of how such places were laid out, with a central complex of chapels surrounded by circular "cells" (where the monks lived) and workshops, all in turn surrounded by a low turf wall or "rath".

Scotland is particularly rich in ruined churches. Some of them are romantic, covered ruins found within the kirkyards of later churches. Others, like the one at Loudoun in Ayrshire, have been converted into burial vaults. Some, particularly in the Highlands and Islands, sit in places that are now remote, but at one time had sizeable populations, their interiors open to the elements and their kirkyards overgrown and neglected. Many were built on the site of Celtic monasteries and churches, and their appeal is irresistible. What were they like when they were in use? Was it a coincidence that they were originally built overlooking a view of mountain and loch? And why does an air of sanctity still permeate them? The imagination runs wild.

Similarly with castles. Some of them are still occupied, and have been added to and gentrified over the years. Others are moss-covered ruins that tell of a time when life was cheap and quarrels were settled with the sword. They sit in every possible location; cultivated fields, within towns and cities, on remote islands and on promontories that reach out into a sea or loch. Eileen Donan Castle must be the most photographed of them all, and has featured in films, TV, picture books and calendars. Starkly beautiful, it sits on an island in Loch Duich in Ross and Cromarty, and is connected to the mainland by a small bridge.

Scotland is imbued with romance and mystery, and it's not just because of its rugged scenery. Man has left his footprints on the landscape for thousands of years, and these add to the aura. Saints and holy men – warriors – scholars – farmers – all have passed this way, and their legacy still delights, mystifies and thrills us all.

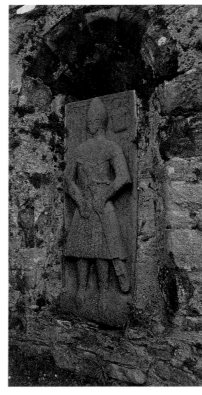

ABOVE

Kildalton Graveslab
In medieval times, Argyll and the Inner Hebrides was a centre for fine stone carving. This beautifully carved graveslab, found within the ruins of Kildalton Chapel on Islay, shows, not a kilted warrior as some people imagine, but a knight in full armour. Legend says that when the Knights Templar were suppressed in 1307, the remnants of this order of soldier-monks found refuge on Scotland's west coast.

OPPOSITE

Kildalton Chapel
No matter where you go in Scotland, you will find a ruined church or chapel. The Reformation wrought the destruction of great cathedrals and abbeys, but more mundane considerations, such as population shifts, saw off many humbler buildings. Kildalton Chapel, sitting near the east coast of Islay, dates from the 14th century. Within the kirkyard is the 9th-century Kildalton Cross, regarded as a masterpiece of early Scottish stone carving (see p.43).

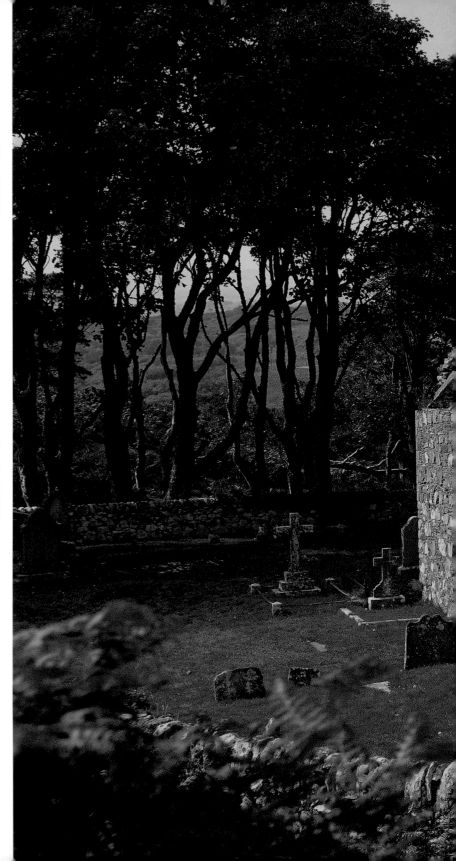

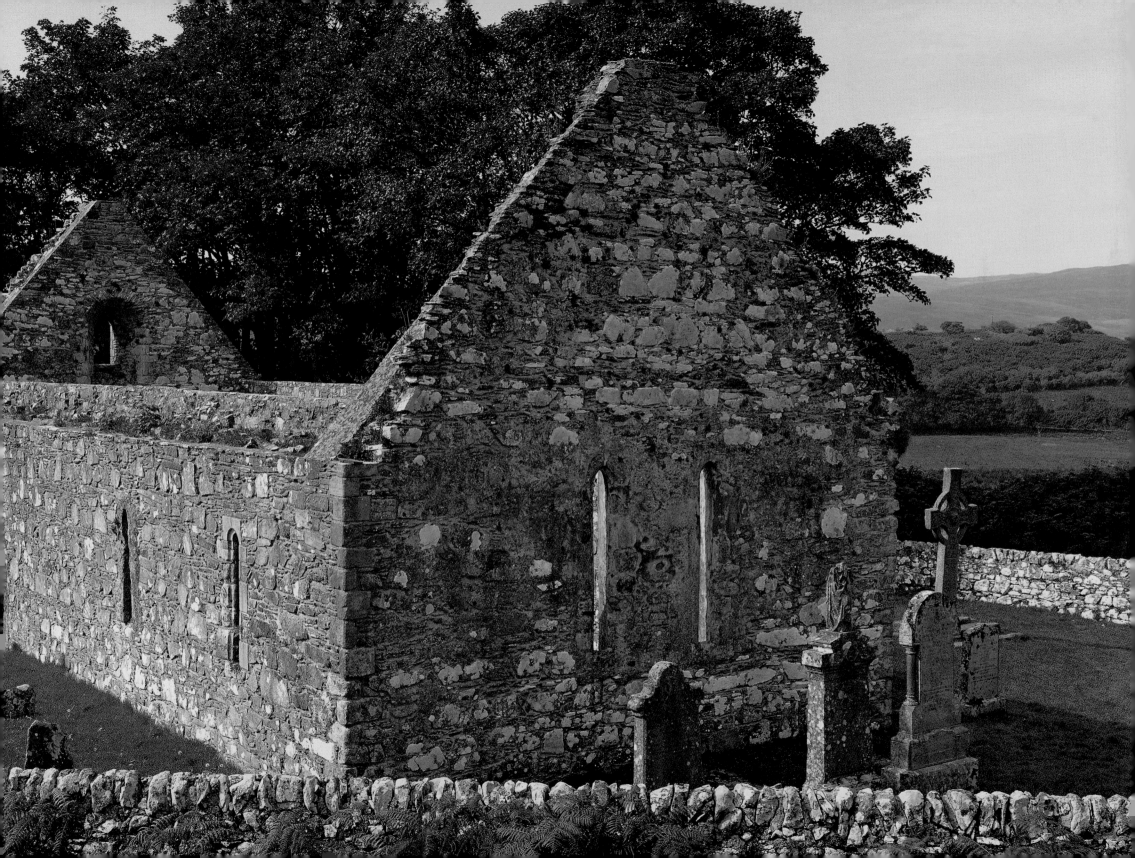

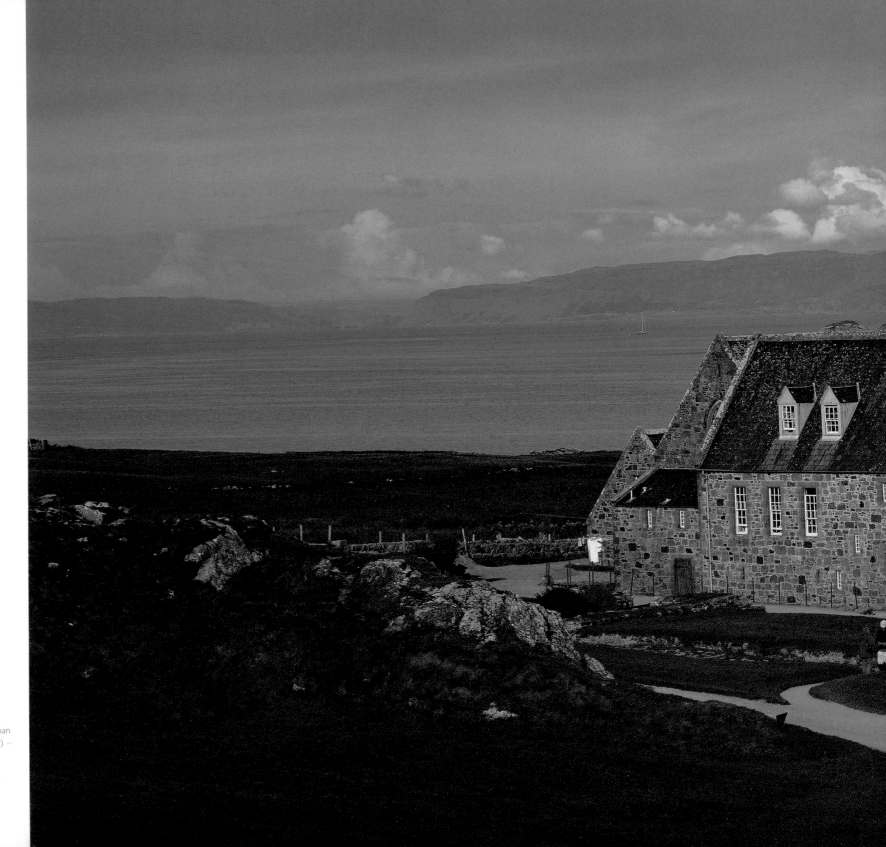

Iona

Most people who visit Iona remark on its air of peace and sanctity. This small island – no more than 3 miles long by 1½ miles wide (4.8 km by 2.4 km) – off the coast of Mull, was where St. Columba established a monastery in 563CE. Little remains of it, although the later medieval abbey has been restored by the Iona Community, an ecumenical movement for men and women.

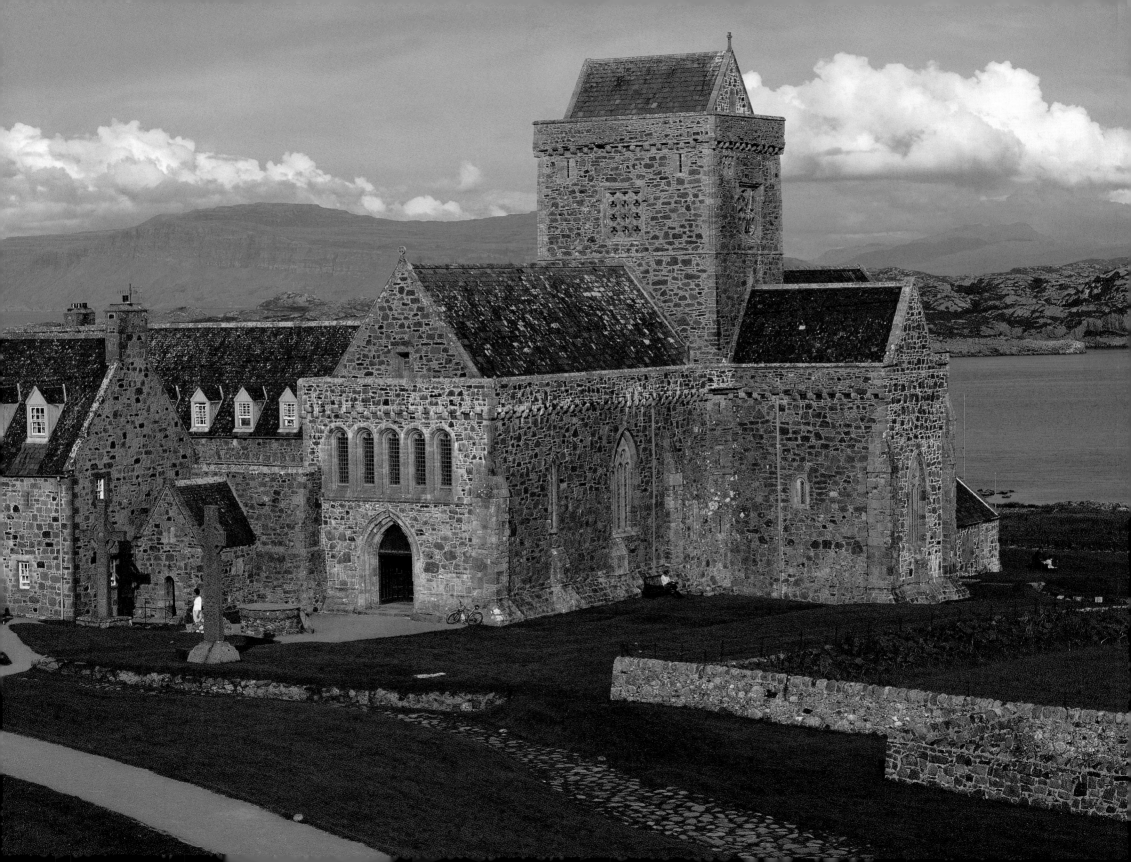

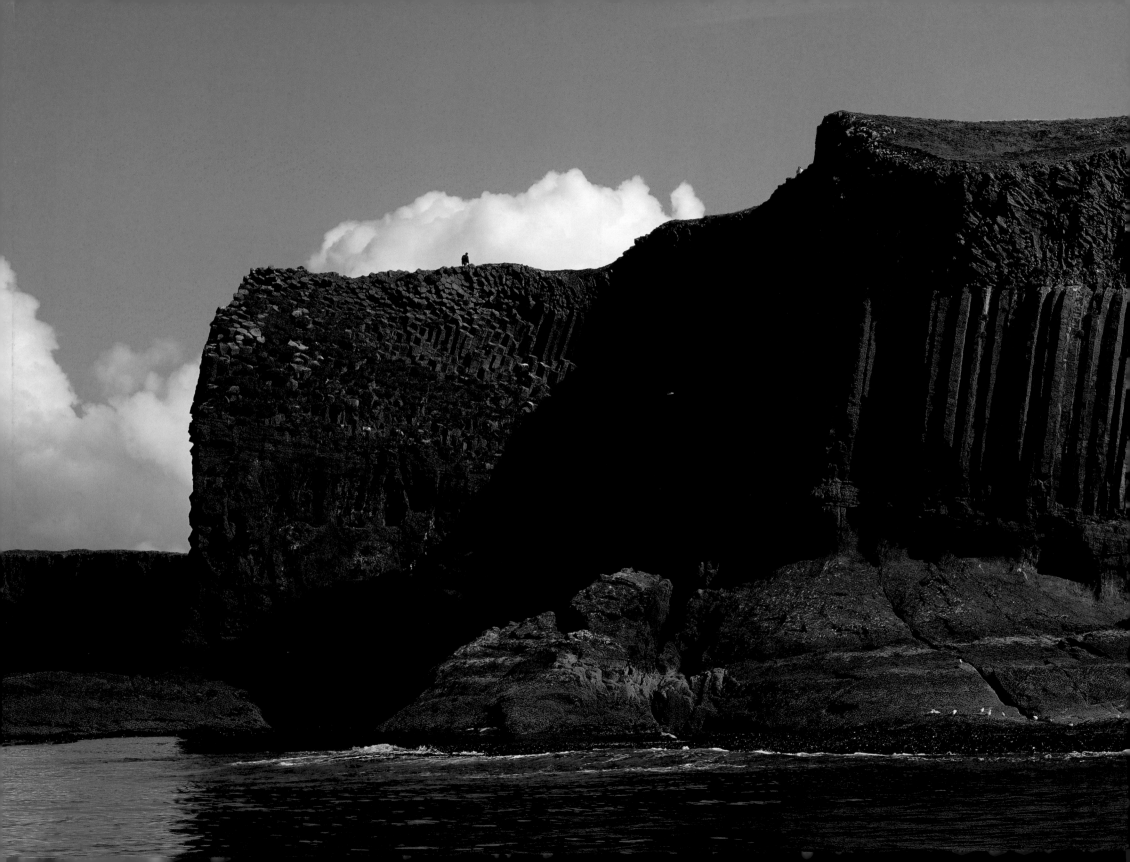

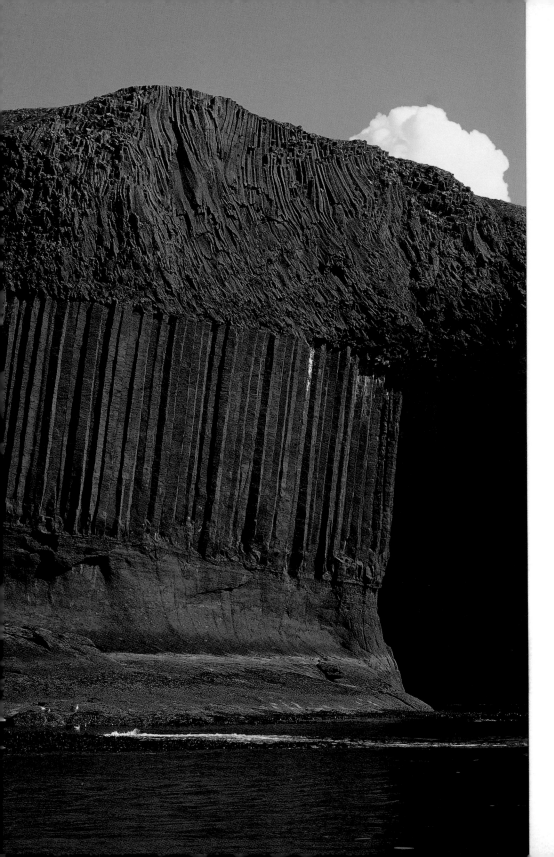

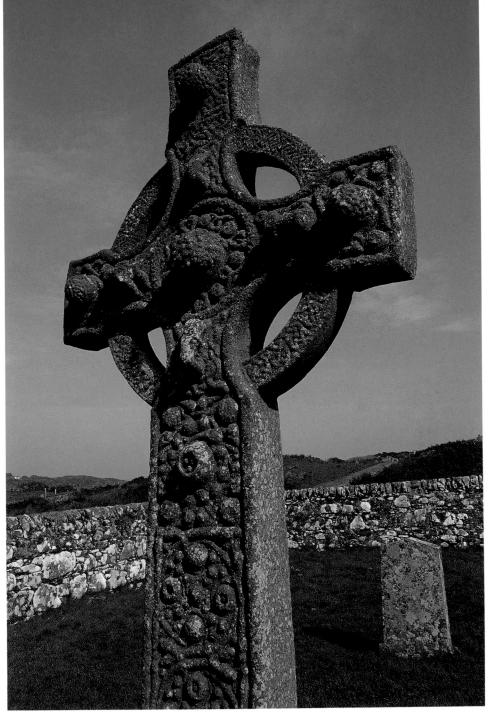

OVERLEAF, FOLDOUT

Staffa

When Mendelssohn visited Staffa in 1829, he was inspired to write the Hebrides Overture by the booming waves within Fingal's Cave. The whole island is awe-inspiring, with its huge basalt columns, once believed to have been built by a race of giants.

ABOVE

Kildalton Cross

Next to the ruins of Kildalton Chapel on Islay, this cross is testimony to the superb stone carving skills of the early Scots. It was carved c.800CE, probably by a sculptor from Iona, and is the only complete example of this age in the country.

Rosslyn Chapel

Famous as the church in which the Holy Grail is supposed to be hidden, Rosslyn Chapel is filled with fine stonework. Of all its carvings, the Apprentice Pillar is the most ornate. Legend says the master mason visited Rome for inspiration before starting work on it. On his return he found his apprentice had already carved it, and killed him in a jealous rage.

BELOW

Campbeltown Cross

Another fine example of a cross is to be found in Campbeltown, although this one dates from the 13th century. It sits near the harbour, and may have been carved on Iona or at Saddell Abbey. It has been called a "masterpiece of medieval carving", and originally stood in a graveyard in Macrihanish before being moved in 1680 and used as a market cross.

OPPOSITE

Melrose Abbey

When fighting between the Scots and the English was at its height, the Scottish Borders – especially its abbeys – bore the brunt of the destruction. Beautiful Melrose Abbey was no exception. It was largely rebuilt after Richard II's forces destroyed it in 1385, but was again attacked in 1545 by the armies of Henry VIII, and was never fully rebuilt.

FOLLOWING PAGE

Carloway

Until the early 20th century, most dwellings on the Western Isles were "blackhouses" – low, thatched buildings where cattle lived under the same roof as people. Surviving examples look centuries old, but in fact many date from the late 19th century. There are still a number left, such as the Gearannan Blackhouses at Carloway, occupied until 1974.

BELOW

Gargoyle on Melrose Abbey

Although the Reformation destroyed much of Scotland's religious works of art and craftsmanship, the ancient abbeys – although ruined – still retain marvellous stone carvings that testify to their original beauty. This gargoyle at Melrose Abbey probably dates from the late 14th or early 15th century.

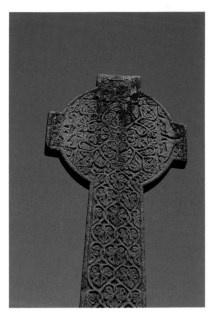

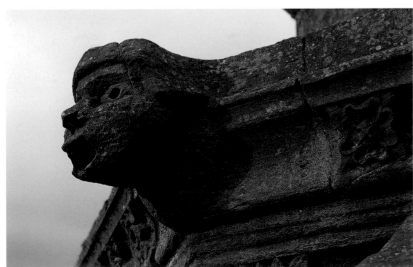

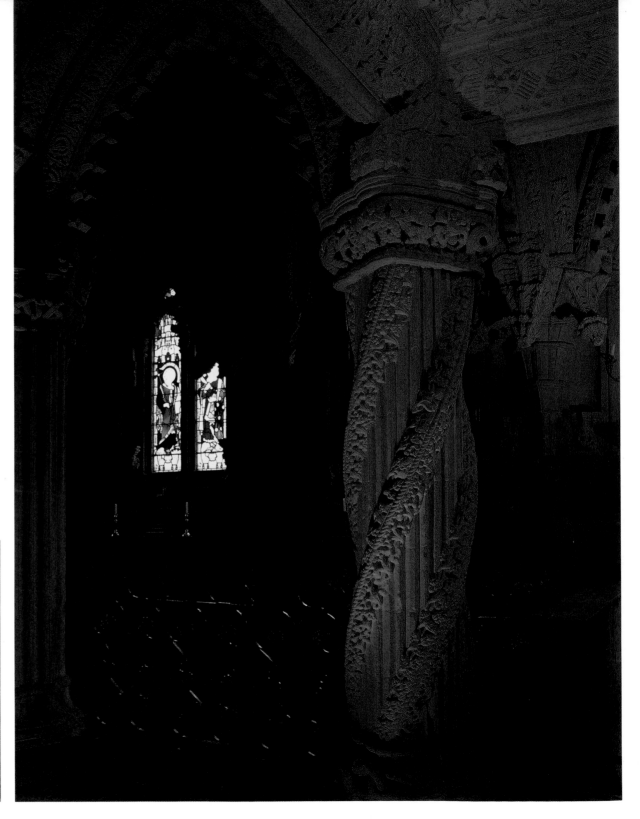

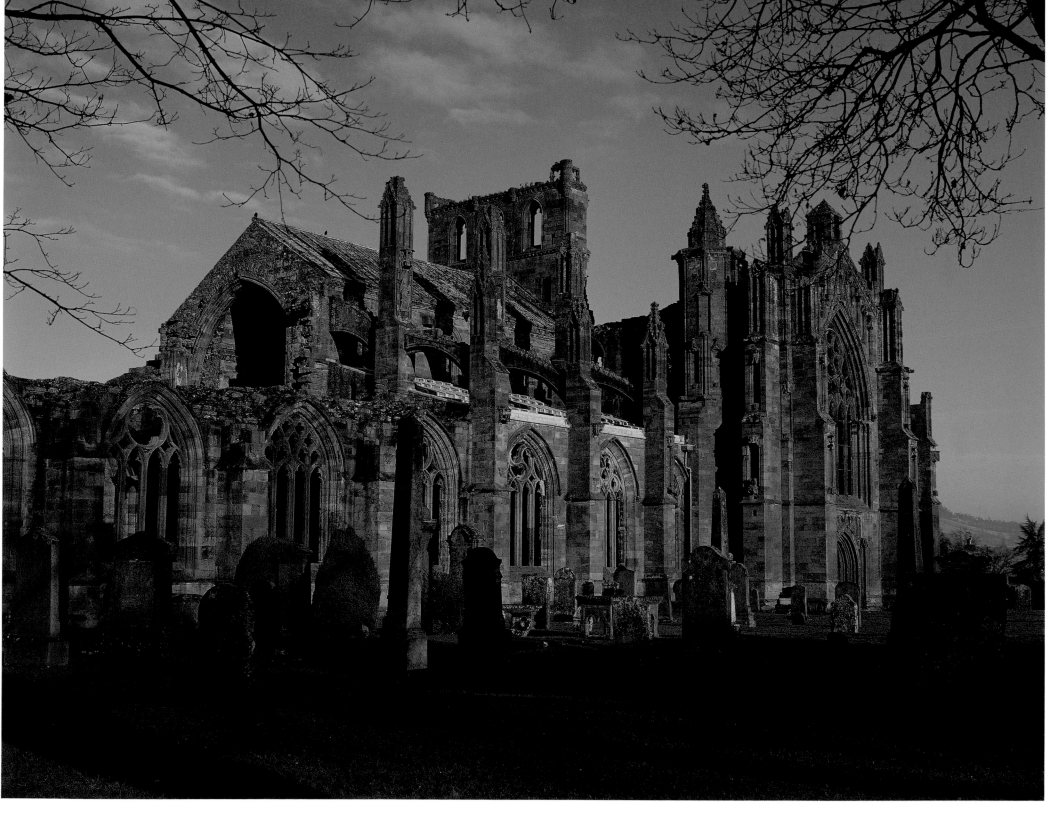

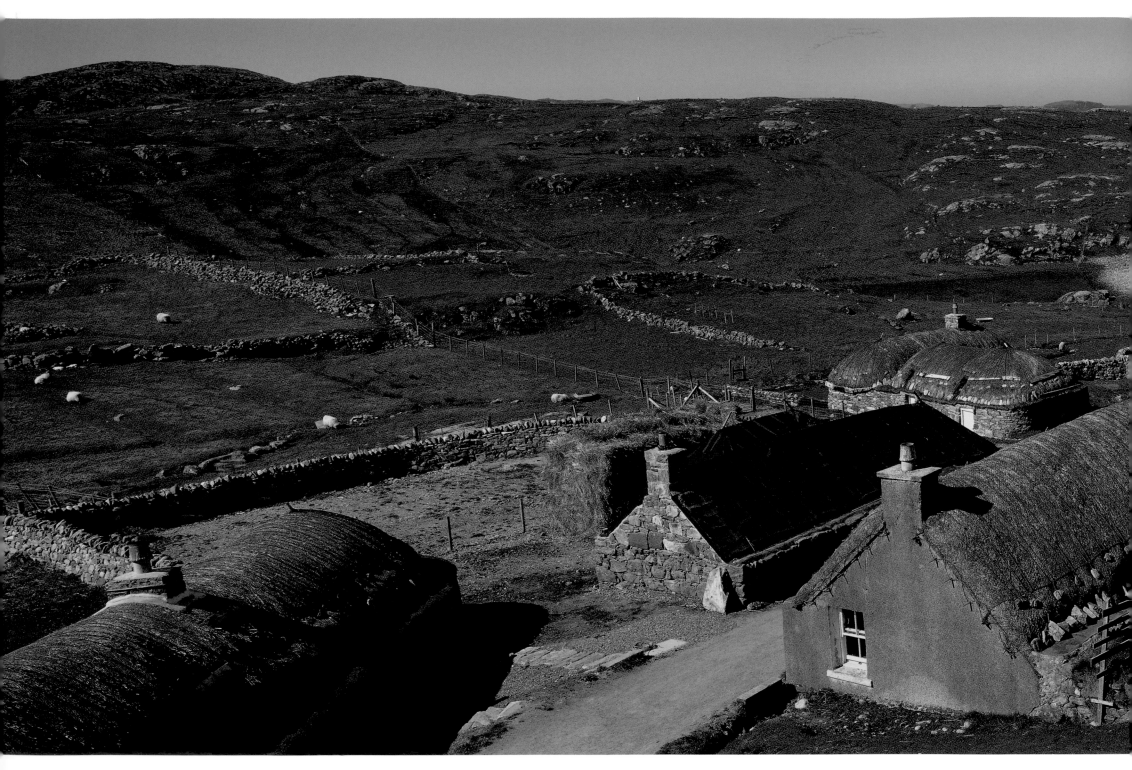

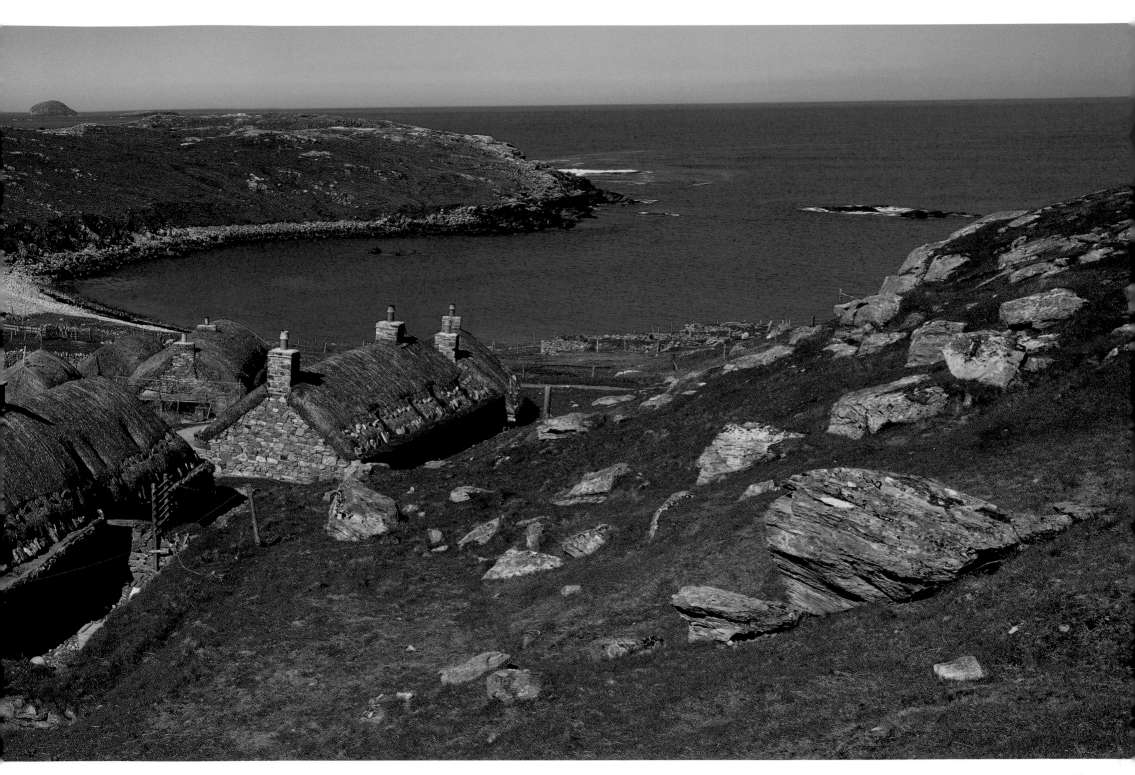

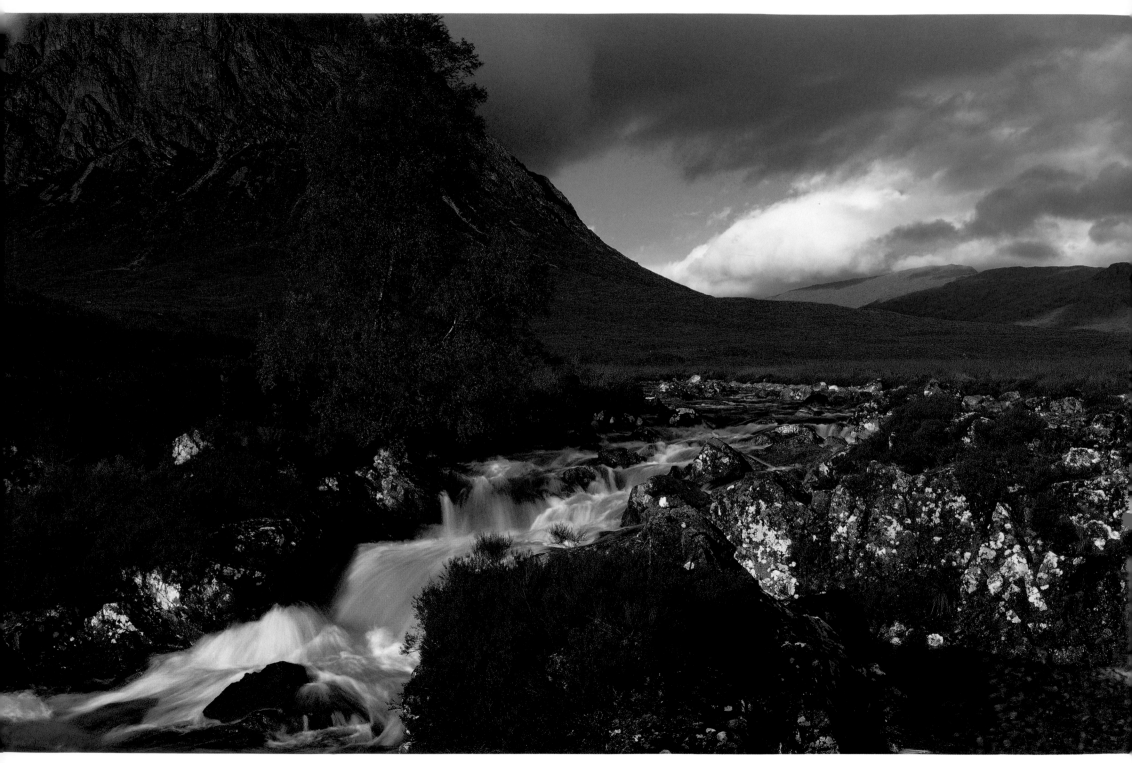

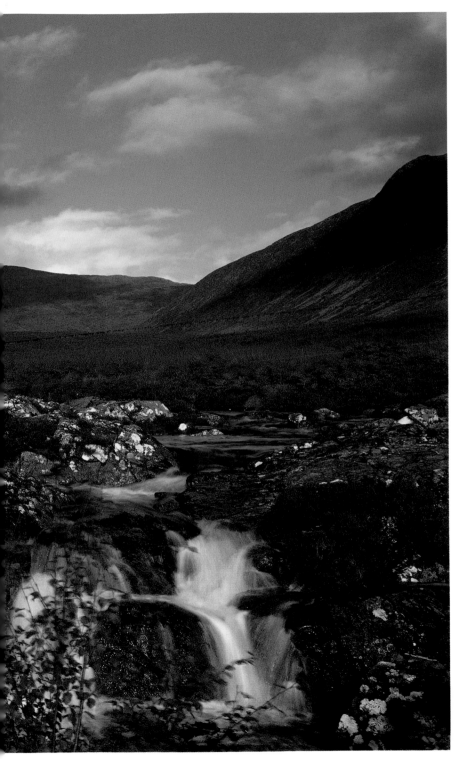

HIGHLANDS AND ISLANDS

Think of Scotland and you think of the Highlands and Islands. Misty mountains – dark glens – deep, brooding lochs – white, shimmering beaches – these are the stuff of a million calendars and postcards, and people flock to see them in real life. This is where Bonnie Prince Charlie and Rob Roy played out their adventures, and where kilts, pipe bands and tartan come into their own. There is romance at every turn, and a castle on every corner. If the castle is a romantic ruin, so much the better.

At one time the Highlands was defined as that area of Scotland lying north of a line drawn between Helensburgh and Stonehaven. However, there are vast areas of intensely worked, fertile farmland in the north, such as Buchan in Aberdeenshire and along the southern shores of the Moray Firth. What many people see as the real Scotland is to be found in Argyll, to the north of Perth, and along the northwestern seaboard.

In truth, the Highlands and Islands, in tourism terms at least, do not form one huge unspoilt area, but a series of easily visited, "must-see" places. Glencoe or the Trossachs, for example, or Urquhart Castle on the shores of Loch Ness. Then there's Eileen Donan Castle – surely the epitome of the romantic Scottish castle – sitting on a small island in Loch Duich, as well as Ben Nevis, Loch Lomond, Monarch-of-the-Glen country and Royal Deeside.

Film companies long ago discovered the photogenic properties of the Highlands. Mel Gibson partly filmed *Braveheart* in Glen Nevis and Glen Coe. Eileen Donan Castle featured in *The Ghost Goes West*, *Highlander* and one of the newer Bond movies *The World Is Not Enough*. Another Bond movie, *From Russia With Love*, was partly filmed in Argyll.

Loch Ness was the setting (naturally enough) for *Loch Ness*, released in 1996 and starring Ted Danson. The village of Plockton was the real star of the popular British TV series *Hamish Macbeth*, and the children's series *Balamory* is filmed among the brightly painted houses of Tobermory on Mull.

But people don't just come to the Highlands and Islands for the scenery or the solitude – they also come for romance and mystery. Culloden, where Bonnie Prince Charlie's dreams of restoring a Stuart to the British throne ended in 1746, is still a place of infinite sadness. Iona has an air of sanctity that reaches out and touches us 1,500 years after Columba established his monastery there. And who hasn't visited Loch Ness and been seduced by the legend of the monster and the sheer beauty of the loch itself? Equally who has seen Loch Lomond and not agreed that its banks are even bonnier than the song suggests?

The best areas of the Highlands are those where many elements combine to make a perfect whole. A high peak is fine, but make it the backdrop to a wooded glen and a peat-dark loch, and you have beauty. Take an old, turreted castle and place it in the midst of some dense woodland, and you have romance. Place a ruined church on a hillside above the sea, surround it with teetering gravestones, and you have mystery.

Of course, lochs can also be inlets of the sea, and here the western seaboard comes into its own. There are many single-track roads that take you along their shores, giving stunningly beautiful views over sea and shore. Snow lies only for a short while here, owing to the Gulf Stream, although there is – make no mistake – plenty of rain. But when it's dry, the sight of yachts bobbing on a sea loch

beneath a sky of cotton-wool clouds, with green hills reaching down almost to the shore, takes the breath away.

Those people who visit John o'Groats are sometimes surprised to find that in fact it is not Britain's most northerly point. This honour goes to Dunnet Head, a few miles to the west. Here, from a cliff top 300 ft (91 m) above the sea, there are glorious views out toward the Orkneys. This is not the Scotland of the Gaels, but of Norse legends and language. Orkney and Shetland themselves did not become part of Scotland until 1472.

The Western Isles too have a strong Norse tradition, although curiously, this is also where Gaelic language and traditions are now strongest. Indeed to some islanders English is a second language. Although not as spectacular as the mainland, the scenery has a truly magical quality. During the summer months the evenings are long and lazy, with plenty of birdsong, and as soon as the sun sets, it seems to rise again. Although Calvinism and Sunday observance is strong, some of the islands – notably South Uist and Barra – have never forsaken Roman Catholicism, even during the Protestant Reformation of 1560, because of their remote location.

The Inner Hebrides comprise many islands lying off Argyll and Inverness-shire. Each one is different, from the spectacular scenery of Skye and Mull to the quiet, pastoral charms of Lismore and the sanctity of Iona. And the names themselves invoke

OPPOSITE

Rannoch Moor and Glencoe
The Highlands of Scotland are not all mountains and glens. There are vast tracks of bleak but beautiful moorland as well, such as Rannoch Moor, shown here. Glencoe is on the right, and on the left is Buachaille Etive Mor, with the River Etive tumbling down through the rocks between them.

pictures in the mind, even if we've never visited them. Canna – Muck – Rum – Eigg – Tiree – Coll – these are names that conjure up mystical qualities. We think of the old Celtic saints who sailed these waters founding monasteries as they went, or the ancient Dalriadan kings progressing from island to island in their royal barges. We think of the later Lords of the Isles, who lived in some splendour on Islay, paying lip service to the Scottish kings but going their own way.

For this reason visitors to the Highlands and Islands should take with them not just their guidebooks and their maps, but their imaginations as well. Although the land appears sparsely populated, people have lived here since time immemorial, leaving something of themselves that cannot be erased. It's this, as well as the scenery, that gives the place its special qualities. So look and admire, but at the same time listen out for the ancient voices that are all around. Your visit will be much the richer for it.

Cottage on Mull
Mull, after Skye, is the second largest island in the Inner Hebrides. Although easily reached by ferry from the mainland, much of it is mountainous, and only accessible on foot. Known to the Romans as Maleus, the island has been inhabited since prehistoric times. It has higher than average rainfall for Scotland, and here we see a typical crofting cottage on Mull against the backdrop of a mist-shrouded mountain.

BELOW
Colbost Croft Museum
Located near Dunvegan on Skye, the Colbost Croft Museum gives an insight into what life was like in a croft in days gone by. The cottage interiors, although primitive by today's standards, were cosy and warm.

OPPOSITE
Loch Linnhe
This is a sea-water loch that penetrates more than 28 miles (45 km) into the heart of the Scottish Highlands, following the path of the geological fault that also formed the Great Glen and Loch Ness. This photograph was taken from Ben Lora in Benderloch, north of the town of Oban, and shows the entrance to the loch.

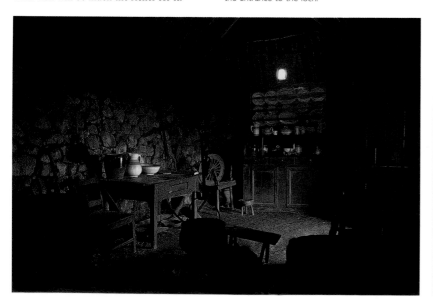

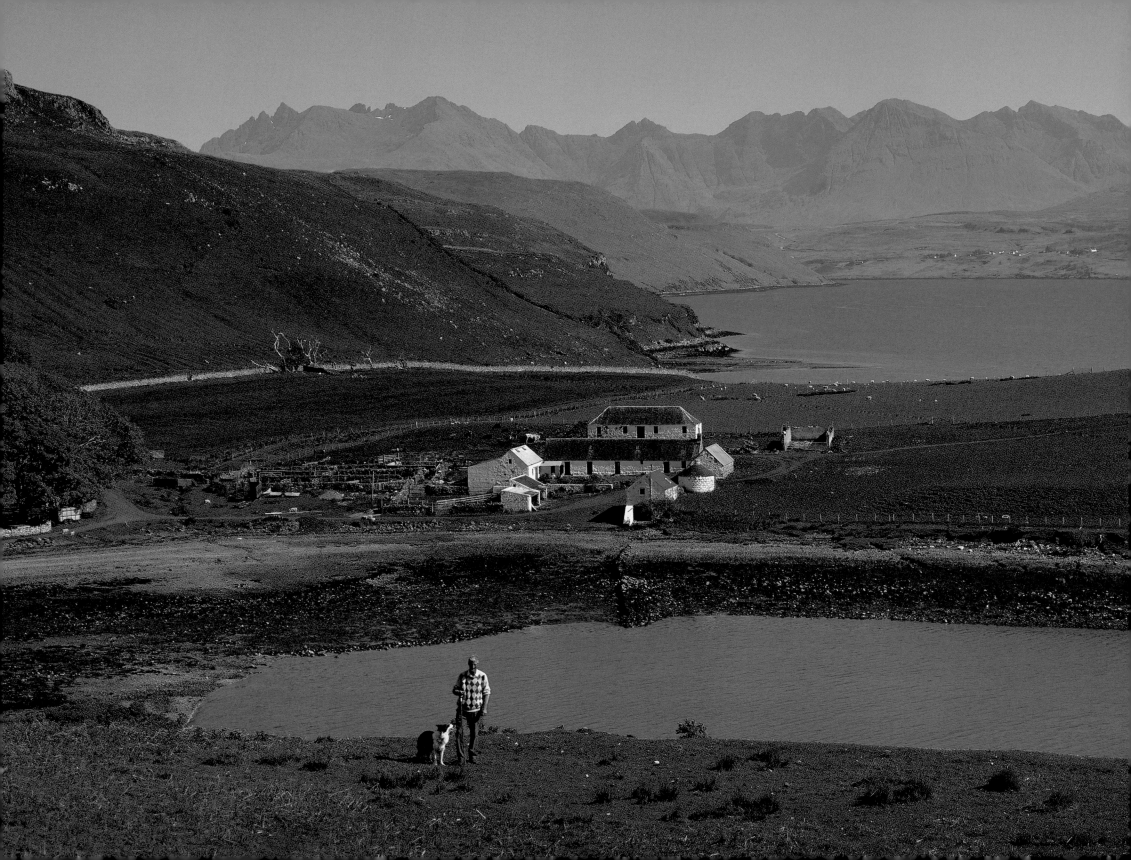

LEFT
Black Cuillins

The Cuillins on Skye consist of two ranges of hills, the Red Cuillins and the Black Cuillins. Of these, the Black Cuillins are the more rugged, having been formed by volcanic activity millions of years ago. Although they are not particularly high (the highest peak, at 3,275 ft/998 m is Sgurr Alasdair), mountaineers have always found them a challenge.

BELOW
Sheep

The period known as the Highland Clearances was one of the most traumatic in Scotland. Between 1790 and 1845 thousands of people were forcibly removed from their lands and homes to make way for sheep, which were more profitable than people to the landowners. The people resettled on the coast or emigrated to North America and Australia.

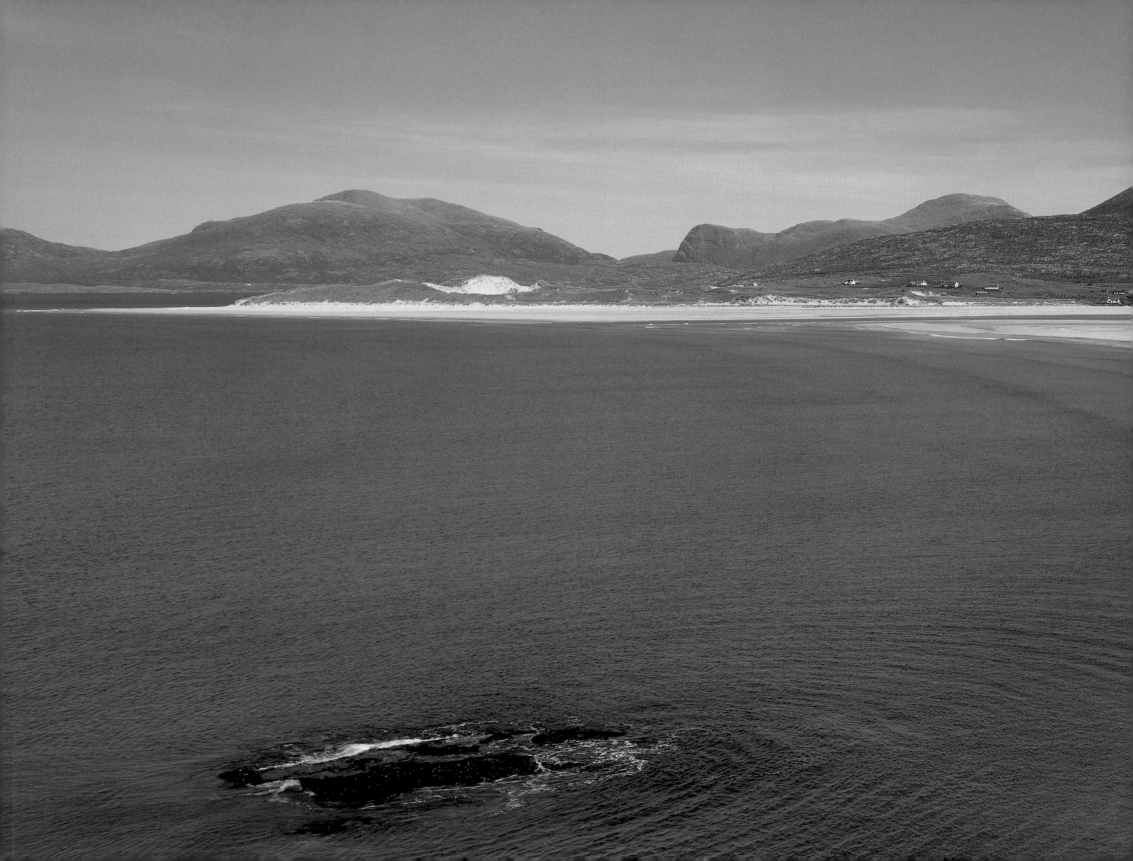

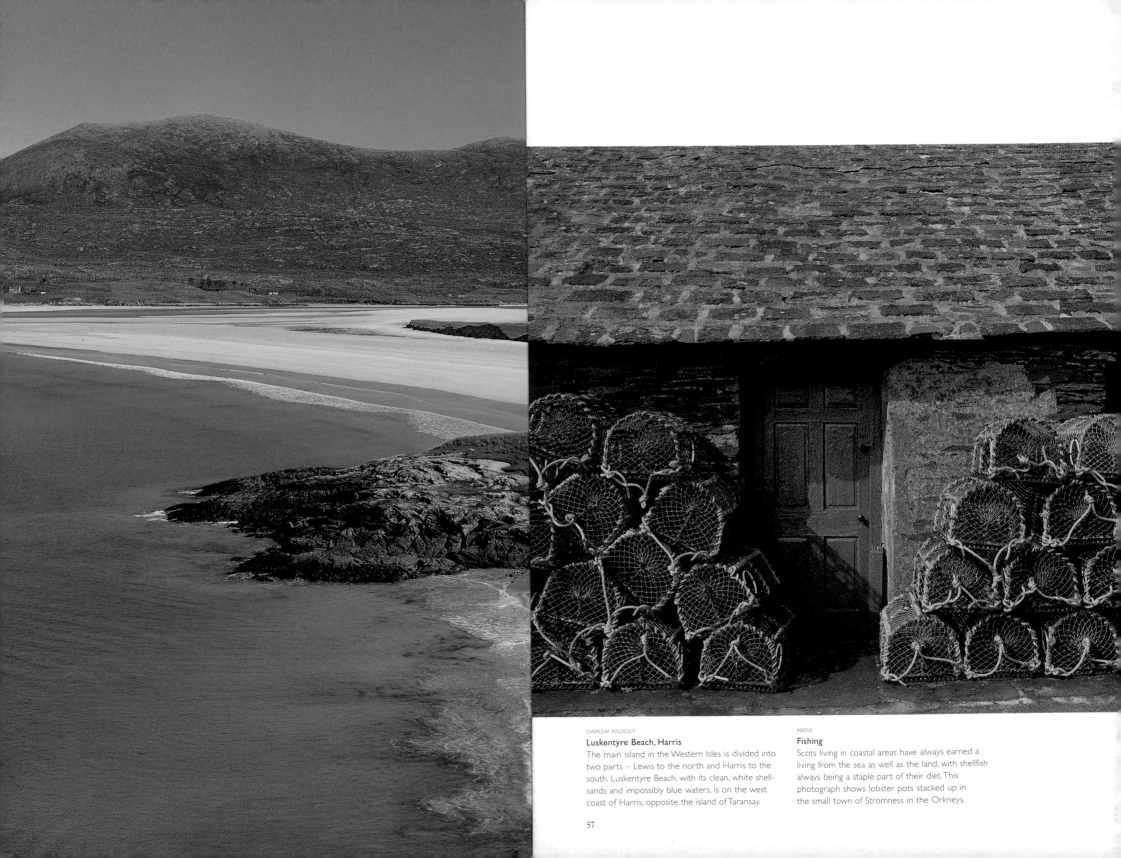

OVERLEAF, FOLDOUT

Luskentyre Beach, Harris

The main island in the Western Isles is divided into two parts – Lewis to the north and Harris to the south. Luskentyre Beach, with its clean, white shell-sands and impossibly blue waters, is on the west coast of Harris, opposite the island of Taransay.

ABOVE

Fishing

Scots living in coastal areas have always earned a living from the sea as well as the land, with shellfish always being a staple part of their diet. This photograph shows lobster pots stacked up in the small town of Stromness in the Orkneys.

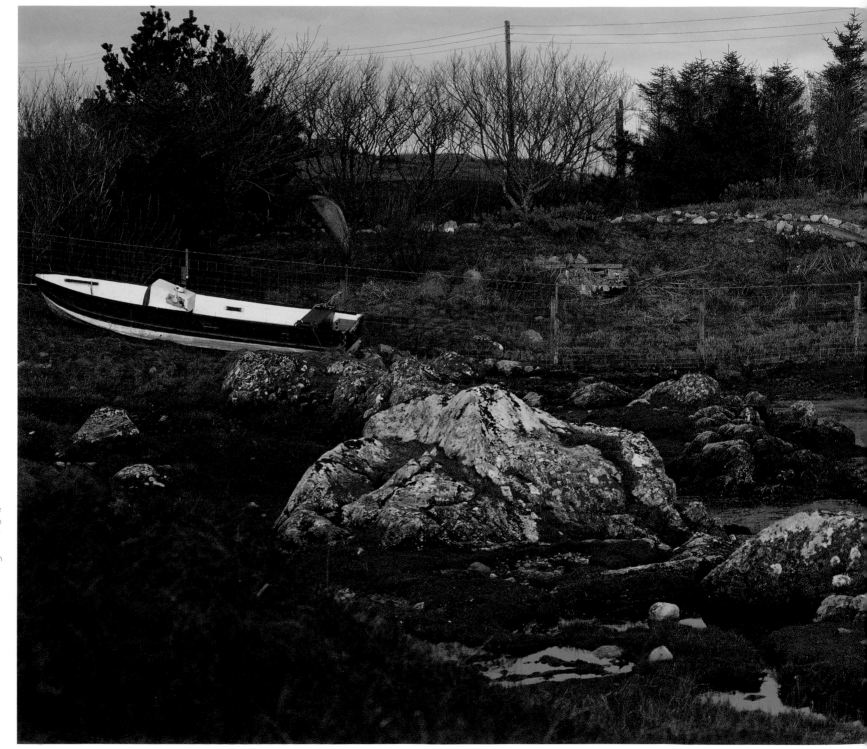

The Simple Life on Loch Carnan

This picture, taken at Loch Carnan on South Uist, seems to typify the idyllic life of a crofter on the Western Isles. The simple cottage and the boat for fishing on the loch represents a way of life that is envied by many. But even on South Uist modern life must intrude. Not far from this rustic scene is South Uist's diesel power station, which supplies electricity to the whole island. Even here, on the edge of Europe, people demand the conveniences of modern life, so a reliable supply of electricity is a must.

FOLLOWING PAGE

Inverpolly

This panoramic view shows Scotland at its finest, with its combination of open skies, scudding clouds, mountains and lochs. It was taken at Inverpolly in Ross and Cromarty, one of three estates that make up an 11,000-acre (4,450-ha) national nature reserve – Scotland's second largest. The mountains shown are Suilven, Canisp and Cul Mor, of which Suilven is often described as "Scotland's best mountain". When seen from the west (this picture looks north) Suilven looks like a steep-sided dome standing in splendid isolation.

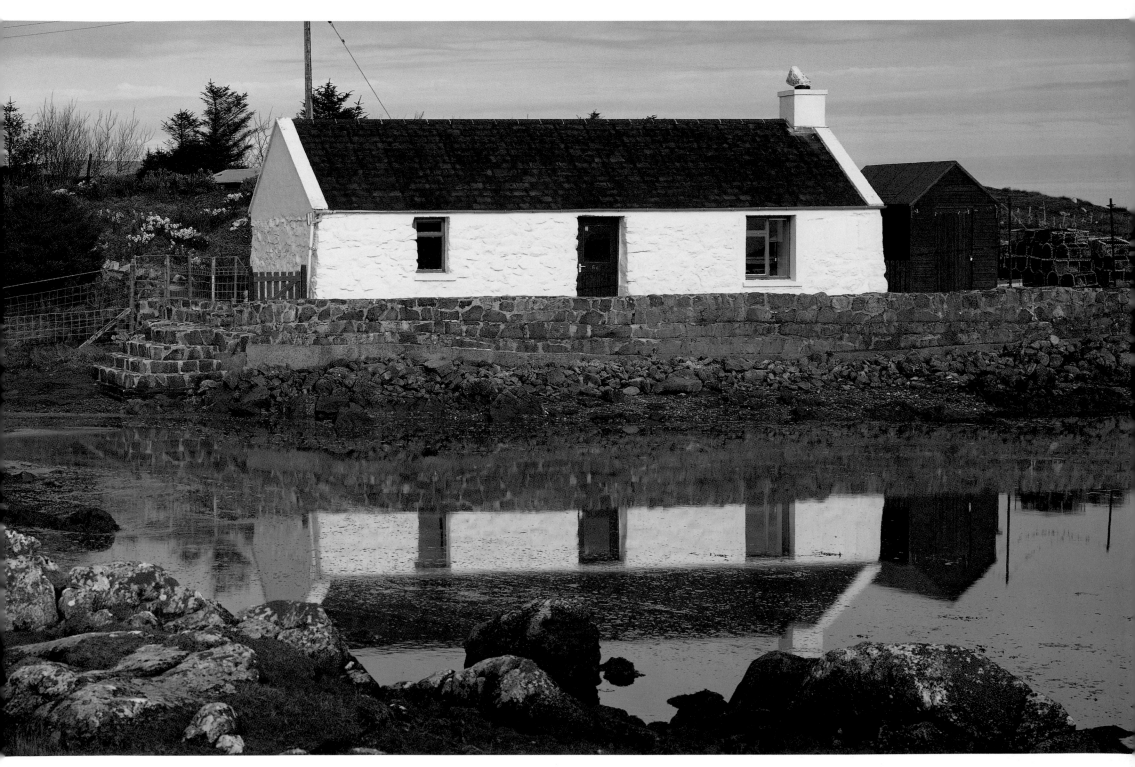

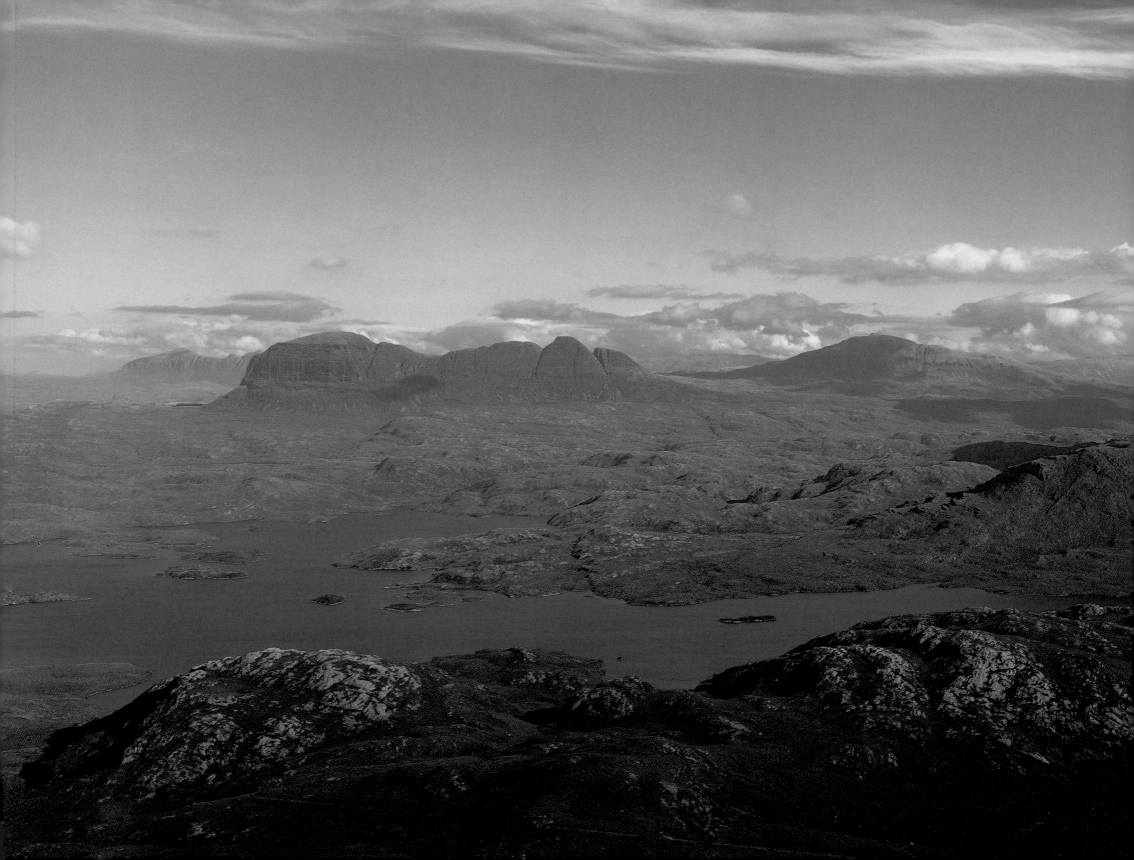

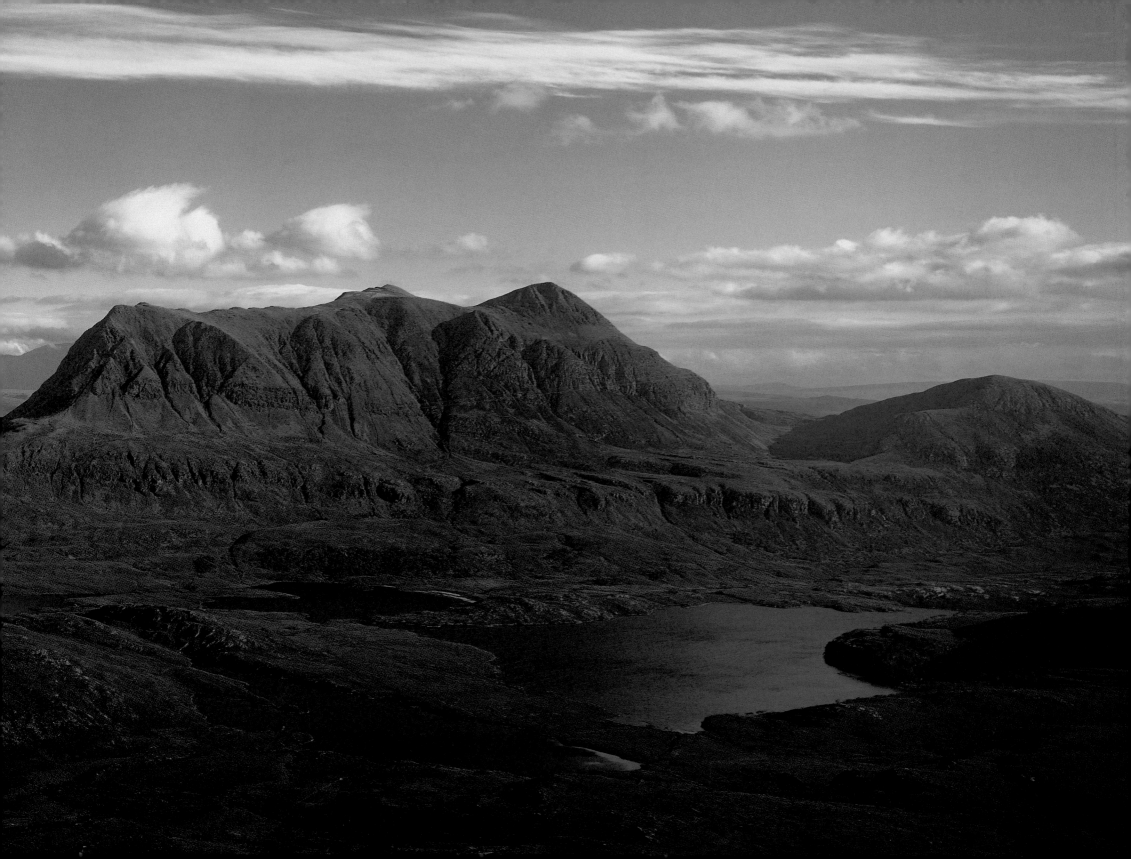

RIGHT

The Loch Ness Monster

The first recorded sighting of the Loch Ness monster was in 565CE, when St. Columba was travelling along the loch on his way to present-day Inverness. His biographer, Adamnan, tells of a monster in the waters that had attacked a man. Columba immediately prayed, and the monster released the man and disappeared beneath the water. Those who travel to Loch Ness today, and who fail to see the monster in the flesh, can visit one of two exhibitions at Drumnadrochit and see models of "Nessie".

BELOW

Deer

Scotland has two species of deer – the red deer and the roe dee – and they are found all over the country. The red is the larger of the two, and found on higher ground, although – and it is a surprise to some – the roe deer is the more dangerous. They have no natural predators, and although they are wild animals, they have been managed for centuries, and at one time the hunting of deer was the preserve of the king and his court.

OPPOSITE

Loch Ness and Urquhart Castle

A mile wide and 23 miles long (1.6 km by 37 km), Loch Ness stretches along the Great Glen and contains more water than any other Scottish loch. Its deepest point, at 754 ft (230 m), is just off Urquhart Castle, where, interestingly, there are more sightings of Nessie – the Loch Ness Monster – than anywhere else.

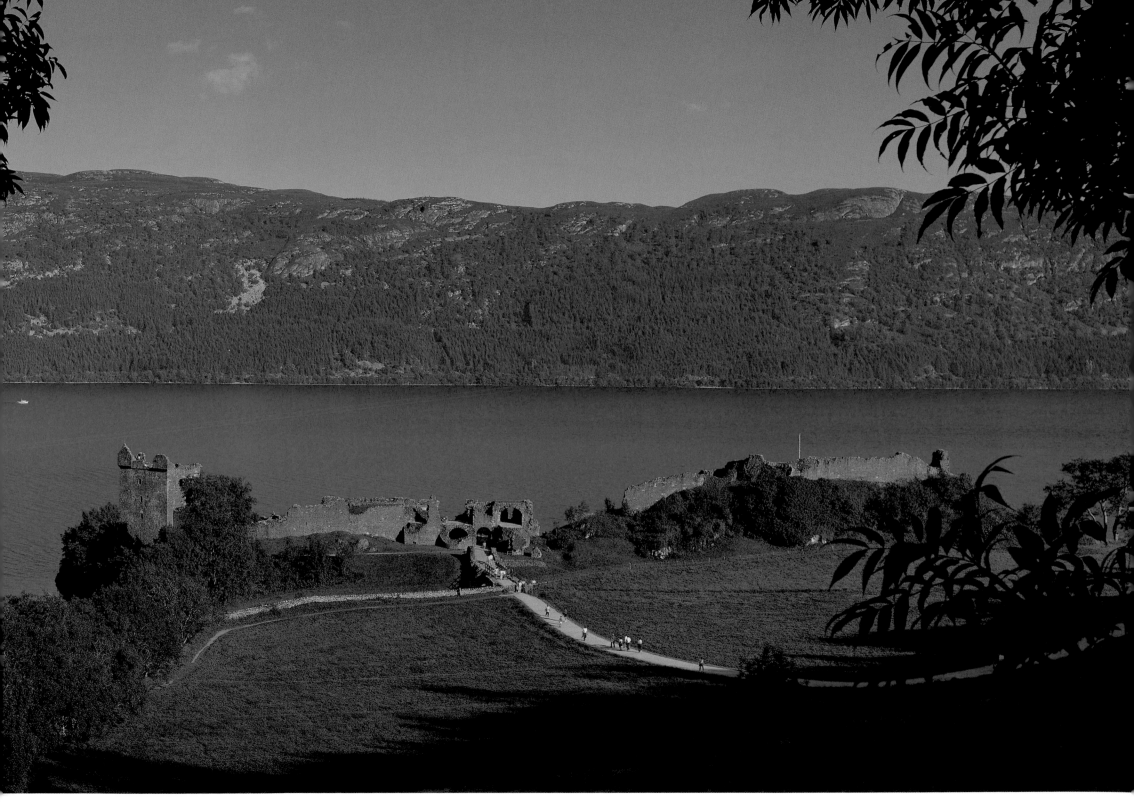

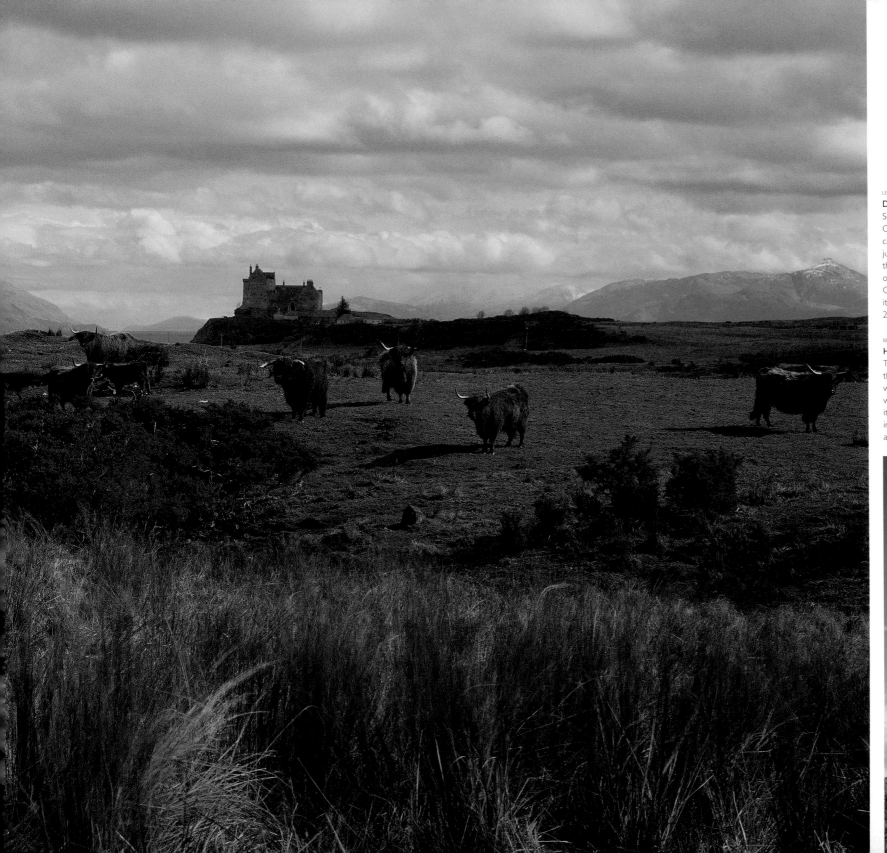

Duart Castle

Seen here, with a herd of Highland cattle, is Duart Castle, the ancestral home of Clan Maclean. The castle is strategically positioned on a promontory jutting out into the sea where the Sound of Mull, the Firth of Lorne and Loch Linnhe meet. The oldest parts date from the 14th century. In 1691 the Campbells acquired the castle and later abandoned it, but in 1910 it was bought by Sir Fitzroy Maclean, 26th chief of Clan Maclean, who rebuilt it.

BELOW

Highland Cattle

The Highland breed of cattle is ideally adapted for the Highland terrain, with its cold, biting winter winds, high rainfall, snow and poor grazings. With written records going back to the 12th century, it is said to be the oldest pedigree breed of cattle in the world, and with its distinctive shaggy coat and large horns, it is immediately recognizable.

Hay-making

Scotland's economy, up until the Industrial Revolution, was based on agriculture. In the Highlands every scrap of cultivatable land had to earn its keep, if not by growing crops, then by providing hay for winter feed. Here we see the farmers turning the hay in late summer.

Thatching

Although slate quarrying was once a major industry in some parts of the Highlands, thatch was the main type of roof-covering up until the early 1900s. Many cottages are still thatched, more for sentimental reasons that practical ones, and both heather and reeds are the main materials used.

A Good Gossip

Scots love children, and are inclined to spoil them. These two delightful charmers are the daughters of the landlord at the Westford Inn at Claddich Kirkibost on North Uist, and they seem to be enjoying a good gossip by the look of them. The Westford is one of only two pubs on the island.

Crofting

Life for many crofters in northwest Scotland or the Outer Hebrides revolved around the land and sea, as this photograph of a croft house and its boat testify. Land was rented from the local landlord, and crops were grown. A croft on or near the coast also had its boat, and a living was wrested from the waves as well. Crofting is still very much alive today, although fishing is not as prevalent as it once was.

Harris Tweed

Harris Tweed (*clo mohr* in Gaelic – the "big cloth") is still woven in the Western Isles. The weavers work from home, either from a room in the house or in an outbuilding (as seen here). The famous Orb symbol can be used only on fabric hand woven from wool that has been spun and dyed by the islanders of Harris, Lewis, South and North Uist, and Barra.

Heavy Traffic on a Highland Road

When you get off the beaten track, Highland roads are a pleasure to drive along. Certainly they can be narrow and torturous, but who would want to drive fast through all that breathtaking scenery? There is an old joke that the rush hour in the Highlands is when the shepherd moves his flock from one field to another. Here we see it might not be a joke after all!

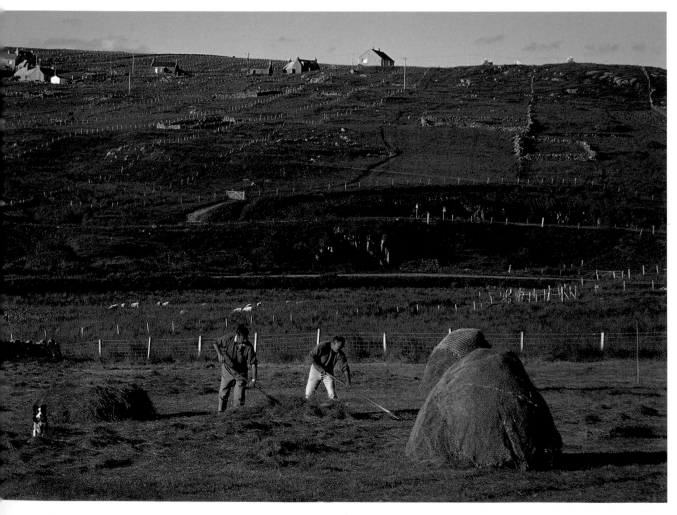

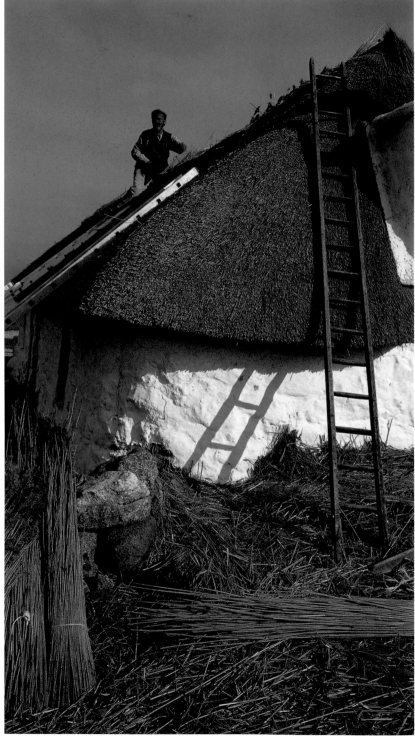

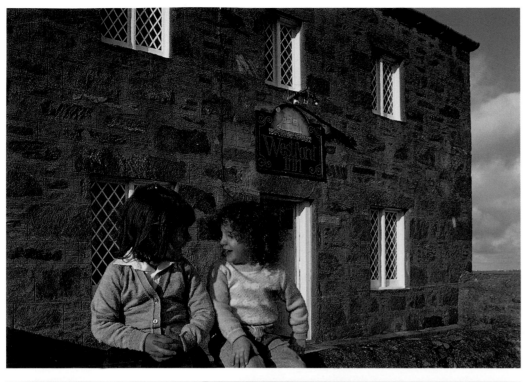

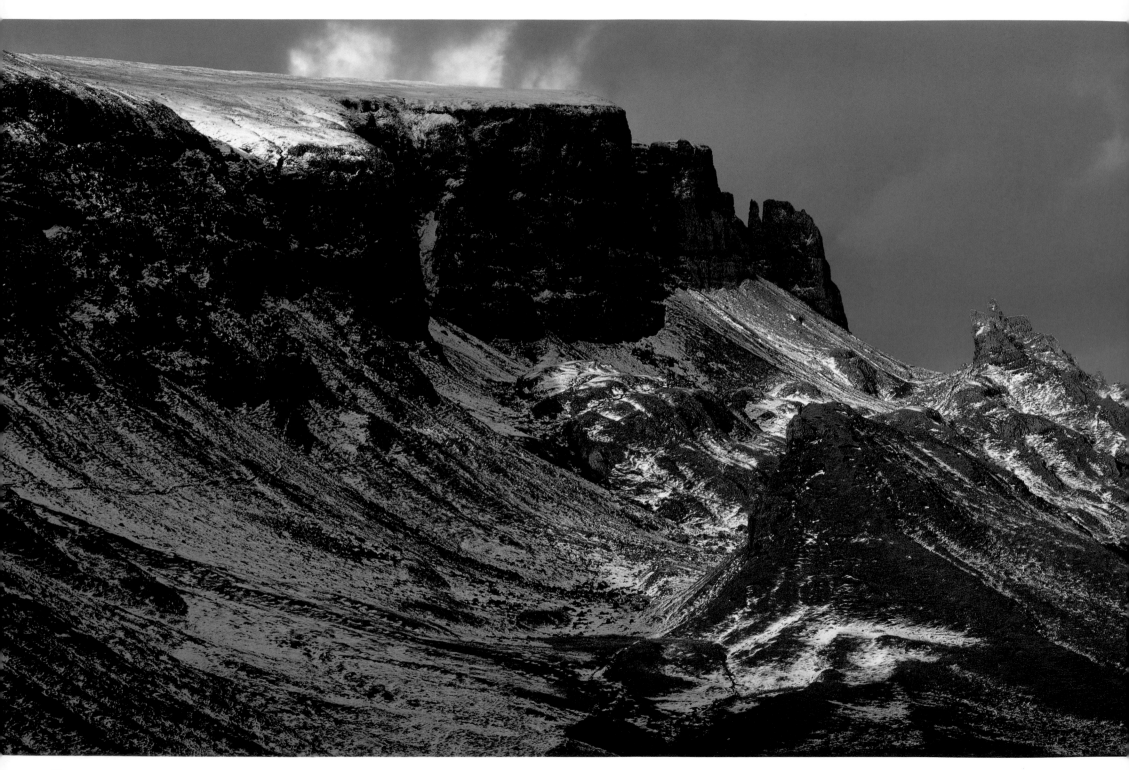

PREVIOUS PAGE
Rannoch Moor

The 50 square miles (130 sq km) of land known as Rannoch Moor sits 1,000 ft (305 m) above sea level, and is a wild plateau of peat bogs and lochs. In winter its vast, snowy expanse is inhospitable and dangerous, and even in summer hikers and walkers should take care. The Glasgow to Fort William Railway line cuts through it from north to south, and it lies on a raft of wood and ash that floats on 20 ft (6 m) of thick peat.

LEFT
The Quirang

Located on the Trotternish Peninsula on Skye, the Quiraing is a group of twisted rock formations that was formed by a mighty landslip many years ago. This is superb walking and climbing country – not as challenging as the Cuillins, but still popular. Here we see it in winter, with a light powdering of snow. Even in summer, however, it has a sombre, but no-less-beautiful, air.

BELOW
A Climber on Clisham

The largest island in the Western Isles is made up of two distinct areas – Lewis to the north and Harris to the south. Their landscapes are totally dissimilar, as Lewis is low-lying, and Harris is wild and mountainous. Clisham on Harris, at 2,622 ft (800 m), is the highest peak in the Western Isles, and is formed from Lewisian gneiss, the oldest rock in the world. The area is popular with climbers, and there are some superb vistas to enjoy.

FOLLOWING PAGE
Loch Lomond

Of all the Scottish lochs, Loch Lomond, with its "bonnie, bonnie banks", is reckoned to be the most beautiful. It straddles the Highland Boundary Fault, the geological fault that separates the Highlands from the Lowlands, and its scenery reflects this. To the south, its banks are green, wooded and fertile; whereas further north, as it narrows, high mountains plunge steeply toward deep, grey waters.

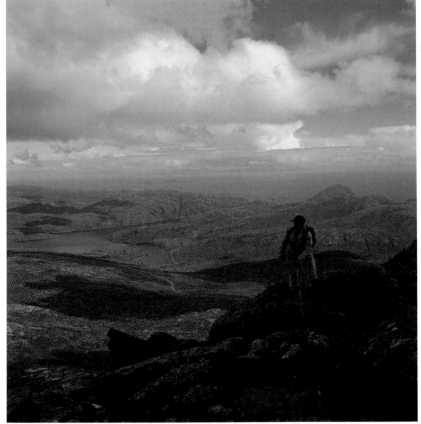

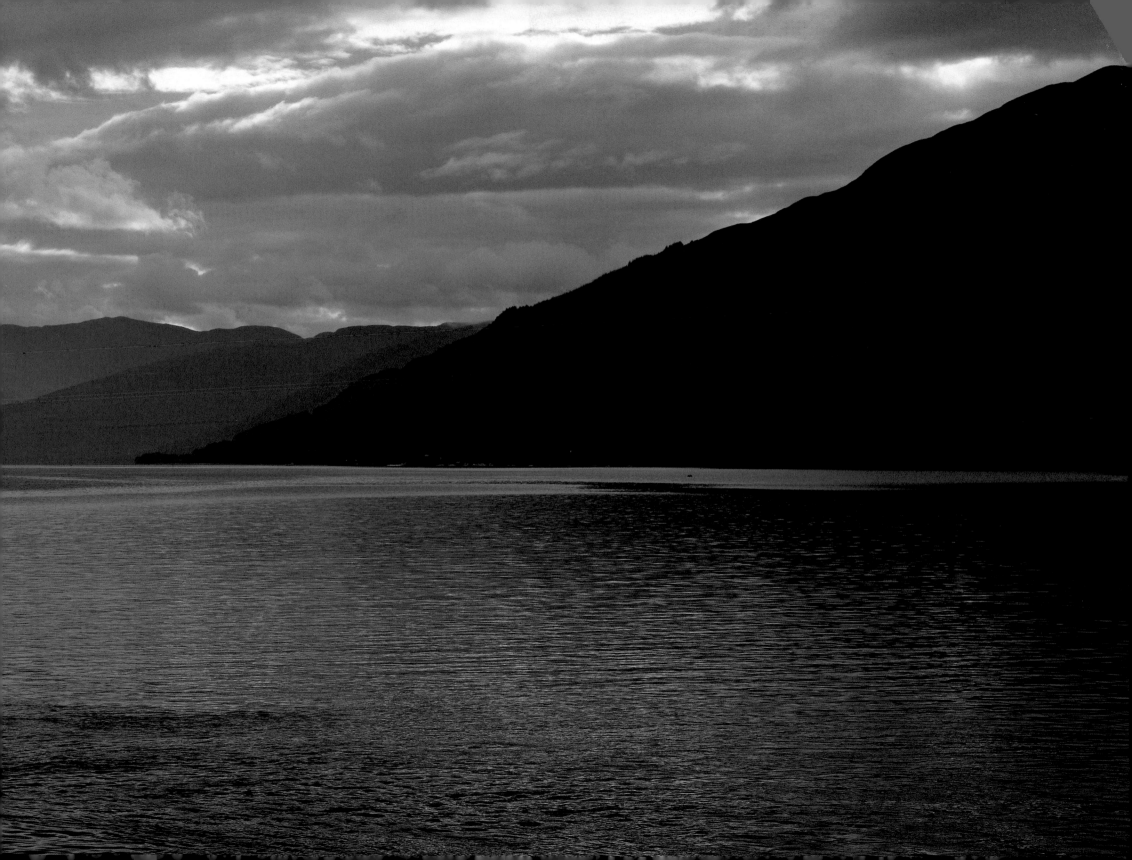

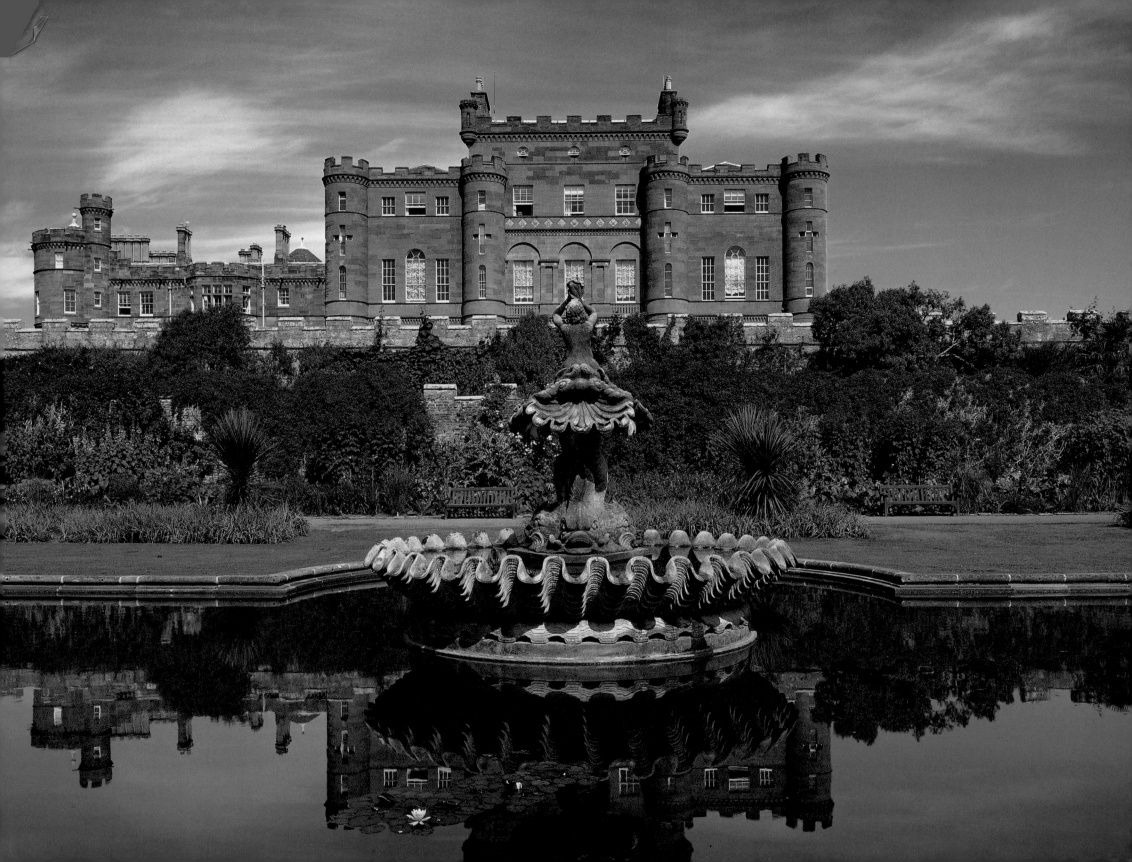

CASTLES AND GARDENS

Scotland's castles are famous. From impressive country homes such as Culzean to the military might of Edinburgh, and from the romance of Eileen Donan to the ruins of Urquhart on the banks of Loch Ness, there is a castle to suit all occasions. The reasons for this plethora of castles are many and varied. Some, such as Dundonald and Linlithgow, were royal foundations, while others, such as Dumbarton and Stirling, were built for reasons of defence. Others still were fortified homes. Dean Castle in Ayrshire and Crathes Castle in Aberdeenshire are good examples of this.

When, in the 16th century, England moved toward comfortable homes, Scotland's ruling class was still building for defence. Some of the finest castles in the country date from the 16th and early 17th centuries, such as McLellan's Castle in Kirkcudbright (a fine fortified town house rather than a castle) and Craigievar in Aberdeenshire, which dates from 1626. It wasn't until the late 17th and early 18th centuries that grand mansions such as Hopetoun House were built, or castles converted into stately homes.

Perhaps the two best known castles in Scotland are Edinburgh and Stirling, as both seem to sum up the country's military past. Edinburgh Castle came to prominence in the 11th century, when it became Malcolm III's favourite residence. St. Margaret's Chapel, the oldest building within the castle, dates from the 12th century, and is dedicated to King Malcolm's wife. It was probably built by their son, David I.

Stirling is Scotland's most strategically positioned castle. It guards that narrow waist of land between the Clyde and the Forth, and anyone wishing to travel north had to pass it. In 1314, when it was held by the English, the Scots laid siege to it. It was agreed that if an English force did not relieve the castle by the middle of June, then its governor would hand it over to the Scots. An English army led by Edward II of England was duly sent, but was defeated at Bannockburn. This battle was the turning point in Scotland's fight for independence from its southern neighbour.

By the late 17th century, Scotland was at peace, and work could begin on creating fine residences. From this period comes Drumlanrig in Dumfriesshire, home to the Duke of Buccleuch and Queensberry. A century later Robert Adam was engaged on designing an elegant new residence on the Ayrshire coast for the Kennedy family – Culzean Castle. This is undoubtedly Scotland's most impressive conversion of an old defensive tower into a family home.

Balmoral came much later, when Prince Albert bought the Highland estate in 1852. The existing castle was considered too small, so a new one was built close by. It is still privately owned by the Queen, and one of her favourite residences.

In Scotland, castles and gardens went hand in hand. Perhaps the finest example of the old-style Scottish formal garden is Edzell in Angus, originally created by Sir David Lindsay in 1604. As well as plants and shrubs, it features extraordinary carvings showing heraldry, the liberal arts, deities and the cardinal virtues. Another fine castle garden is the one at Pitmedden in Aberdeenshire, laid out in 1675 by Sir Alexander Seton. It was replanted in the 1950s with 30,000 annuals and more than 5 miles (8 km) of boxwood hedges, creating intricate floral designs.

However, it is no coincidence that most of Scotland's great gardens are on the west coast. Thanks to the Gulf Stream, temperatures are higher than other parts of the country, and there is more rain. Some unexpected species thrive quite happily here, and more than one visitor to southwest Scotland has been surprised to see palm trees flourishing.

Logan Garden in Wigtownshire has been described as "Scotland's most exotic garden". It is part of the Royal Botanic Garden, and on a sunny day you would almost believe you were in the southern hemisphere. Palm trees vie with plants from Australia, New Zealand and Chile. The great "Gunnera Bog" has plants from southern Brazil, with leaves 6 ft (2 m) across and stems 9 ft (3 m) high.

There's a cluster of gardens in this area, including Glenwhan, Castle Kennedy and Ardwell. Glenwhan is modern, work having started on it in 1979. Castle Kennedy sits between two lochs, and contains two castles, Castle Kennedy itself, which is a romantic ruin, and Lochinch Castle, completed in 1864. Ardwell Gardens surround an

ABOVE
Servants' Bells
The great families of Scotland's stately homes had servants to look after their every need. Here we see the bells in the servants' quarters of Hopetoun House. Each bell was labelled with the name of the room where the bell pull was located.

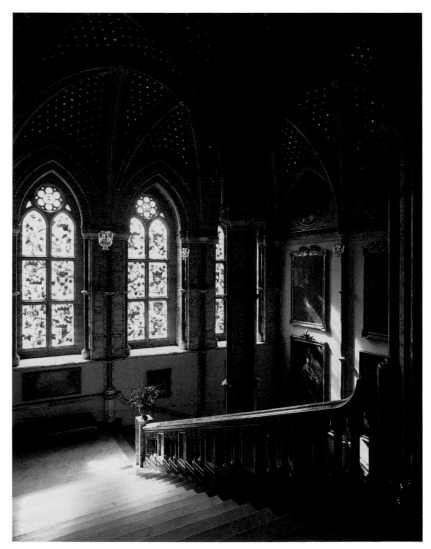

OPPOSITE
Culzean Castle
Built in the late 1700s, and majestically perched on a cliff above the Firth of Clyde, Culzean is the most visited of all the National Trust for Scotland's properties. In 1945 the NTS, to show Scotland's gratitude for General Eisenhower's leadership during World War II, presented him with the life tenancy of a flat within the castle. He stayed there several times, once when he was President of the United States.

ABOVE
Mount Stewart
One of the necessities of a stately home was an imposing and grand entrance with which to impress visitors. This photograph shows the staircase leading up from the hall in Mount Stewart on the island of Bute. It was built by the 3rd Marquis of Bute in Victorian times to replace an earlier building destroyed by fire, and is one of the finest Gothic Revival buildings in the country.

18th-century house, and are noted for their azaleas, camellias and rhododendrons.

The Borders too have some fine gardens. In Melrose there is the walled Harmony Garden, attached to the sweetly named Harmony Hall and owned by the National Trust for Scotland. Across the road, next to the abbey ruins, is Priorwood Garden, again owned by the NTS. This is a specialist garden, as all the plants are suitable for drying.

By Victorian times, Scotland had fallen out of love with formal gardens, and preferred nature to appear untamed, flowers to grow untended, and paths to meander. This was the inspiration for the great gardens of the

Western Highlands, notably Arduaine and Inverewe. Arduaine, south of Oban, sits on a promontory, covers 20 acres (8 ha), and was laid out in 1898 by James Arthur Campbell. It has woodland walks and a water garden, and among its plants are rhododendrons, azaleas, blue Tibetan poppies and giant lilies.

Campbell was greatly influenced by Osgood MacKenzie, who laid out the 50-acre (20-ha) Inverewe Garden far to the north in Ross-shire. He began the work in 1863, and it surprises all who visit. We are on the same latitude as Northern Labrador, and yet we can see and enjoy flowers and plants from New Zealand, South Africa, Tasmania and Chile.

RIGHT
Dunrobin
The majestic yet elegant bulk of Dunrobin, seen from its gardens, looks more like a French château than a Scottish castle. At its core is a medieval fortress, converted in 1845 to a sumptuous home.

BELOW
Inverewe Garden
One of the most astonishing gardens in Scotland, northerly Inverewe benefits from the warm Gulf Stream and high rainfall, and is home to plants from places such as New Zealand and South America.

FOLLOWING PAGE
Castle Stalker
Set in a stunning location on an island in Loch Laich, the present Castle Stalker dates from c.1446. Owned variously by the MacDougall, Stewart and Campbell clans over the centuries, it was last rebuilt in 1975.

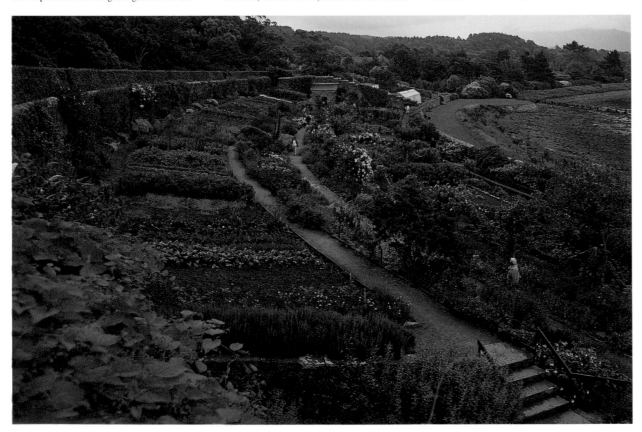

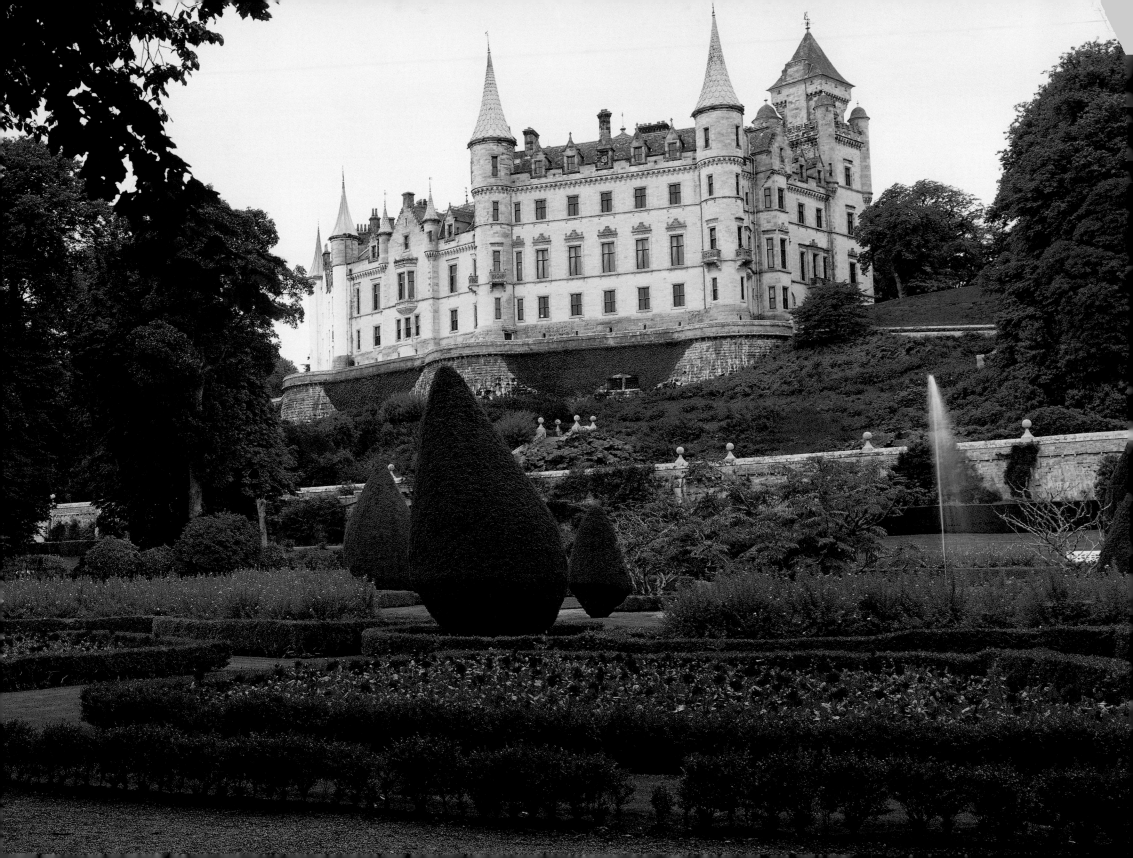

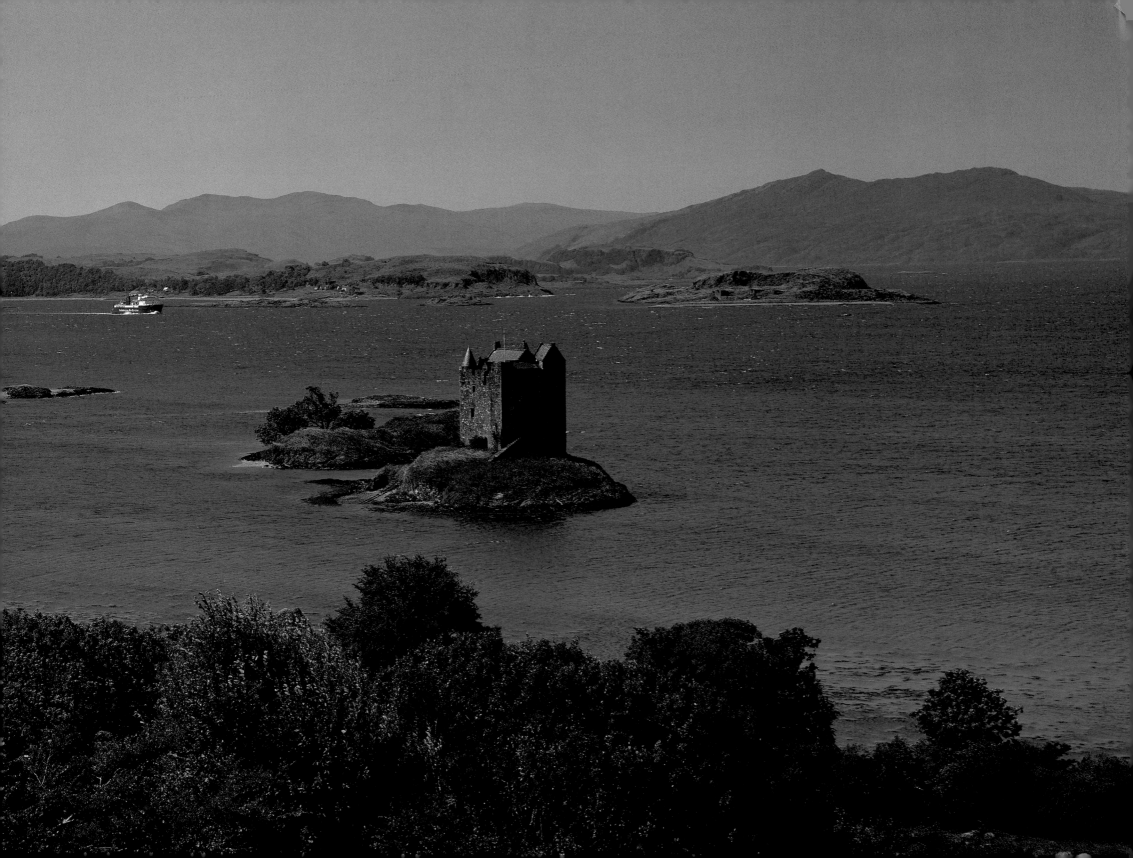

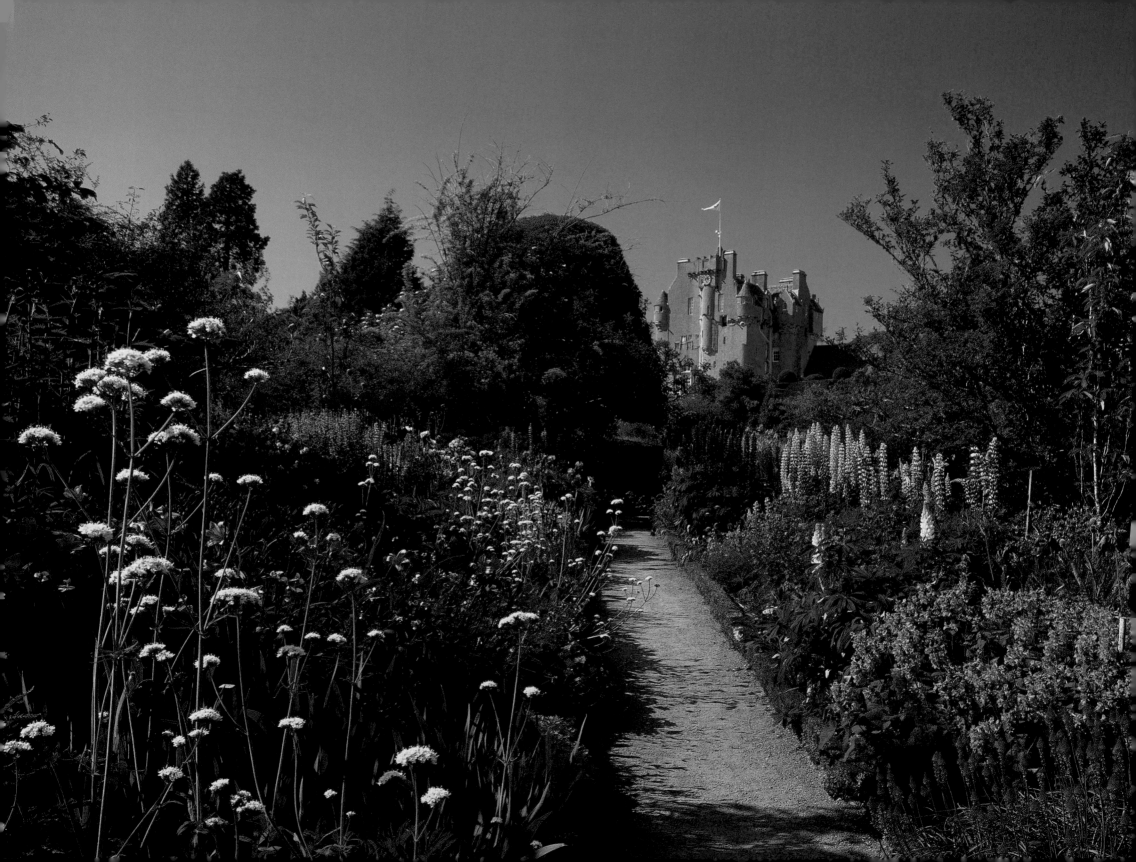

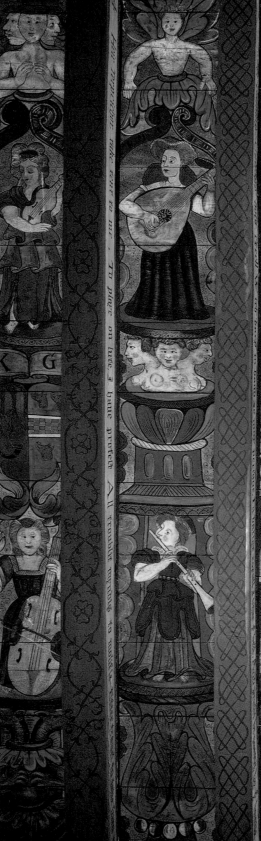

Crathes Castle

In 1323 King Robert the Bruce granted the Lands of Leys in present-day Aberdeenshire to the Burnett family for their support during the wars against the English. At the same time he presented the family with the jewelled Horn of Leys, which can still be seen in the castle's Great Hall. In the 16th century the present L-shaped castle was built, a fairy tale concoction of turrets, corbels, small windows and high, sheer walls. It was gifted to the National Trust for Scotland in 1951 by Sir James Burnett of Leys.

LEFT

The Painted Ceilings of Crathes Castle

The interior of Crathes Castle retains many of its original features, the most famous being the Jacobean painted ceilings. They can be seen in the Chamber of the Muses, the Chamber of Nine Worthies and the Green Lady's Room, which also has that other prerequisite for a genuine Scottish castle – a ghost. The ceilings were subsequently covered over and then rediscovered in 1877. Now they have been restored to their original glory.

FOLLOWING PAGE LEFT

Graigievar Castle (exterior)

This neat concoction of pepper pot turrets, small windows and high walls was built by William Forbes, an Aberdeen merchant, in 1626. For nearly 350 years the castle remained occupied by Forbes' descendants, until, in 1963, it was presented to the National Trust for Scotland.

FOLLOWING PAGE RIGHT

Graigievar Castle (interior)

The castle's crowning glory is its superb plasterwork ceilings. This photograph shows the hall, where the ceilings depict heraldry, biblical characters and leaves, along with the arms of William Forbes and his wife Margaret Woodward.

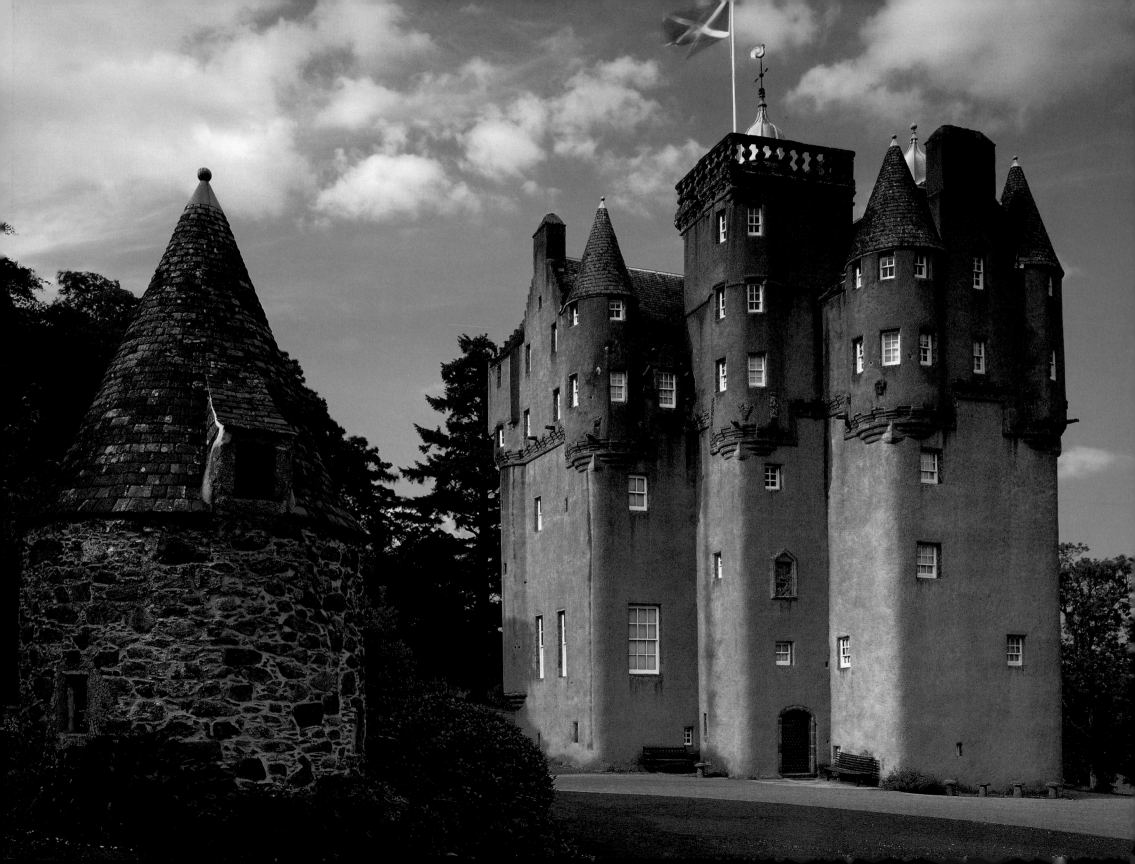

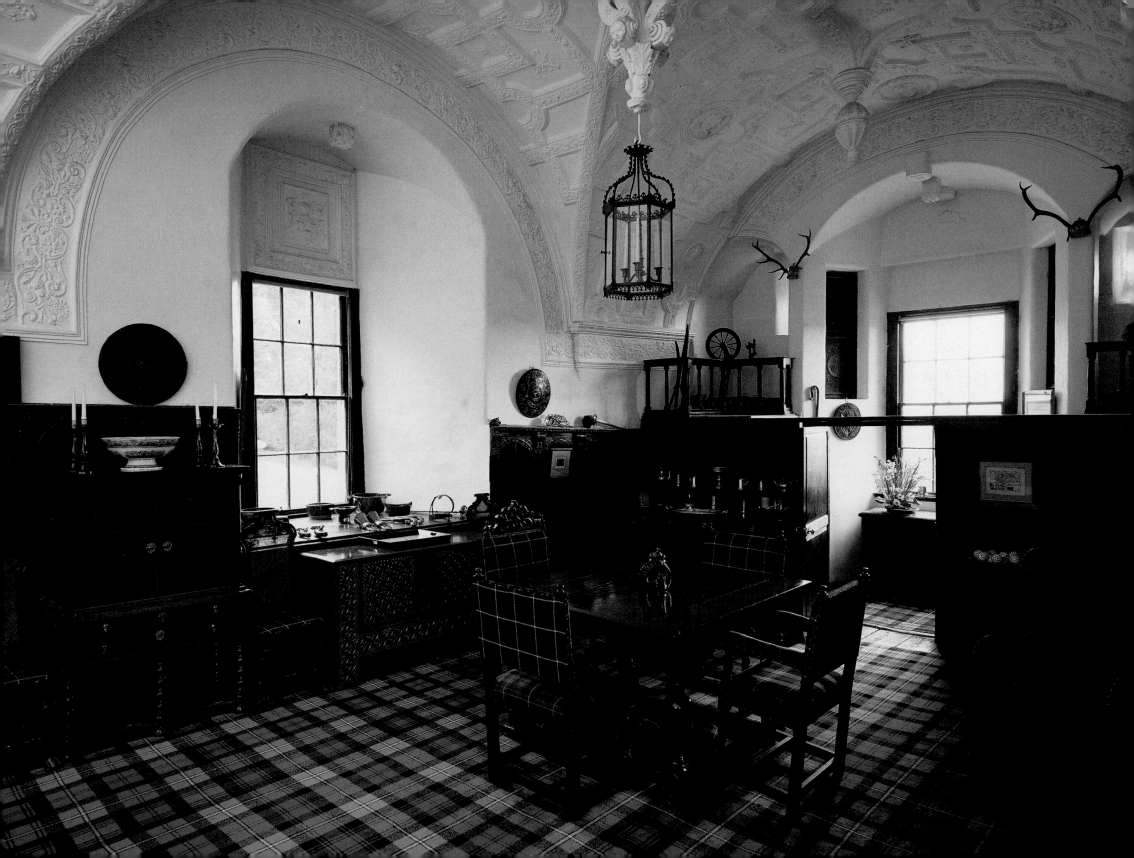

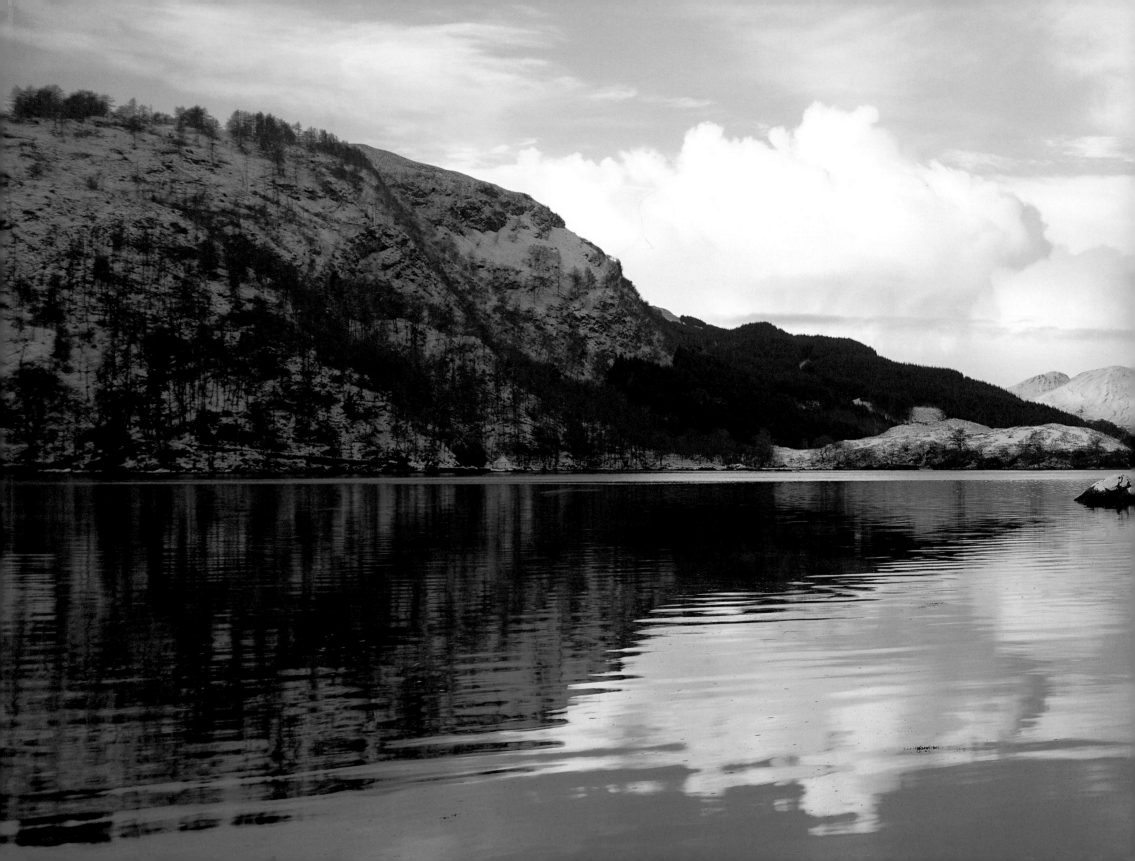

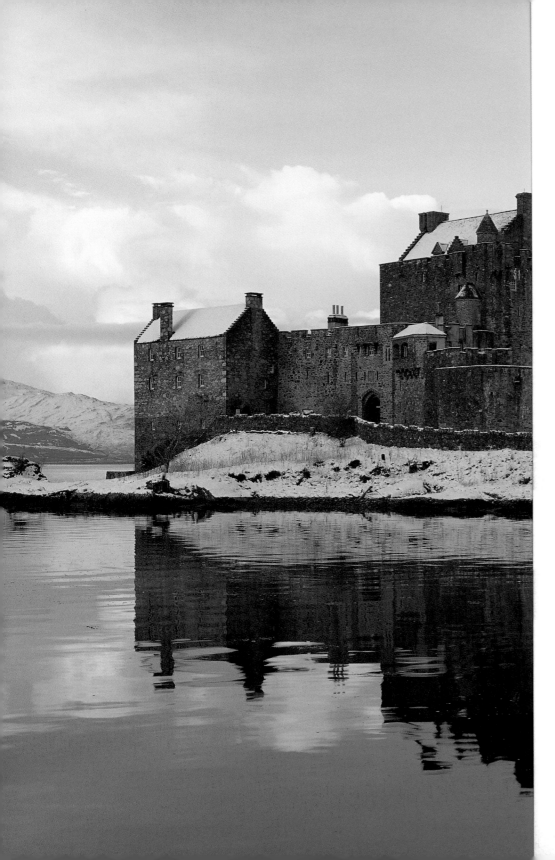

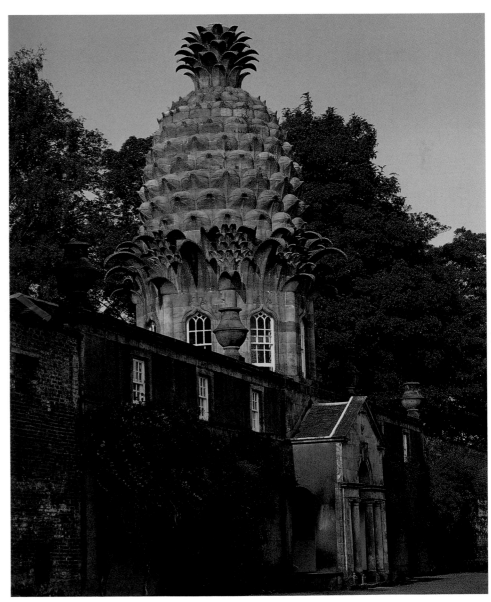

OVERLEAF, FOLDOUT
Eileen Donan Castle

Some castles seem to sum up Scotland as a place of
high romance, and Eileen Donan is one of them. Built
in the early 1200s, it now belongs to Clan Macrae,
and houses a small clan museum within its walls.

ABOVE
The Pineapple House

Built in 1761 by former governor of Virginia in
North America, John Murray, the Earl of Drummore,
the bizarre 45-ft (14-m) tall Pineapple was originally
a centrally heated summerhouse.

87

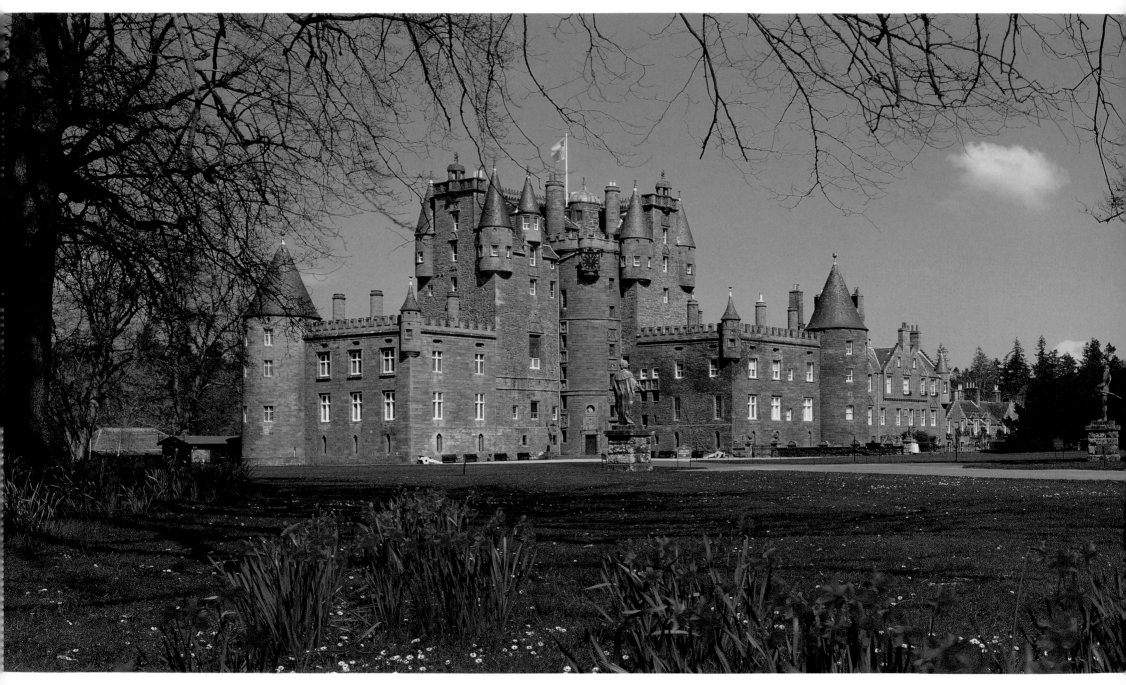

LEFT

Glamis Castle

Glamis (pronounced "Glams") Castle is the seat of the Bowes-Lyon family, Earls of Strathmore and Kinghorne. Its most famous member was Queen Elizabeth, the Queen Mother, who spent her childhood here. Glamis has many royal connections. Malcolm III of Scotland (c.1031–1093) died in a previous castle that stood on the site; Princess Margaret, late sister of Queen Elizabeth II, was born here in 1930, and, according to Shakespeare, Macbeth, King of Scots, was Thane of Glamis.

RIGHT

Glamis (detail)

Although a castle has stood on the site for over 1,000 years, the present Glamis Castle, with its wealth of architectural detail, such as seen on this door, dates from the 15th century, with many later additions. The castle is famous for its ghosts and legends, and is said to have a secret room, the access to which is known only to the Earl of Strathmore and his heir. In *Macbeth*, Shakespeare set the murder of Duncan in Glamis Castle, although in fact the foul deed took place far to the north near Elgin.

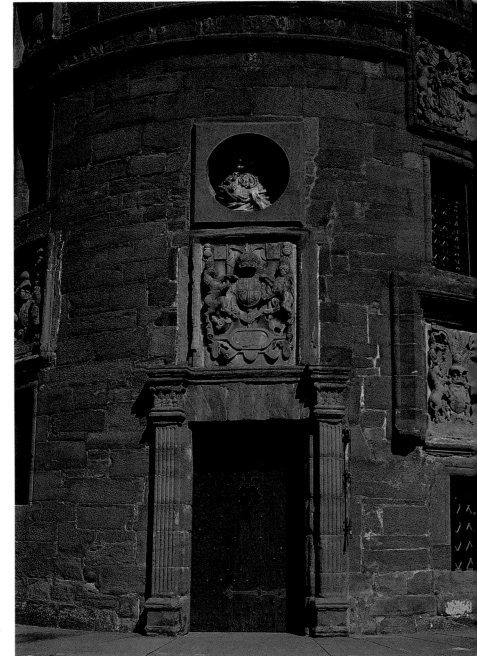

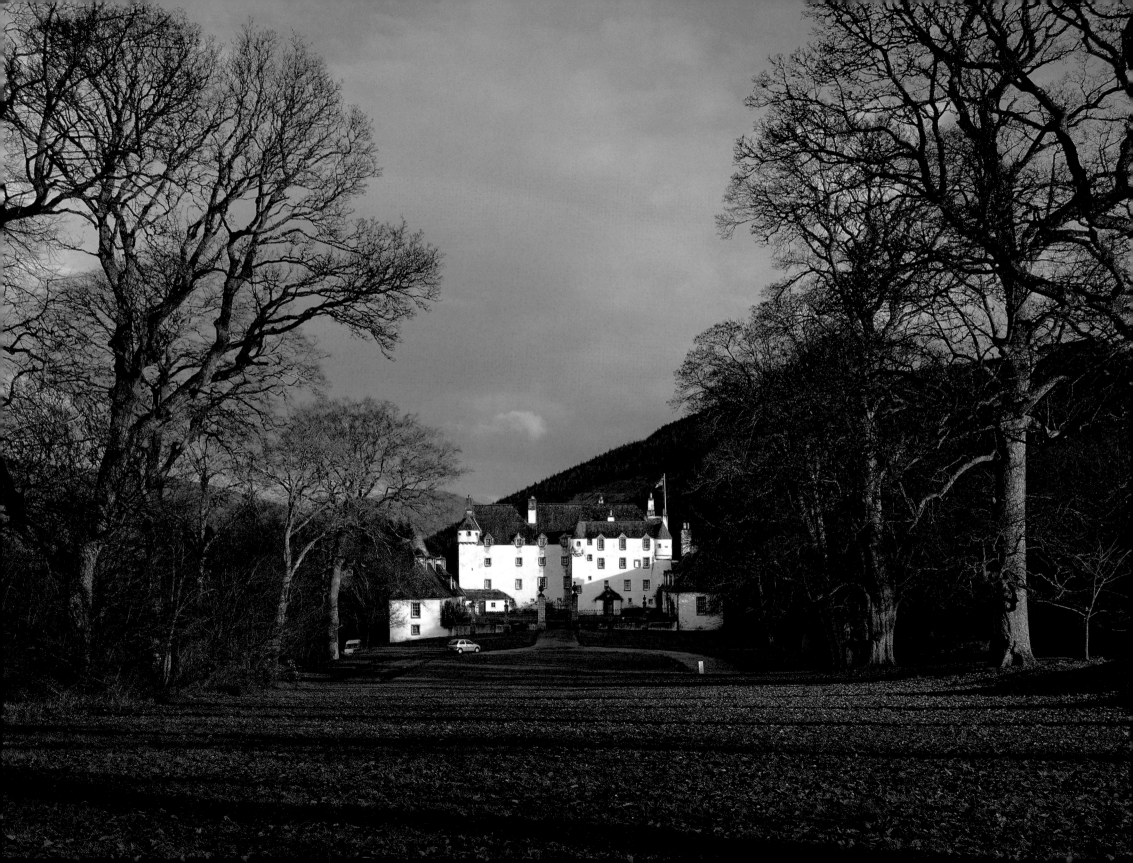

OPPOSITE

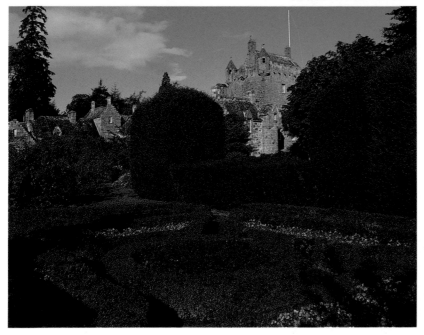

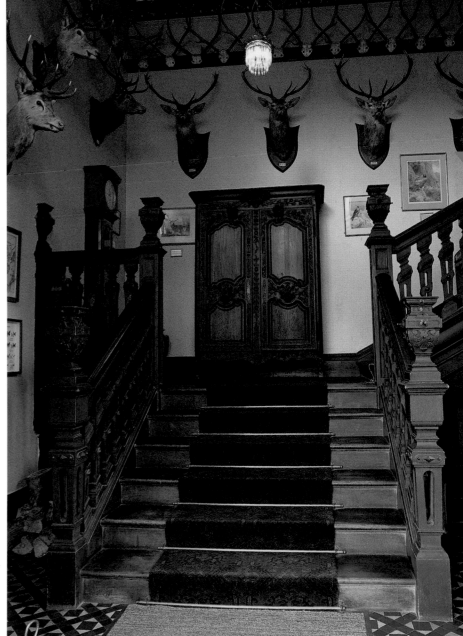

Traquair

Said to be the oldest continuously inhabited house in Scotland, Traquair, in the Borders, started off life as a hunting lodge for Scottish kings and was built c.950CE. Mary Queen of Scots slept here, and her bed can still be seen. So, too, did Bonnie Prince Charlie, as the owners, the Earls of Traquair, were fervent Jacobites. When the Prince left the following morning, the first Earl closed the great Bear Gates at the entrance to the driveways and vowed they would never again be opened until a Stuart ascended the throne once more. They have stayed closed ever since.

Cawdor Castle

Like Glamis Castle, Cawdor is mentioned in Shakespeare's *Macbeth*, where the king is hailed by the witches as Thane of Cawdor. The present castle, however, dates from the 14th century. Legend says that the original tower house was built round a hawthorn tree after its builder, Thane Andrew, set a treasure chest on the back of a donkey and vowed to build his castle where it rested at night. The animal sank down beneath the tree, and Andrew duly built his castle there. The tree can still be seen in the castle tower, but it is in fact a holly.

Torosay Castle (exterior)

Some Scottish castles are not all they seem. One such castle is Torosay, on the island of Mull. It looks as if it has stood for centuries, but in fact it was built in Scottish baronial style in 1858. It is the only castle in all Scotland with its own private railway – a narrow gauge track connecting it to the pier at Craignure, the terminal for the Oban ferry.

Torosay Castle (interior)

Although the castle is modern, Torosay's interiors still hark back to olden times, with the antlers, the Gothic detail, the heavy furniture, the dark wood and the ancestral portraits hanging from the walls. The house was a favourite holiday haunt of Sir Winston Churchill, and some memorabilia connected to his stays here are on display.

The Old Royal Station, Ballater

The railway came to Deeside in 1853, when the line between Aberdeen and Banchory opened. In 1866 it was extended to Ballater, which became the western terminus. At first Ballater Station was a simple affair, but Queen Victoria had a royal waiting room added, as this was the nearest station to Balmoral Castle, and it soon became known as Royal Ballater Station. The station saw many famous people pass through it, including royalty, statesmen and politicians. It finally closed in 1966, but has now been refurbished as a tourist office and restaurant.

Crathie Parish Church Signboard

While in England, the kings and queens of Great Britain are heads of the Church of England, but when in Scotland they are mere members of the Church of Scotland, which, at their coronations, they take an oath to preserve. While staying at Balmoral, the Royal Family worships at Crathie Parish Church, and their Sunday visits attract many tourists.

Tourist Signs

Royal Deeside is firmly on the Scottish tourist trail, thanks to Balmoral Castle, the Queen's holiday home. Its outstanding beauty attracted Queen Victoria in the early 19th century, and even without its royal associations, it would still attract many people today.

Crathie Parish Church

The church where the Queen worships when at Balmoral is surprisingly modern. It was built as late as 1895 to replace a church that itself replaced the 13th-century Church of St. Monire, the ruins of which stand in its kirkyard. However, it is still a beautiful building, with an interior that contains much fine woodwork, stained glass and royal memorials. Queen Victoria is said to have enjoyed the simple worship found in the Church of Scotland in contrast to the more formal worship she was used to in England.

Balmoral Castle

This castle is not an official residence of the Royal family. It is privately owned by them, and used as a much-loved holiday home. It was bought by Prince Albert in 1852, soon after Queen Victoria fell in love with the Highlands, although the castle that then stood in the 50,000-acre (20,243-ha) estate was considered too small for their needs. So they commissioned William Smith, an Aberdeen architect, to design a grand new residence in the fashionable Scottish baronial style, which was completed in 1856.

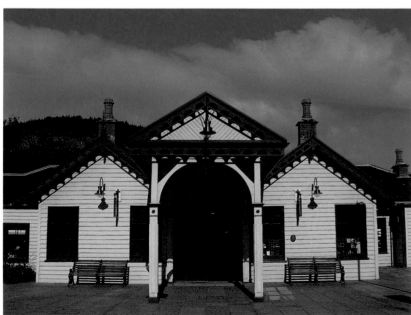

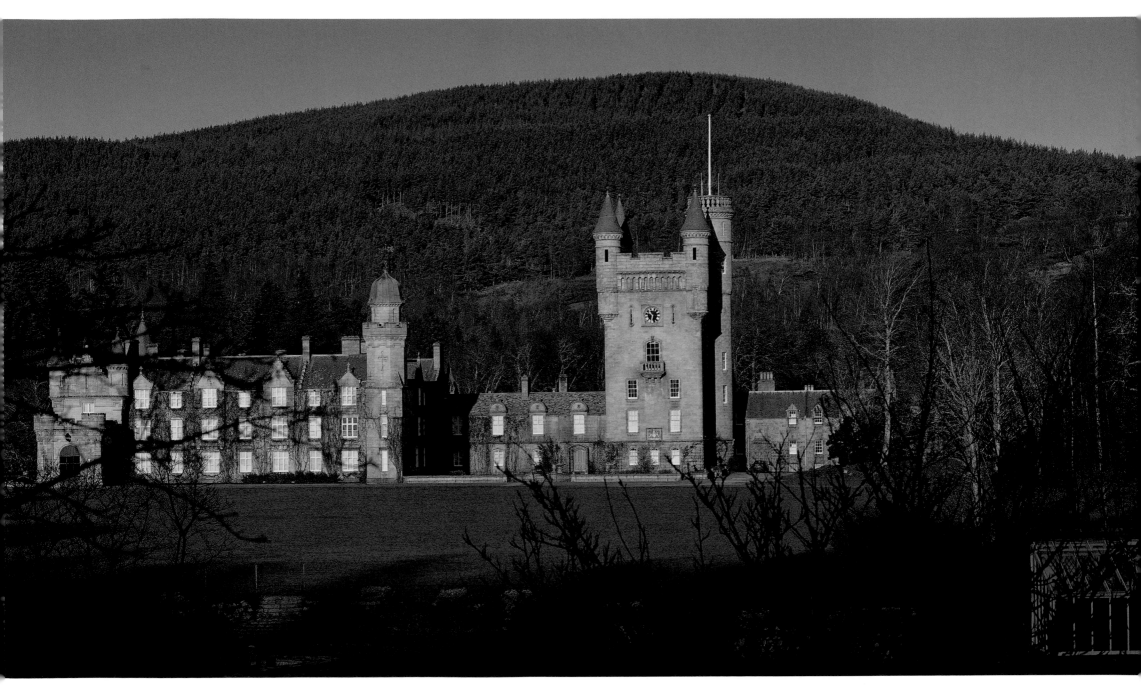

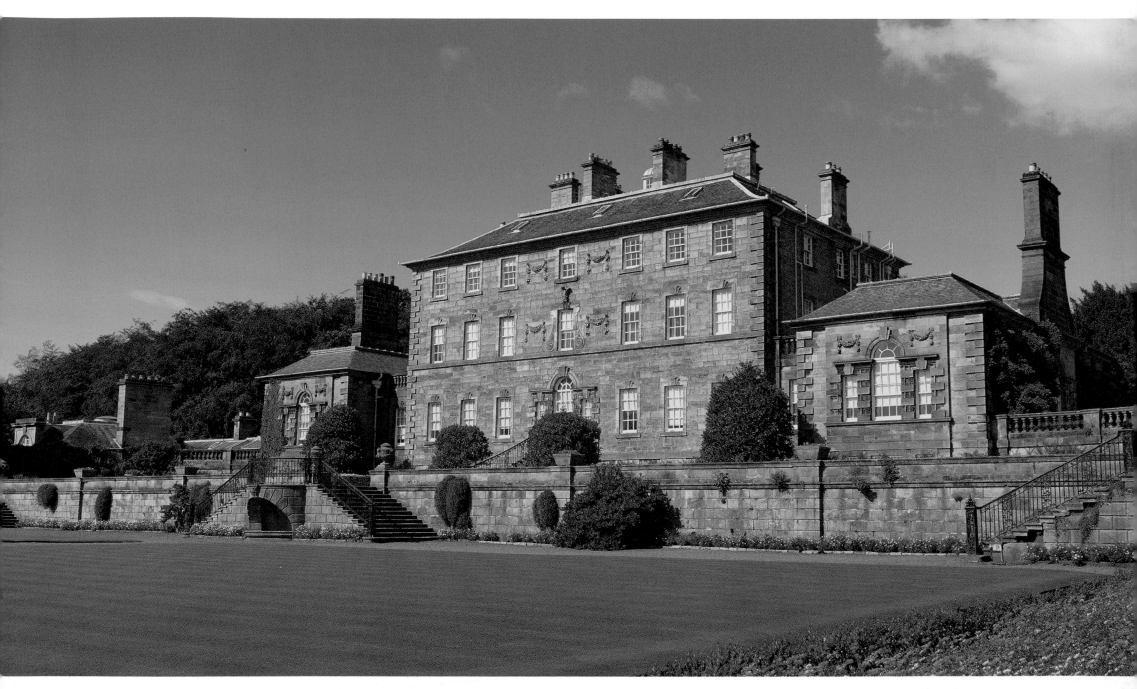

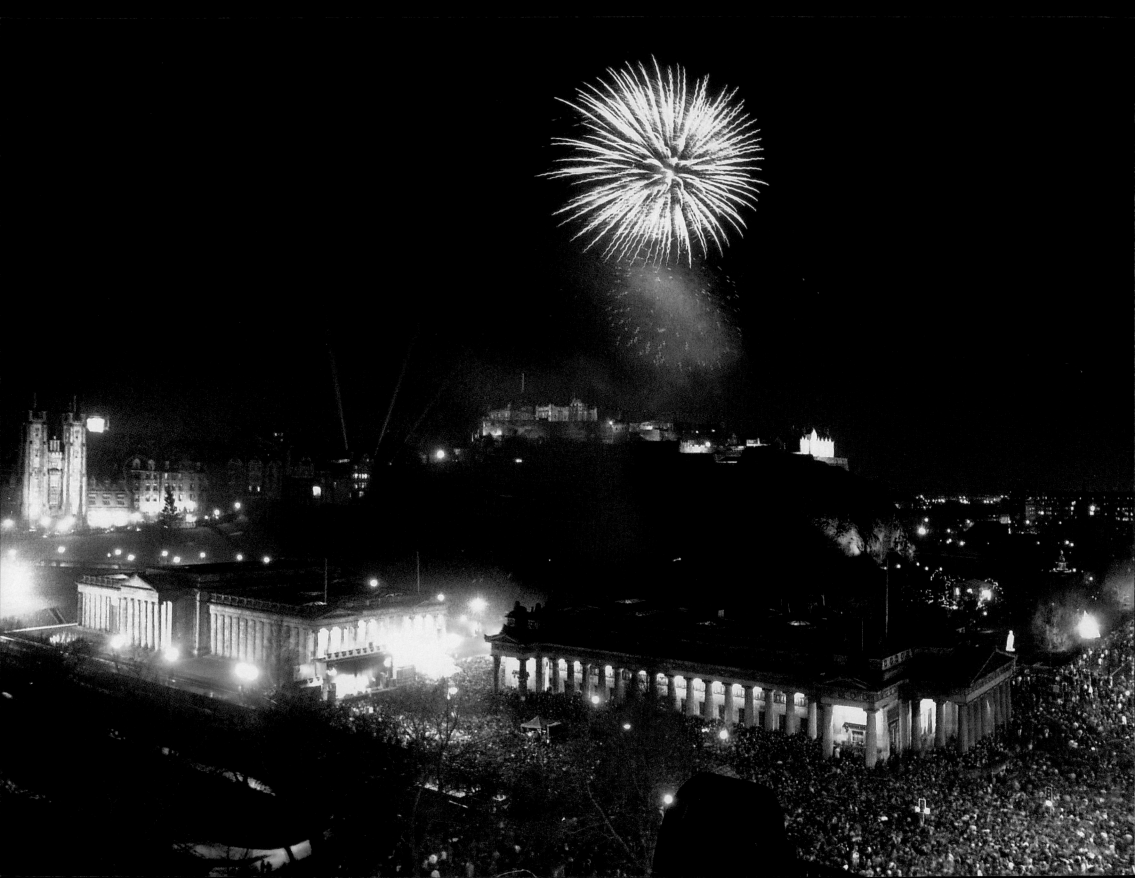

TOWNS AND CITIES

For a country that has so much empty space, it may seem strange that the majority of Scots live in towns and cities. The movement away from the land began during the Industrial Revolution, when people made their way to the industrial cities of Glasgow and Dundee, and, to a lesser extent, to Edinburgh and Aberdeen. This was also the time when industrial towns, such as Paisley, Motherwell and Coatbridge, saw huge increases in population.

Edinburgh and Glasgow are Scotland's largest cities. Edinburgh is the nation's capital, and has always been self-assured and complacent, fuelled by old money and tradition. "Fur coat and nae knickers" is a jibe often levelled at it, as it seems to value respectability over reality. Education – the law – banking – the church – medicine – these have been, traditionally, the fields that offered the most acceptable ladders to success in the city. It is the fifth-largest financial centre in Europe, and, now that Scotland once again has a parliament, is where the country's major decisions are taken.

During the Edinburgh Festival and its Fringe, the city becomes a different place – a hotbed of artistic endeavour, where every kind of entertainment from the excellent to the dire compete equally for the attention of the ticket-buying public. The Edinburgh Military Tattoo, held at the same time as the Festival, showcases Scotland's military traditions against the backdrop of Edinburgh Castle.

The Royal Mile tumbles down a ridge between the castle and Holyroodhouse, once the residence of Scottish kings. However, it's a queen that captures the imagination here – Mary Queen of Scots. Thrice married, and surrounded on all sides by intrigue and plot, she lived part of her life within its walls.

In the late 18th century, the city broke free of its medieval confines and expanded northward, creating the New Town, an elegant suburb that gave the moneyed classes the chance to escape from the disease and overcrowding of old Edinburgh. This was gracious living on the grand scale, with wide streets, and spacious gardens and homes, where the upper classes could live and take the air without having a chamber pot emptied on their heads from an upstairs window – up until then, this was Edinburgh's recognized way of sewage disposal.

Glasgow is different. It has never been ashamed of earning money or flaunting it. Even today it values fashion over tradition. Versace and Armani rule, and image is all. It started life as an ecclesiastical centre, grouped around the medieval cathedral, then became a place of trade. This in turn led to engineering, and finally to the service industries. In recent years, it has become chic and fashionable, full of theatres, opera, shops, nightclubs, pavement cafés, concert halls, restaurants and pubs.

It is the birthplace of Charles Rennie Mackintosh, a man whose designs epitomize the "Glasgow style". Of course, there is also his money-making potential, and no souvenir shop in the city is complete without a range of Mackintosh-inspired jewellery, crockery and tacky gewgaws. It is perhaps a small price to pay for his genius, and there is still enough authentic Mackintosh around to show us what he really achieved. The Glasgow School of Art is possibly his best-known work. Designed in 1896 in the art nouveau style, even today it fulfils its function as a working college of art. Another of his designs is Scotland Street School, on the south side of the city. In the late 1970s this school was closed down, and now it is a museum of education.

OPPOSITE
Hogmanay
Until the 1940s, New Year ("Hogmanay") in Scotland was a bigger event than Christmas. Today, Christmas predominates, although Hogmanay is still important. The major cities hold street parties, and here we see the largest, held in Princes Street, Edinburgh.

LEFT
The Royal Mile
Edinburgh's Royal Mile is, in fact, a series of streets – Castlehill, Abbey Strand, the Lawnmarket, Canongate and High Street. The Lawnmarket was where the city mercers sold linen and other textiles.

BELOW
The Pipe Band
No celebration, protest or major sporting event is complete in Scotland without a pipe band. Although not playing any instrument, the pipe major always leads a marching band, throwing and twirling his baton, or "mace" in the air as he does so. This is known as "flourishing". He also uses the mace to give drill commands, as no voice could ever be heard above the noise of the bagpipes!

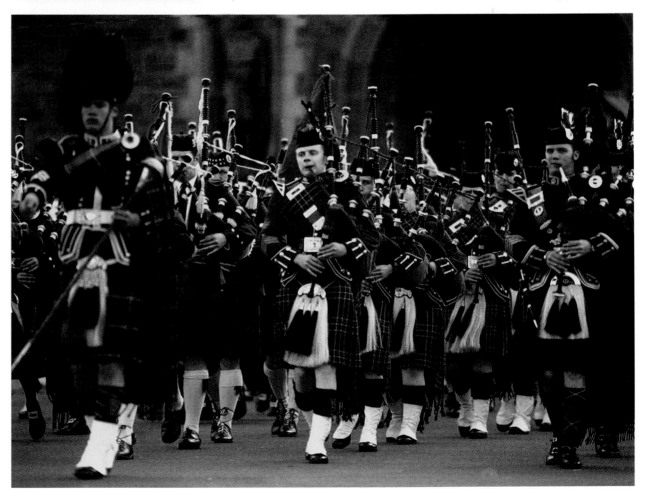

Of course, the above comments on Glasgow and Edinburgh are generalizations. Edinburgh, too, has its nightclubs and theatres, and Glasgow has its financial sector and its history. But like all generalizations, there is an element of truth in them. If it's history and medieval architecture you want, head for Edinburgh. If it's café society and razzmatazz, head for Glasgow. If you want both – well, the two cities are only 40 miles (65 km) apart.

Although the "big two" dominate, Scotland has other cities. Aberdeen is famously the oil capital of Europe, and it's harbour throngs with vessels supplying the North Sea oil platforms. Though not as cosmopolitan as Edinburgh or Glasgow, it still rings with foreign accents – notably American – and a burgeoning nightclub and restaurant scene.

Dundee, for all its history, is an industrial city that was once famous for the "three Js" – jam, jute and journalism. The most famous jam factory was that of James Keiller. The story goes that in the late 1790s his mother invented marmalade, and he founded a business to exploit this in 1797. The business was a roaring success and went on to produce all manner of preserves, jams and jellies.

Raw jute was imported from India, with the Dundee mills transforming the material into carpet backing, ropes, upholstery linings and sailcloth. The industry is commemorated in the Verdant Works, one of the finest industrial museums in Scotland. And journalism still survives today in the form of D.C. Thomson, publishers of the Dandy and Beano, one of the most widely read children's comics in the world. The company also publishes many magazines and newspapers.

Inverness was proclaimed a city in 2000. Often called the "capital of the Highlands", it is one of Britain's fastest growing places.

Although it has a population of no more than 50,000, the range and quality of its shops are impressive, and to cap it all it has the Highlands on its doorstep.

Stirling is Scotland's sixth, and smallest, city, granted its charter in 2002. Although it has a population of just 35,000, it is one of the country's most historic places, with a castle guarding the main route north. The defining battle in Scotland's history, the Battle of Bannockburn, was fought in 1314 just south of the city – Robert the Bruce defeated an English army that was heading north to relieve the English-held Stirling Castle.

There are those who claim that Scotland has two further cities. Up until local-government reorganization in 1975, Perth and Elgin had "lord provosts", meaning that they did indeed have city status. Did they revert back to being towns in that year? It's a moot point. Perth still calls itself the "Fair City", and Elgin has the impressive ruins of its cathedral, one of the largest in Scotland.

Scotland, up until recent times, didn't place much emphasis on city status. The greatest honour a town could have was to become a "royal burgh" – a settlement owing allegiance to only the monarch. There were many such burghs in the country – Linlithgow, where Mary Queen of Scots was born; Ayr, now a seaside resort; and Lanark, where William Wallace began his campaign to free Scotland from the yolk of England, are typical examples.

But there are other towns as well. Up until the early 1800s, Oban was no more than a huddle of cottages around a small bay. Now it is a holiday resort, and the main ferry port for the Inner Hebrides. Fort William grew from a fort established in the 18th century to keep the highland clans in check after the Jacobite Uprising. And Hamilton was where Hamilton

Palace once stood. It was the seat of the powerful Dukes of Hamilton, the premier ducal family of Scotland.

Then there are the industrial towns. Some are very old, such as Kilmarnock and Falkirk, while others – Grangemouth, Coatbridge, Motherwell, Airdrie – grew out of the Industrial Revolution. While not all of them are picturesque or quaint, these towns contributed so much to Scotland's prosperity, and all should be honoured as playing a part in the country's unfolding story.

BELOW
The Queen's Gallery
Queen Elizabeth II opened the Queen's Gallery in Abbey Strand, Edinburgh, in 2002 as Scotland's first permanent space to show off regularly changing exhibitions of paintings and other works of art from the Royal collection. Before it became a gallery, the building was a church and school.

OPPOSITE
Calton Hill
This is one of the best viewpoints in Edinburgh. On the summit is Scotland's memorial to the dead of the Napoleonic Wars – a vast Parthenon. Work started on the memorial in 1822, although money soon ran out and it was never completed, earning it the nickname "Edinburgh's shame". This picture shows the view along Princes Street, with, to the right, the monument to Dugald Stewart, an Edinburgh philosopher.

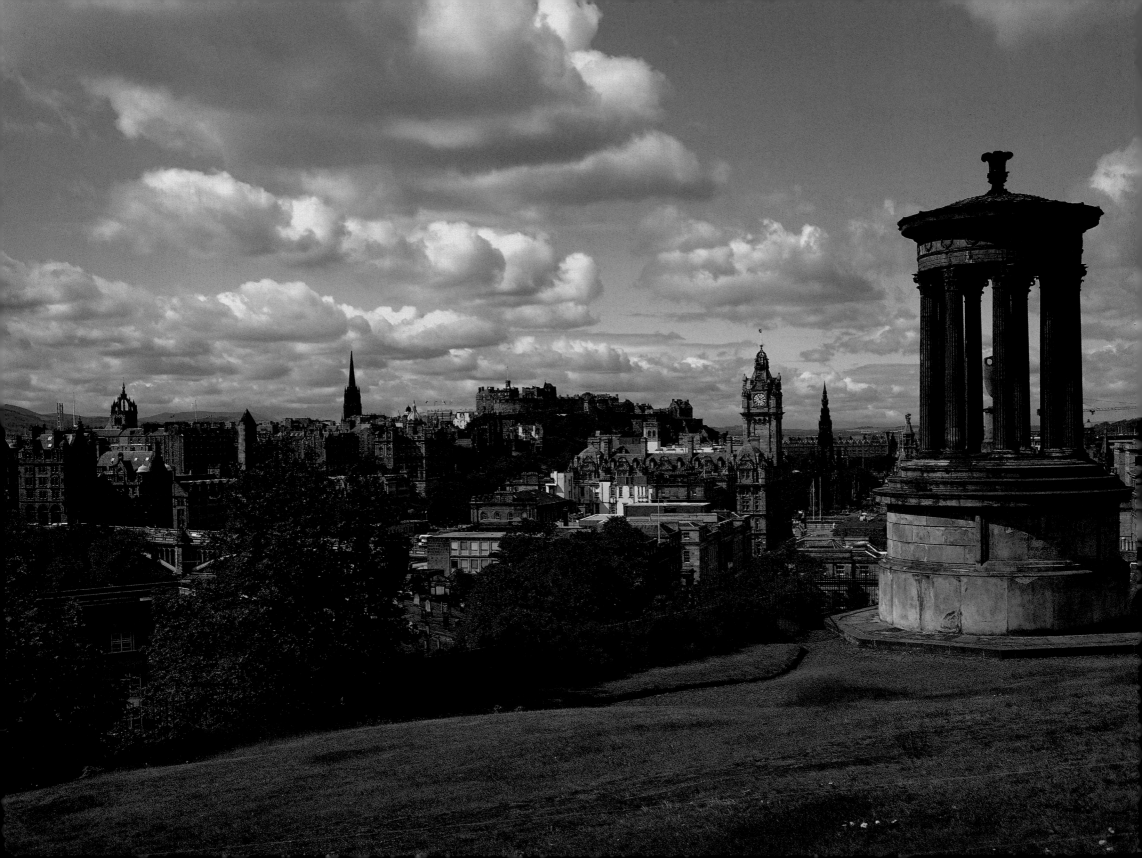

ABOVE

Edinburgh New Town

In 1766, a young architect called James Craig won the competition for the layout of an elegant new suburb – soon to become known as the New Town – to the north of Edinbugh's medieval core. There were to be formal gardens, wide streets and substantial homes to take the aristocracy and upper middle classes. The photograph shows an elegant curve of housing at Royal Circus.

RIGHT

The Dean Gallery

This is one of several National Galleries of Scotland, which are dotted around Edinburgh. It was opened in 1999 within what was the Dean Orphan Hospital, and contains the Galleries' collection of modern art, including works by the late Sir Eduardo Paolozzi, an Edinburgh artist who was created "Her Majesty's Sculptor in Ordinary for Scotland" in 1986.

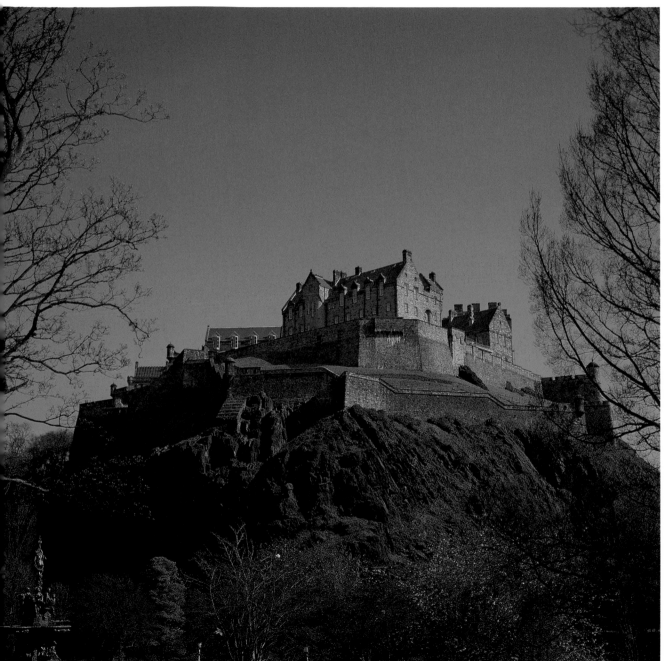

LEFT
Edinburgh Castle

Although not the most strategically important castle in Scotland, Edinburgh Castle's overpowering presence nevertheless defines the Scottish nation, as it stands proudly lording it over both the Old and New Towns. The castle is not one building, but a series of buildings contained within a curtain wall. The oldest building is St. Margaret's Chapel, which dates from the 12th century.

ABOVE
Royal Botanic Garden

Edinburgh's Royal Botanic Garden was founded in 1670 as a "physic garden" – a place to grow medicinal plants. Now it covers more than 70 acres (28 ha), and is one of the most important botanic gardens in the world, having – in one form or another – one in five of all the world's plant species.

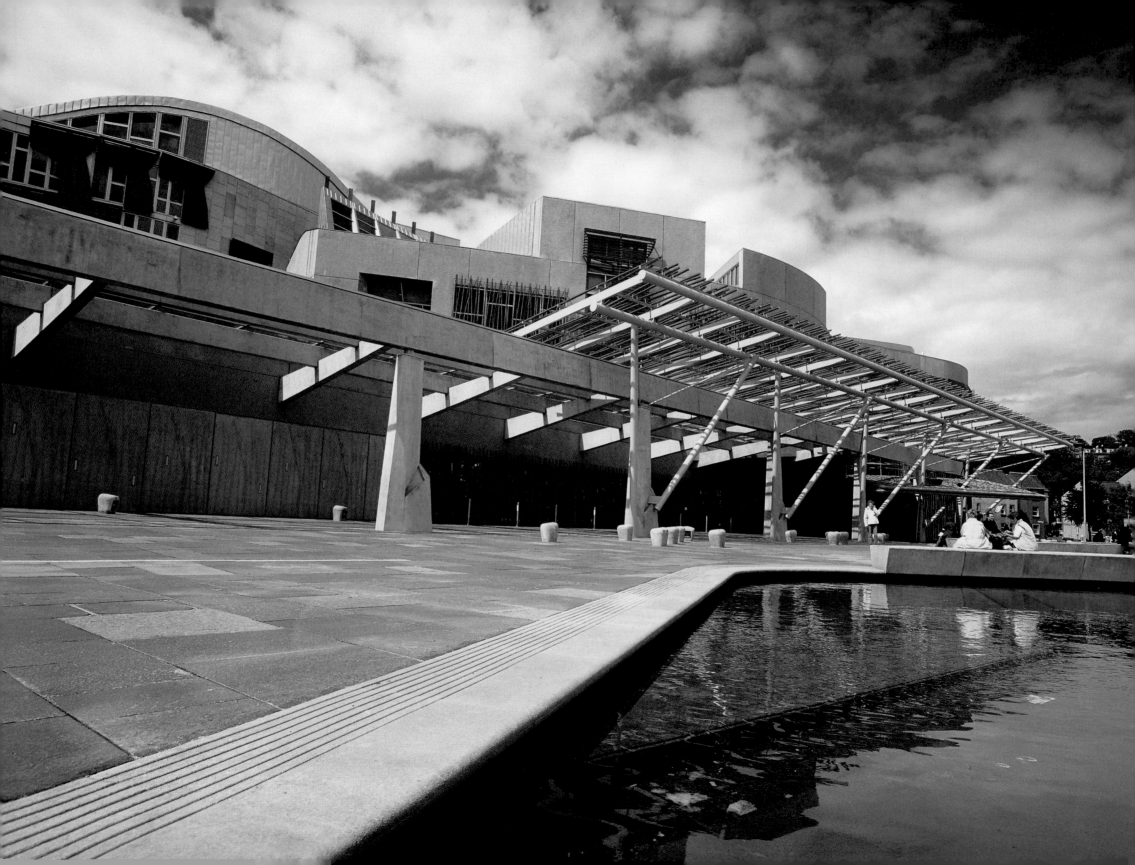

The Scottish Parliament

Although it is part of the United Kingdom, Scotland has had a devolved government since 1999. The Scottish Parliament building (opposite), was officially opened in October 2004, and has created a lot of controversy. Costing more than £431m ($796m), about nine times its original budget, it was designed by the late Barcelona architect Enric Miralles. Some people love the place and some people hate it. Much wood has been used on the outside of the building, as seen below in the windows of the MSP (Members of Scottish Parliament) building, where members of parliament have their offices.

Glasgow Science Centre

Located on the south bank of the River Clyde at Pacific Quay in Glasgow, the Glasgow Science Centre is a visitor attraction that combines entertainment and science. To the left of this photograph is the 400-ft (122-m) Glasgow Tower, which can revolve through 360 degrees, giving superb panoramic views from its observation platform. In the middle of the picture is the Science Mall, where there are many hands-on exhibits and a planetarium.

The IMAX Cinema

The Glasgow Science Centre also has an IMAX cinema with a huge screen measuring 80 ft by 60 ft (24 m by 18 m) and a 12,000-watt sound system. The building, seen here, is a futuristic concoction of titanium panels and glass with a snail-like shape that gives it great strength.

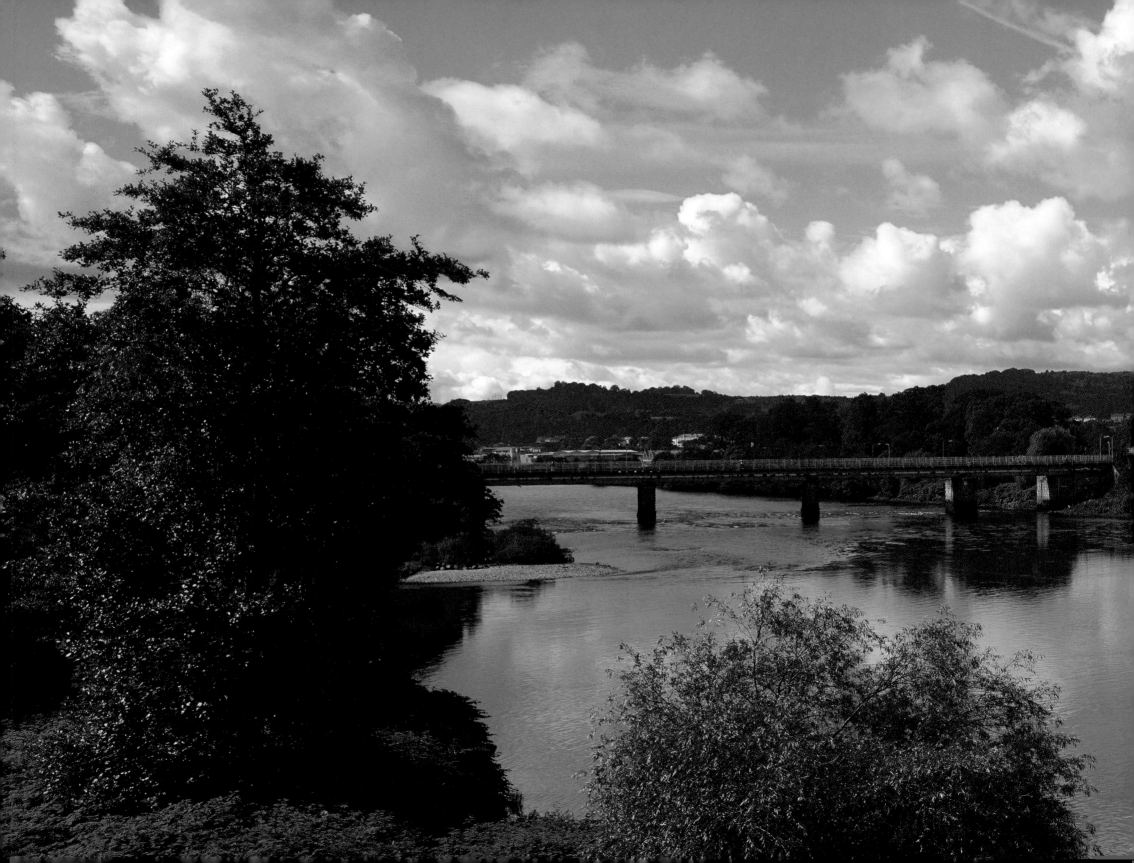

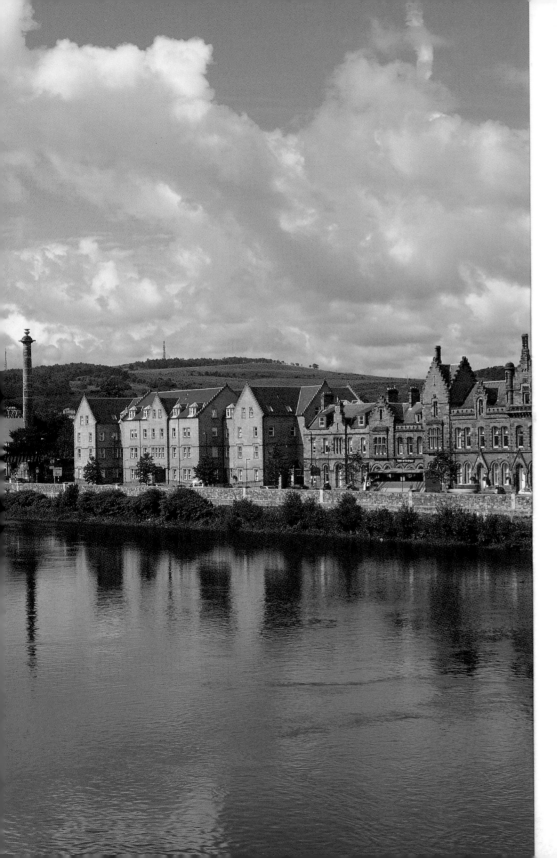

OVERLEAF, FOLDOUT
Perth
The "Fair City of Perth" sits on the River Tay. It is a prosperous place, full of shops and elegant housing, and home to the medieval church where John Knox sparked the Scottish Reformation in 1559 by preaching a fiery sermon.

ABOVE
The Discovery at Dundee
The RSS Discovery was the ship that took Captain Scott and his ill-fated expedition team to Antartica in 1901. It was built in Dundee, and came back to the city in 1986. Now the ship is the focal point of Discovery Quay, a tourist attraction.

109

RIGHT
Oban

The port of Oban ("Little Bay"), in Argyll, is blessed with an ideal position. It grew in the mid-19th century as an important holiday resort for Glasgow's middle classes owing to the arrival of the railway. Because it is built around a sheltered bay, it has become the main ferry port for the Inner Hebrides, giving it the nickname the "Gateway to the Isles".

FOLLOWING PAGE
The City Chambers, Glasgow

Glasgow was at the height of its industrial powers in the late 19th century. It was a city confident of its place in the world, and was often called the "second city of the Empire". So when the City Fathers decided to build new council chambers in the late 19th century, they did it on the grand scale. Opened in 1888, the building is right at the heart of the city. It oozes confidence and opulence – so much so that, in movies, its interior has stood in for the Vatican in *Heavenly Pursuits*, the British Embassy in Moscow in *An Englishman Abroad*, and a period New York interior in *The House of Mirth*.

RIGHT

The Willow Tearoom (exterior)

The famous Willow Tearoom was designed by Charles Rennie Mackintosh in 1904. It was refurbished and reopened in 1997, and welcomes diners and those seeking a refreshing cup of tea or coffee as it did all those years ago, when it was owned by Kate Cranston. She was Mackintosh's most prolific patron, and over a 20 year period he did work on her four Glasgow tearooms.

OPPOSITE

St. Andrew's Cathedral

Modern and traditional architecture sit happily side by side in Glasgow. Here we see, reflected in a modern office block, the outline of St. Andrews Roman Catholic Cathedral (built between 1814 and 1817) on the banks of the Clyde. The office block in which it is reflected is actually the cathedral offices.

BOTTOM LEFT

Glasgow School of Art

The Glasgow School of Art is architect and designer Charles Rennie Mackintosh's masterpiece. Sitting in Renfrew Street, it brings together everything that Mackintosh – who was born in the city – believed in, and its Art Nouveau lines, its confidence and its downright practicality have been admired ever since he designed it in 1896. Mackintosh is revered in Glasgow, and there are reminders of him everywhere.

BOTTOM RIGHT

The Willow Tearoom (interior)

Charles Rennie Mackintosh was not just an architect, he was a designer as well. Every aspect of the Willow Tearoom, for example, received his attention, from the exterior to the interior decor – the seating, cutlery, floor coverings, door fittings and crockery. It took its name from the name of the street it stood in – Sauchiehall Street, "sauchiehall" meaning "willow haugh".

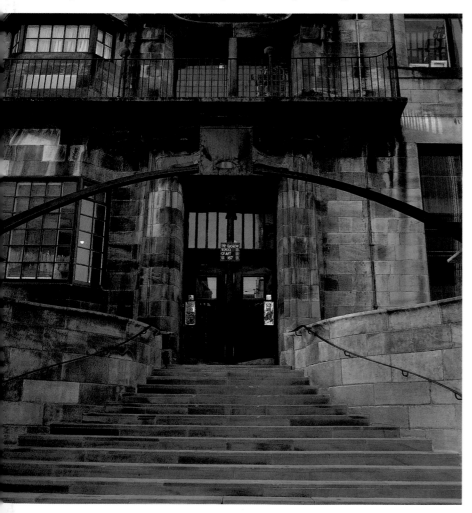

Victoria Park Garden

Glasgow has, in relation to its population, more parks that any other British city, the most famous one being Glasgow Green, a short walk east from the city centre. This photograph shows the gardens of Victoria Park in Jordanhill, to the west of the city, reckoned to be the prettiest of the city parks, and has the famous "Fossil Grove", where you can see the fossilized remains of trees that are millions of years old. They were uncovered in 1887 when the park was being laid out.

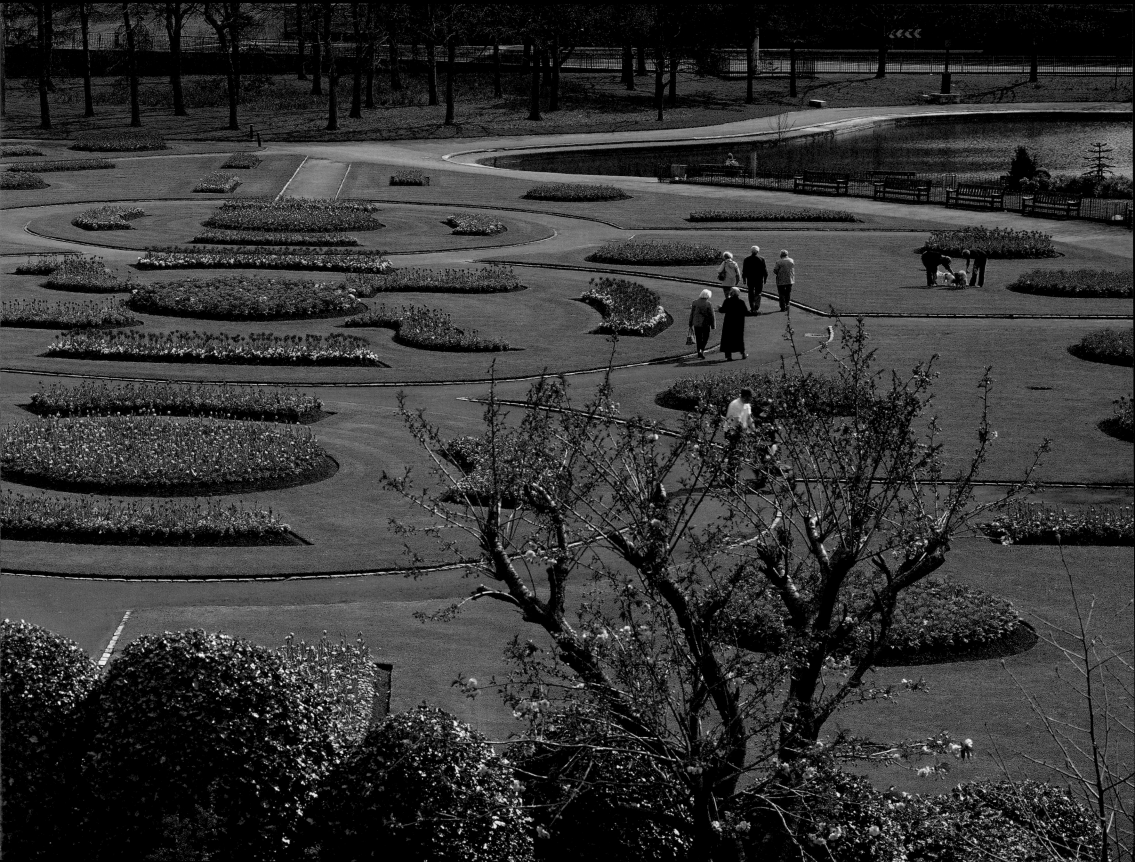

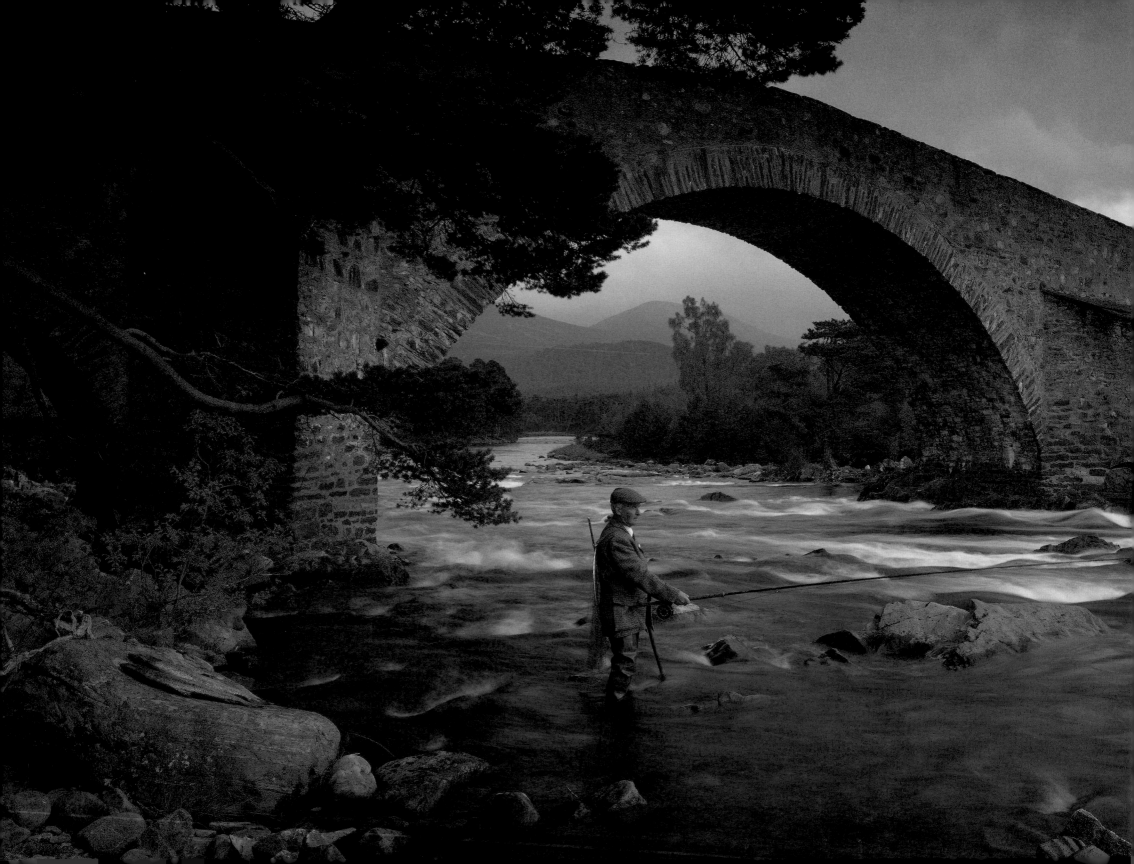

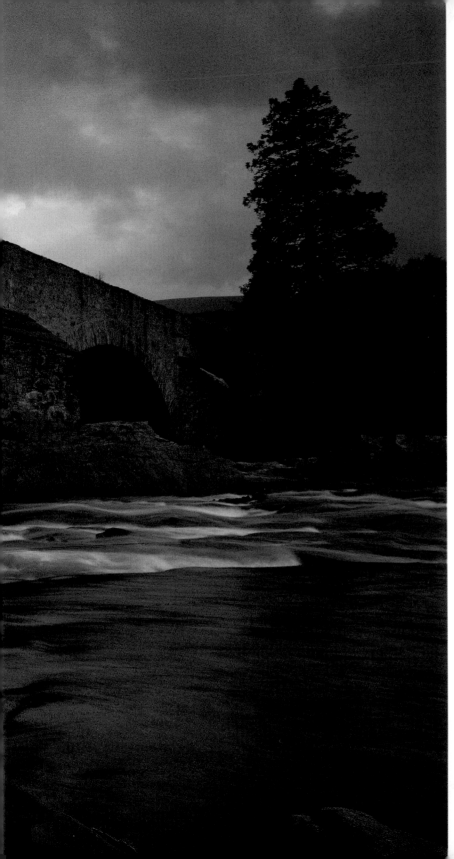

SCOTTISH LIFE

There are still Scots who become misty-eyed when they think of a wee cottage in a Highland glen, with a grey-haired old granny at the spinning wheel and a stream running past the front door. "Granny's Heilan Hame" is a powerful icon, even though today granny is more likely to be holding down a tough PR job in Edinburgh. This is because we Scots still hanker after our past and like to honour our traditions and heroes. Bonnie Prince Charlie – William Wallace – Robert the Bruce – Robert Burns – these are names that all set our pulses racing.

Take the bagpipes. Although not exclusively Scottish, we have claimed them as our own, and they are played everywhere. No village fête, or celebration or protest march is complete without a pipe band. And playing this unusual instrument is popular with the young, even though their preferred weekend entertainment is a mix of bars, throbbing clubs and pubs. Then there's tartan. It originated as a recognizable cloth during the 15th and 16th centuries, when its different designs denoted an area rather than a family. However, in the early 18th century, it became associated with specific clans, and it was gentrified in the 19th century when Queen Victoria discovered Scotland. Now young Scottish men have reclaimed both tartan and the kilt. But they do not necessarily wear the kilt as a piece of formal attire, what some Scots call the "full Brigadoon outfit". It has now become an item of leisure wear, worn with socks, boots and a shirt or sweater. Some purists disapprove, but young people rightly go their own way, pointing to the history of the garment and saying that it evolved from an everyday piece of Highland clothing.

And they are right. The original kilt was a belted plaid – a long piece of cloth wrapped round the waist with one end draped over the shoulder, all held in place by a belt. Gradually this evolved into the garment we know today, with Sir Walter Scott playing a big part when he designed the outfits for George IV's visit to Edinburgh in 1822.

We also take time to honour our national poet, Robert Burns. Most Scots know some words from at least one of his poems, be it *Auld Lang Syne*, *To a Mouse* or *Tam o' Shanter*. Every year, on or about January 25, we sit down to a Burns Supper, where his verses are recited and his songs sung, all accompanied by haggis and "neeps" (turnips), uproarious speeches and a few drams.

Despite our climate, we Scots have always enjoyed the outdoors life. How could we not, with such beautiful scenery? Yes, there is rain in summer – plenty of it. But there is also warm sunshine, and this is when just being out on the hills is pleasure enough. And in winter there is snow, which led to the founding of ski resorts. In recent years there has never been enough snow, however, leading to some of the resorts closing down. When there's a good covering, the sport is excellent, although not on the same scale as Continental or American resorts. Skiers now tune in anxiously to weather reports before heading off for the hills.

Highland Games, for all their fame, have become rather genteel spectator sports nowadays, with athletes following the Highland Games "circuit" to take part. The games were founded when clansmen of old showed off their strength and courage by throwing heavy weights, tossing tree trunks and dancing barefoot between the sharp blades of swords. Now track events, tug-of-war, sack races, children's competitions, Highland dancing, livestock judging and

even home-baking stalls are included in what is a great day out for all the family. The most famous games are the Braemar Gathering in September, which the Royal family attends, and the Cowal Highland Gathering, the world's largest, held near Dunoon in Argyllshire every August.

But perhaps the sport that sums up Scotland most of all is golf. In 1457 James II banned it, as it was interfering with archery practice. He was unsuccessful, and by 1504 his great grandson James V was enjoying a round or two. The modern golf courses are legendary, with the "links" courses (on the coast) being the most famous of all. Turnberry – Royal Dornoch – St. Andrews – Muirfield – Royal Troon – Carnoustie – these are the names that are known and respected everywhere. The Royal and Ancient Club in St. Andrews, founded in 1754, is not the oldest golf club in the world (that honour belongs to the Royal Burgess Golf Society of Edinburgh, founded in 1735), but it is the arbiter in all things golf throughout the world, with the exception of the United States. It also runs the British Open Golf Championship – the most prestigious in the world – and has a worldwide membership of 2,400.

Shooting and fishing are also traditional sports in Scotland. You need money to take part in them, as many Highland estates are increasingly commercialized, selling deer- or grouse-shooting weekends for thousands of pounds. And many stretches of the famous salmon rivers have gone the same way.

OPPOSITE
The Old Brig O' Dee
Built in the early 18th century, the old Brig O' Dee lies to the east of Braemar in Aberdeenshire. The Dee is one of the best salmon rivers in Scotland, and here we see a fisherman underneath the Brig's graceful three-arched bridge.

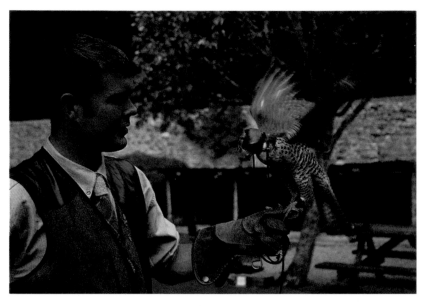

TOP LEFT
Falconry at Dunrobin Castle

No one knows when falconry was introduced into Scotland, but there is no doubt that it has always been a pastime of kings and courtiers, who had the time and the money to train and rear birds of prey. It is still a popular sport today, although the hunting element is largely gone, and there are falconry schools throughout the country that will teach you the essentials of using owls, hawks, falcons and eagles. Dunrobin Castle in Sutherland hosts daily displays of falconry in the summer, and here we see one of their finest birds.

TOP RIGHT
Stalking on Harris

Deer-hunting is big business in Scotland, with estates charging large amounts of money for hunting on their land. The huntsman will usually be accompanied out onto the moors by a ghillie, who advises on the lie of the land and the best places for good shots. Here we see a hunter and a ghillie stalking deer on Harris.

BOTTOM LEFT
Fishing in the River Awe

Loch Awe in Argyll is one of the great salmon and trout lochs of Scotland. The River Awe is comparatively short, and flows from the loch, entering Loch Etive at Inverawe. For all its length – it is only four or five miles (six or eight km) long – it too has salmon and trout. Here we see someone enjoying a good day's sport on the river.

BOTTOM RIGHT
The Ghillie

Every great estate in Scotland has its ghillie, from the Gaelic word meaning "servant". The name nowadays has come to mean an outdoor servant who looks after the estate and its wildlife, especially grouse, deer and fish.

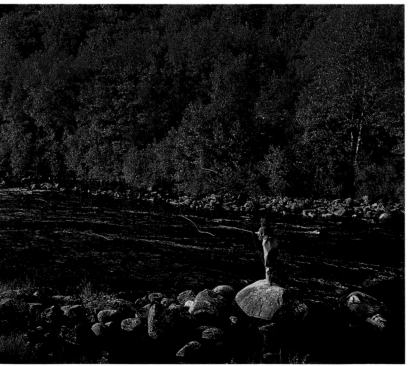

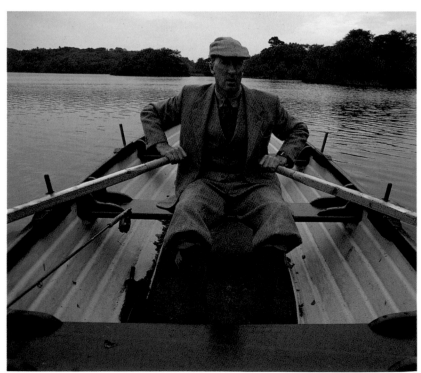

However, there are still some modest rivers where a day's fishing can be had for several pounds. And don't just look in the Highlands for them – the Lowlands have some fine sporting rivers as well, such as the Nith, the Tweed and the Stinchar.

All this activity takes place against some of the finest scenery in Europe, and for this reason hill-walking and climbing have always been popular. Large tracts of Scottish land can be accessed only on foot, and anyone contemplating going out on to them should be well clothed and equipped, even in summer. "Munro bagging" is an offshoot of this activity. Mountains over 3,000 ft (914 m) in Scotland are called Munros, and there are 284 of them. They are named after Sir Hugh Monro, who complied a list of them in 1891. Some people try to climb, or "bag" every one, taking a lifetime to do so.

Scotland's two great team sports are football (soccer) and rugby. The two Glasgow teams of Rangers and Celtic can command crowds of 50,000 and above at home games, with other Premier League teams usually trailing far behind. The international team has a support known as the "tartan army", which follows the team abroad, and which has a reputation (rare nowadays) for good behaviour and friendliness. The Scottish Borders is the home of rugby, although it is played in all the large towns and cities as well. It was at Melrose in 1883 that the world's first "rugby sevens" (basically a seven-a-side rugby team) competition was held. Now it is played throughout the world.

We have other sports as well. Sailing is popular on lochs and around the coast. Shinty, often called Scotland's national sport, is mostly played in the Highlands, and is akin to hockey. And each town and city has a

number of publicly and privately owned gymnasiums, athletic tracks, swimming pools and sports centres.

City dwellers have other activities to amuse them. Café society has taken off in Scottish cities, with pavement cafés and all the street life you associate with mainland Europe on display. In Edinburgh there is the added bonus of history and medieval architecture, making it one of the must-see cities of the world. It comes alive during the Edinburgh Festival each summer, and though it pulls in the tourists, many locals also enjoy the music, dramas, comedy and art that is on offer. You can actually visit Edinburgh during the Festival and be thoroughly entertained by the street theatre alone.

Glasgow is brasher than the capital, although it is home to many theatres, as well as to the Scottish Opera, Scottish Ballet and Royal Scottish National Orchestra. It also showcases the fine architecture and interiors of Charles Rennie Mackintosh. In addition it has a throbbing nightlife and many fine restaurants and pubs. But for all its brashness, Glasgow also has history. St. Mungo's Cathedral is mainland Scotland's only complete medieval cathedral, and has its origins in the 6th century, when St. Mungo, patron saint of the city, built a church on the site. The present cathedral dates from the 12th century onward, and it is well worth visiting. In the crypt is St. Mungo's tomb.

It is this dichotomy of past and present that defines Scottish life today. We can head for the hills and derive great pleasure from our rugged landscapes. We can relive great deeds by visiting the places where they took place. Then we can head home to watch TV, surf the web, visit the cinema, attend a concert or go to the theatre. We are truly blessed.

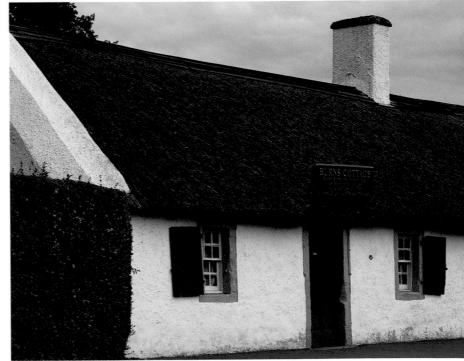

FAR LEFT
Hole in the Wa', Dumfries
Robert Burns, Scotland's national poet, died in 1796, aged 37. His favourite taverns were the Globe Inn and the Hole in The Wa', whose sign we see here.

LEFT
Engraving in the Globe Inn
This pub, said to be haunted, is a trove of Burns memorabilia, including this window pane, where the poet scratched some verses.

BELOW LEFT
Burns Statue in Dumfries
Dumfries is proud of its Burns connections, as this 1882 marble statue of the great man shows.

BELOW
Burns Cottage, Alloway
This cottage, in Alloway in Ayrshire, is where Robert Burns was born on January 25, 1759, the son of a tenant farmer. It is now the centrepiece of the Burns National Heritage Park, and has a museum attached.

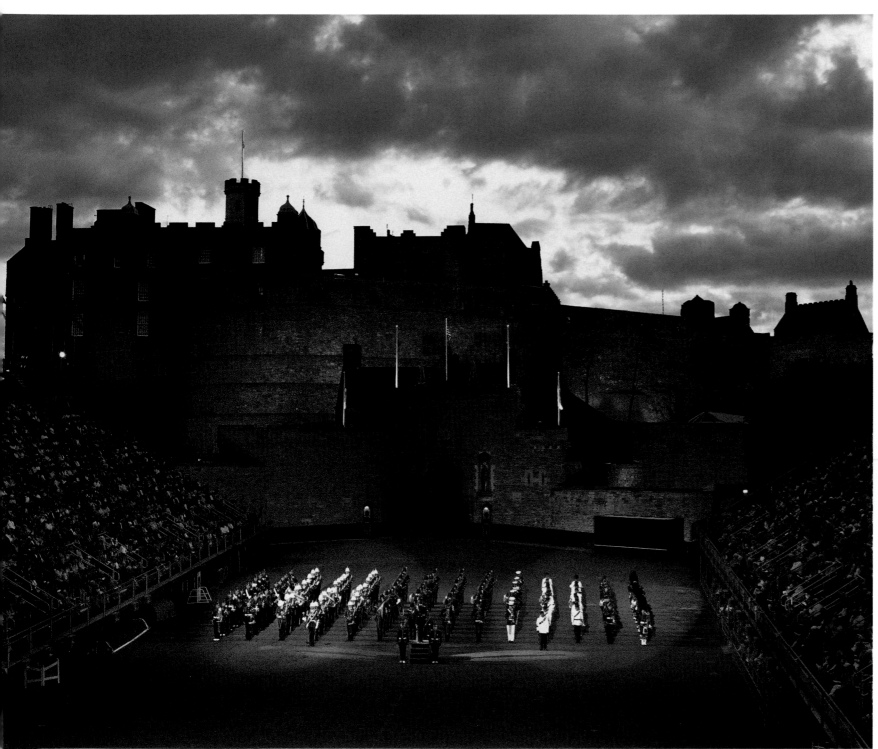

OPPOSITE
The Edinburgh Festival

Every year in late summer Edinburgh hosts the largest arts jamboree in the world – the Edinburgh Festival. It's actually series of festivals, the most famous being the Fringe, where anything seems to go. Every church hall, every pub, every meeting place in the city is commandeered by some group or other, with the quality of the acts varying from the sublime to the dire. The city's streets are filled with jugglers, fire eaters, musicians, actors and dancers, all trying to persuade you to visit a particular show. It's possibly the biggest free show on earth.

LEFT
The Edinburgh Military Tattoo

Although not part of the official Edinburgh Festival, no festival would not be complete without the Edinburgh Military Tattoo. It is held on the esplanade of Edinburgh Castle, and is a majestic and colourful spectacle of music, marching, and military precision. Scotland's proud regimental history – from kilted pipe bands to sword dancing – forms the backbone of the Tattoo, but it has in the past featured soldiers and performers from such countries as the United States, Russia and Australia.

BELOW
Buskers

Busking has always been part of the Edinburgh street scene, especially in the Royal Mile. Most buskers are quite willing to have their picture taken if you give them a few coins. Here we see a piper in full Highland regalia with a young admirer outside St. Giles Cathedral.

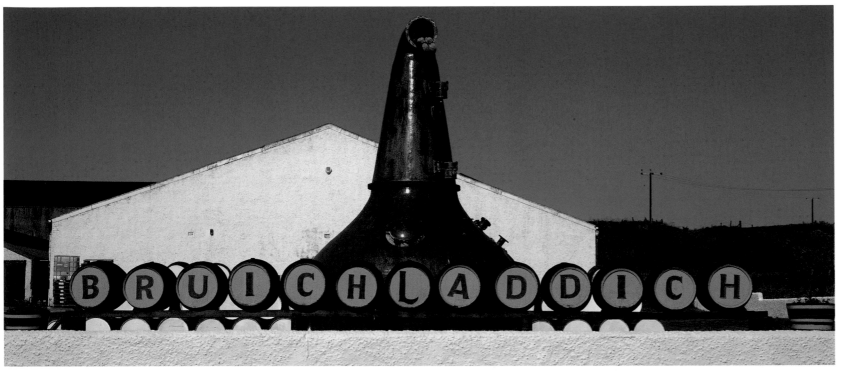

OPPOSITE
Balvenie Distillery, Speyside
To make good whisky, you need four things – barley, water, yeast and years of experience. First the barley is soaked so that it starts to germinate (known as "malting"), then it is dried, as shown here. Next it goes to the mash tun, where distilling begins.

LEFT
Bruichladdich Distillery, Islay
Islay whisky has a distinctive, smoky taste, because the seven distilleries on the island, of which Bruichladdich is one, dry the barley over a peat fire during the whisky's production process.

BELOW LEFT
Speyside Cooperage, Craigellachie
Whisky is matured for many years in oak casks before bottling. Often the casks used have previously stored American bourbon or Spanish sherry. They can be used repeatedly, for up to 60 years, but have to be constantly repaired – a skilled operation.

BELOW
Gordon & MacPhail
As well as distilling its own brands, Gordon & MacPhail sells a vast range of whiskies in its own shop in Elgin, seen here. The company is the largest malt-whisky specialist in the world, and some of the whiskies on offer are more than 50 years old.

Pennan Lifebelt

The tiny fishing community of Pennan in Aberdeenshire was the location, in 1983, for the filming of the movie *Local Hero*, with Burt Lancaster. Called "Furness" in the movie, Pennan sits at the base of a cliff, with its houses' gables facing the sea. The red telephone box used by Burt Lancaster in the movie was, in fact, a specially made prop, although the real one is only a few feet away. Many people now get their photograph taken against it.

Isle of Scalpay, Harris

The small harbours around the Scottish coast are a delight. This one can be found on Scalpay, an island in the Western Isles. Fishing was once a major industry on Scotland's western seaboard, although it has shrunk in recent times. However, over half the adult male population of Scalpay still fish for a living. In 1997 the island was connected to the mainland by a 900-ft (274-m) bridge costing over £6m ($10.5m).

OVERLEAF, FOLDOUT

Thatched Cottage, North Uist

Struan Cottage at Sollas in North Uist is a thatched cottage typical of the kind built all over the Western Isles up until the mid-19th century, when slate roofs and mortared walls were introduced. It is now rented out as a holiday cottage.

ABOVE

The Colintraive Ferry

Bute, in the Firth of Clyde, is an island that is rugged and high in the north and low and fertile in the south. The ferry is Bute's only connection to the mainland, and it runs from Rhubadoch to Colintraive in Argyll, across the narrow Kyles of Bute.

131

Ballachulish – Loch Leven
Scotland's west coast is rugged and beautiful, with sea lochs reaching far into the mountains. Owing to their deep and sheltered waters, they are ideal for watersports. One of the most beautiful lochs of them all is Loch Leven, south of Fort William, where you can sail, go canoeing, scuba dive, and cruise.

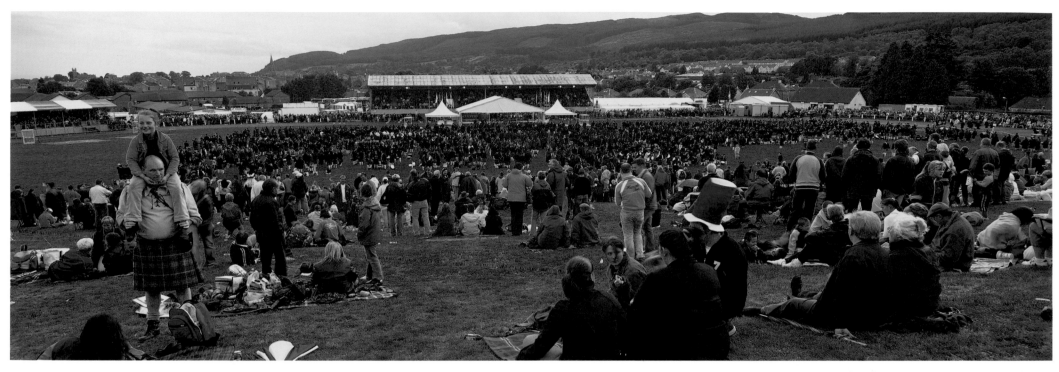

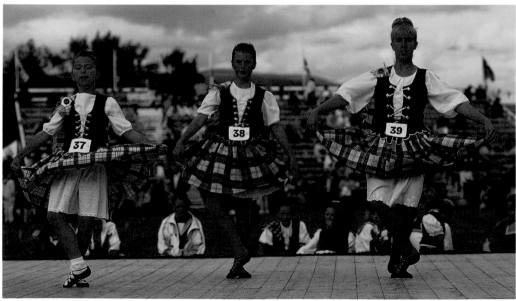

The Cowal Highland Gathering
This colourful and entertaining event started in 1894 and is now the largest annual Highland Games in the world. It is held over three days in August at Dunoon, on the Cowal Peninsula, and attracts more than 3,500 competitors from all over the world.

Highland Dancing
These dancers are competing in the Braemar Gathering and Highland Games, held on the first Saturday in September every year on Deeside, an event always attended by the Royal family.

Shot Putting at the Braemar Games
This popular event sees strong-armed athletes throw a heavy ball as far as they can. The sport originated when warriors of old threw heavy stones to improve their arm muscles.

Skiing
There are five recognized ski and snow boarding areas in the Highlands – Nevis, Cairngorm, Glenshee, Glencoe and The Lecht. Although not world class, Scots still flock to the slopes in winter, even though recent mild winters have seen a marked absence of snow. Some of the resorts have had to close for lengthy periods, even though snow making machines have been brought in. This photograph shows Glencoe, with, in the background, the Orchy Hills and Rannoch Moor.

Sailing
The west coast of Scotland is recognized as one of the best sailing and yachting areas in the world, with marinas dotted all along the coastline. There is no finer scene than looking out onto the blue waters of a sea loch, such as this scene near Craobh Haven in Argyll during the West Highland Yachting Week, and seeing the white billowing sails of yachts as they take advantage of the stiff breezes that are so much a part of Scotland's western seaboard.

OPPOSITE

Golf

Scotland and golf are synonymous. The most famous course in Scotland – and indeed the world – is the Old Course at St. Andrews, and here we see the culmination of a British Open at the 18th hole, with the Red Arrows flying overhead in salute.

BELOW

The 18th Hole at St. Andrews

The Royal and Ancient Golf Club of St. Andrews was founded in 1754. Here we see the marker for possibly the most famous hole in the world – the St. Andrews' 18th.

RIGHT

Gleneagles

Of Scotland's many famous and challenging inland golf courses, Gleneagles has one of the prettiest locations. Set in the Perthshire countryside, there are actually four courses, one of them, the "Wee", being nine holes. The courses are grouped round the Gleneagles Hotel, renowned for its five-star luxury.

FOLLOWING PAGE

Loch Creran, Argyll

The autumn light over Loch Creran in Argyll creates a memorable vista that sums up Scotland's life and landscapes. Scotland is beautiful in all weathers, and once seen it is never forgotten.

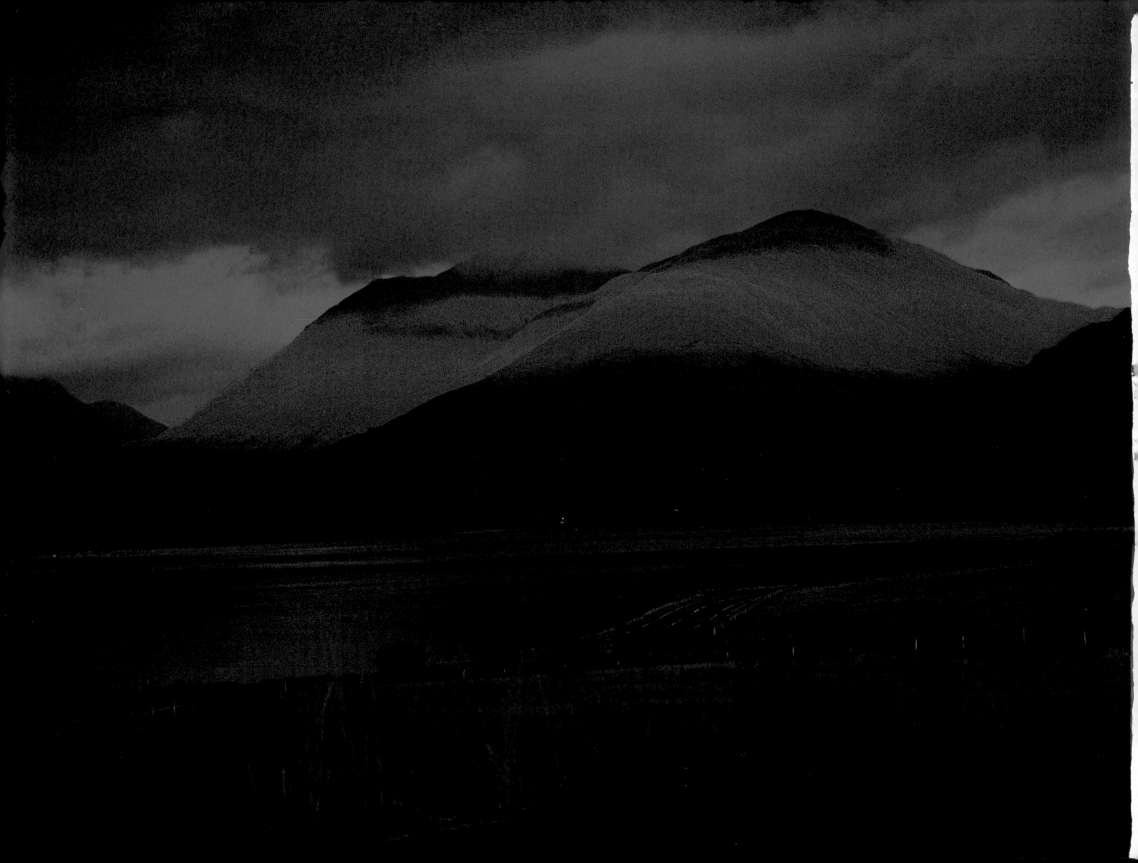